The Century of the Body

The Century of the Body

100 Photoworks 1900–2000

Edited by William A. Ewing

Musée de l' Elysée, Lausanne

With 121 duotone photographs and 36 color photographs

Thames & Hudson

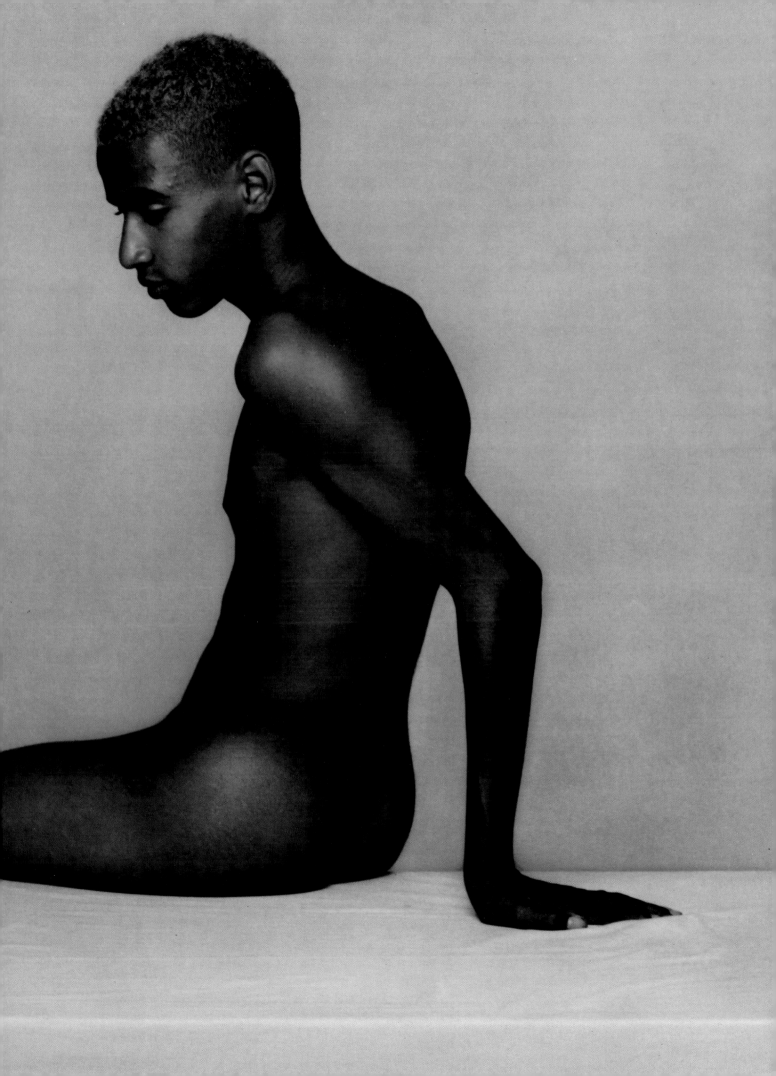

To the photographers of the twentieth century, who never tired of searching for new ways to depict the human body.

The Musée de l'Elysée wishes to thank the Fondation AR&J Leenaards, Lausanne, for their generous support of this publication.

First published in hardcover in the United States of America in 2000 by Thames & Hudson Inc., 500 Fifth Avenue, New York, New York 10110

Library of Congress Catalog Card Number 00-101122
ISBN 0-500-51012-1

Printed and bound in Italy by Poligrafiche Bolis SpA

Pages 2–3 **Olivier Christinat**
Swiss, b. 1963
Josephs nus
1997
Gelatin silver print

Contents

Foreword

Three reasonable questions:
Why the body?
Why photography?
Why twentieth-century photography of the body?

T h e n e w m i l l e n n i u m has inevitably provoked searching questions about the future of our society – and even of our species – revealing a disturbing mixture of hope and fear. We are especially ambivalent about developments relating to the body, now that we grasp the key to its 'software' in our hands. Manipulation of the genetic code holds out the tantalizing promise of disease-free lives, increased longevity and *super*human capacities, but it also raises fears of potential abuse, as the debates raging over human cloning make clear. But, for better or worse, we can be sure of one thing: the human body is no longer an absolute entity, fixed by nature and destined to be eternally replicated, at least until evolution's next throw of the dice. The era of the genetically engineered body has begun.

We are beginning to think of the bodies we inhabit in much the same way as we do the clothes we wear – as changeable according to climate, task, fashion and whim. And it is not simply genetic engineering which is altering the body's architecture; mechanical engineers are also at work. We are allowing our bodies to be transformed not just for reasons of health and longevity, but for reasons of vanity, as the rapid growth of cosmetic surgery attests. But, whatever the goal, 'flesh-and-blood' is an increasingly dubious description of the material that comprises a human being, now that plastic and metal parts, electromechanical components and animal organs are routinely grafted onto the organic 'platform' and foreign fluids pulse increasingly through synthetic arteries, valves and veins. Technologists already have a word for the new 'posthuman' beings coming slowly into existence: *cyborgs* – complex hybrids of organic and electromechanical components. And who needs sex, when reproductive technologies can deliver a superior product? Even intelligence is being created artificially – already some years have passed since IBM's 'Big Blue' triumphed in chess against its human antagonist. (Sceptics take note: there have been successful grafts of living nerve cells with electronic circuit boards.[1])

We are well on our way to cyborg status, persuaded on all sides to look upon our own bodies as high-tech machines in need of regular fine-tuning (and in the case of athletes, turbocharging) and the newest parts. The latest models on the

7

Pierre Boucher
French, b. 1908
Electra
1961
Gelatin silver print

assembly line – our grandchildren's bodies – may be expected, we are told, to last two hundred years, provided that their owners are willing to entrust their souls to the high priests of biotechnology.

Do these visions – dreams to some, nightmares to others – correspond to reality, or are we allowing our imaginations to get the better of our reason? One fact is undeniable: the body is at the core of our dreams and our nightmares because it is being transformed in fundamental ways. And precisely because it is being *reconfigured* by engineers, it is being *reconsidered* by artists.

Photography features prominently in both this restructuring and this rethinking. During the twentieth century a vast archive of photographic imagery was created, serving the many branches of science, technology, government, medicine, commerce, entertainment and art. Consider, to cite but one example, the role of photography in documentation. In medicine, photography has been used extensively to record pathological conditions, 'before and after' states of reconstructive surgery, disfiguring diseases, the results of treatment, and the normal structure and functioning of organs and tissues (including parts and processes too small to be seen by the human eye). It has played a major role in registering abuses of the human body – no other visual medium can show as clearly and objectively (when not consciously manipulated) the maimed and dismembered bodies of war and massacre, accident, crime and violence – so much so that legal 'proof' often requires photographic evidence. It has been indispensable (though somewhat dubiously, in retrospect) as an anthropometric device in criminology, sociology, anthropology and archaeology. And it has been used in commerce and industry to record and analyse the physical capabilities of human beings in order better to adapt products to their bodily needs.

But photography of the body has not only proved useful: it has also proved pleasurable. The fields of dance and sport, for example, have benefited immensely from the popularizing engine of photography. Today's newspaper is inconceivable without its steady stream of dramatic sports pictures. Sentiments of love and affection have also been well served: at one end of the spectrum, the photography of familial *rites de passage* (births, marriages, anniversaries and the like) has long ago achieved industrial proportions; at the other, erotic photography (in all its manifestations from 'soft' to 'hard') dwarfs all other forms of photographic production. And the prodigious output of beauty, glamour, fashion and advertising photography – in a word, the photography of seduction – ranks this genre a close second to its lascivious cousin.

8

The artistic archive is also extraordinarily rich. The tradition of the nude is the most coherent and best known of photography's body-centred aesthetic genres, but there are others in which the body figures prominently: many photographers who privilege the realm of dream and fantasy place it at the centre of their fertile imaginings. The 1920s and 1930s was a particularly vibrant period of visual whimsy, as the burst of activity in the practice of collage and photomontage makes clear. In the 1960s and 1970s 'Body Artists' used photography to record their ephemeral performances, while today's installation and performance artists are well aware that photography remains an indispensable recording medium.

Documentation, education, communication, persuasion, exploitation, titillation, investigation, celebration: these, then, are the principal functions of photography of the body.[2] As a result of myriad efforts by practitioners across a range of disciplines and sub-disciplines, our awareness, our knowledge and our appreciation of our bodies has grown – it is fair to say – *exponentially* over the past one hundred years. This knowledge derives from many fields, of course, but it is thanks in no small part to photography that we have a far better idea today of how we are constructed and how we function – what makes us tick – than anyone could possibly have imagined in 1900. *The Century of the Body: 100 Photoworks 1900–2000* offers an overview of this richly varied twentieth-century archive.

T h e p h o t o g r a p h s in *The Century of the Body* are selected from the exhibition shown at Culturgest in Lisbon between October 1999 and January 2000, and for the rest of the year 2000 at the Musée de l'Elysée in Lausanne (where it was composed of three parts: 'The Triumph of the Fragment', 'The Triumph of Form' and 'The Triumph of the Flesh'). The book features 100 fully representative photographs chosen from the 500 included in the exhibition.

Andrew Sabin
British, b. 1958
The Sea of Sun
1991–92
Coloranodized aluminium chain,
with transposed photographic imagery

The book's structure differs from that of the exhibition in that it is organized chronologically, thus allowing the reader to follow the evolution of body-centred imagery over the past one hundred years. The exhibition was organized according to a different concept, involving thirteen key themes, a structure that allowed often unexpected affinities between images to be revealed. In order not to lose these insights, mention of the thematic sections in which each photograph was exhibited accompany each caption. The themes may be briefly summarized as follows:

1. *Microcosm:* microscopic imagery of the body's interior.
2. *Gaze:* the most exposed or 'public' part of the body – the face, with its seeing eye.
3. *Flesh:* the naked body as opposed to the artistic nude.
4. *Memory:* the labyrinth of the mind.
5. *Icon:* the idealized body; notions of perfection.
6. *Gesture:* the language of the body; dance, sport, decoration, Body Art.
7. *Desire:* sensuality and eroticism.
8. *Form:* the great tradition of the nude: the body seen whole or fragmented, the body seen as a geometric scheme, and the body subject to transformation.
9. *Pain:* the suffering body.
10. *Politics:* the body's meanings and values contested.
11. *Enquiry:* the domain of scientific investigation.
12. *Fiction:* the realm of imagination; dream and fantasy.
13. *Macrocosm:* the single human body in relation to the cosmos.

Today the body is of central concern to science and is the burning issue of art. It is not fashion that drives artists to reflect on the subject, however, but necessity, as the natural body if buffeted increasingly by technological tremors and emotional shocks. Art helps us discern what is happening and enables us to make considered choices about our future. Photography has proved to be an indispensable and versatile tool, both for those whose interest is further knowledge and for those who feel that what we already know is miraculous enough.

William A. Ewing
Director
Musée de l'Elysée, Lausanne

11

Yves André
Installation views of
'The Century of the Body' exhibition
at the Musée de l'Elysée, Lausanne
February 2000

Form, Fragment and Flesh

'Le regard est l'érection de l'œil.'

Jean Clair

I m a g e r y o f t h e h u m a n b o d y is one of the richest and most diverse domains of photography. A close look, however, proves that most of this wealth was accumulated in the twentieth century – hence the nature of this book. It would be difficult to make an equivalent claim for the medium's first sixty years. Nineteenth-century photography was timid in its approaches to the body. In large part, this reflected society's attitude, which was generally one of fear and denial.[1] But photography's immaturity was also a critical factor. Artists, scientists and specialists across a wide variety of disciplines could not yet envision all the ways in which the new medium could assist them. Both its methods and apparatus were, with a few exceptions, simply too rudimentary to be put to effective and widespread use. The photography of warfare, to cite one example, was out of the question during the long period of the glass negative (known as the wet-plate): the preparation of each plate, which had to be done on the spot, was too time-consuming and complicated to allow a photographer spontaneity of reaction; added to that, the plate had to be developed immediately afterwards; and even if, by some extraordinary luck, the photographer was prepared for a dramatic event, he lacked the means to freeze movement. So except for pictures of battlefields *after* the carnage had ceased – once the gruesome evidence had been removed, or cadavers even rearranged for propaganda or pictorial purposes – we have no historical documentation of nineteenth-century warfare in which the human body plays a significant role.[2]

Similar technical obstacles also prevented photographers from recording more gentle pursuits: dancers or athletes in motion, for example. Lenses and films were not fast enough, and flash photography, despite valiant attempts to control explosive materials, was not yet a viable option.[3] Photographing any indoor activity with stop-action photography was therefore out of the question. Attempts to reduce blurring by propping the subjects up for the long time exposures required (a dancer on point was sometimes suspended by cables, while a batter was poised in the studio behind a baseball hung on a string) resulted in what appears to modern eyes to be wooden and scarcely credible imagery.[4]

13

We must remember that photography, when it first appeared in 1839, was not seen as filling a pictorial vacuum. There was the thrill of novelty, certainly, but many other kinds of pictorial representations of dancers or athletes performing or soldiers battling heroically already existed in the form of engravings, lithographs and other types of traditional print media.[5] Such picture-making alternatives were also available to scientists. To physicians, monochrome photographs of human bodies, inside or out, seemed primitive and lucklustre in comparison to the neatly rendered, exquisitely coloured lithographs and aquatints of the same subjects. Moreover, because scientific illustration had been based on handwork for hundreds of years, the fact that the role of the hand in photography was reduced to the pushing of a button (or so it seemed to those who had not themselves tried to make photographs) led to considerable disdain for the photographer and his primitive craft.[6]

Lastly, while photography as an *image-making* system made substantial gains in the nineteenth century, as an *image-reproducing* system it did not succeed well enough to compete effectively with well-established print media, in particular wood engraving and lithography. Indeed, original photographs ended up on the pages of magazines as handworked, engraved interpretations of the former. The era of photomechanical reproduction, which allowed extremely convincing facsimiles of true photographs, would not arrive until the turn of the century: only then would photographic imagery begin to rival more established mass media.[7]

This is not to say, however, that no attempts were made to photograph the body in the nineteenth century. In the field of medicine, despite scepticism from colleagues, certain physician-photographers began documenting what they saw with their own eyes and wished to share with distant colleagues: orthopaedic problems, skin ailments, physical injuries and congenital deformities, often of the most dire kind. But photography of the interior of the living body did not become possible until the camera was connected to the endoscope, a nineteenth-century invention involving a system of mirrors that allowed doctors to peer inside their patients. Primitive photographs of the stomach, bladder and larynx were accomplished in this way.[8] Far more significant for medical research and diagnosis, however, was Wilhelm Konrad Röntgen's discovery in 1895 of the X-ray: henceforth, much could be learned of the living body's interior condition without recourse to invasive surgery.

It is also possible, of course, to photograph parts of the body which have been removed but which continue to live for a discrete period of time. The invention of photography coincided with a new awareness of the cell as the structural and

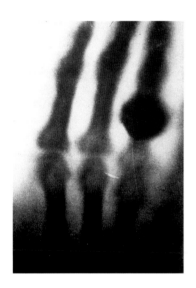

14

Wilhelm Konrad Röntgen
German, 1845–1923
Untitled (X-ray of His Wife's Hand)
c. 1895
X-ray silver halide film

fundamental unit of all organisms, and the camera attached to the microscope proved of great value in recording this other realm of the previously invisible.[9]

Another domain of 'the invisible' was also targeted by photographers. It was the conventional wisdom of the time that the face mirrored the soul.[10] Given its own mirror-like aspect, photography seemed a perfect tool for capturing fleeting facial expressions, thereby allowing 'physiognomists' to build up a full inventory of such expressions, each of which could then be associated with a specific emotional state: fear, joy, astonishment and the like. The most extensive work in this domain was undertaken by Guillaume-Benjamin Duchenne de Boulogne, working in collaboration with the photographer Adrien Tournachon. Convinced that mankind's emotions were God-given, universal and immutable, Duchenne de Boulogne began a thorough study of the subject, recording his results systematically with the camera. Rather than waiting for the emotions to register naturally, however, he stimulated the appropriate facial muscles individually with electrodes. That he was thereby undermining the supposed objectivity of his approach, and merely confirming his prejudices, never seems to have occurred to him. Today, his multi-image plates of what he called a 'living anatomy', published in 1862, seem no more than a charming and misguided effort, though thoroughly comprehensible in light of the era's penchant for exhaustive classification and its utter conviction that positivist science could unravel every mystery in the universe.[11]

Similar sentiments informed other photographic enterprises. Investigations were begun by men of science into what the face revealed of basic and unchangeable character. Francis Galton invented composite portrait photography in order to identify persons who were predisposed towards criminal behaviour. He did this by printing a number of faces of known criminals – killers, thieves and sex offenders – on top of each other on a single plate, thereby averaging out facial features.[12] Some European police departments saw photography as a potent weapon in identifying not generalized types, but specific individuals. Such practices can be found as early as the 1840s, but the most sophisticated method was developed by the Frenchman Alphonse Bertillon, who proposed an explicit system of measurement by means of photography of selected features of the body, including front and right profile photographs of the head taken from specific viewpoints, supplemented by notes on baldness, foot length and the shape of the ear (which he considered 'the immutable legacy of heredity and intrauterine life'). Bertillon's method formed the basis of twentieth-century criminal identification programmes.[13]

The thinking that characterized physiognomy paralleled thinking about the entire body. Physical anthropologists were fascinated by the issue of race, and were attempting to classify the astonishing array of peoples who were becoming known to Western man as a consequence of exploration, colonization and general ease of travel. Europeans of course simply assumed that whites were of the highest evolutionary order and blacks of the lowest.[14] Any visible difference between them was therefore proof of the former's superiority. Photography, or what in this specific usage was called anthropometry, was a way of scrutinizing both the gross physical differences between the races and the more minute differences between people of different tribes. Extensive 'family trees' of such photographs were constructed by various European anthropologist-photographers, the only essential difference between them being that German scientists put the Kaiser and his family at the uppermost level while their British counterparts inserted Queen Victoria and her kin. As for nakedness, this was to be found at the lower levels (after all, tribal peoples were closer to 'nature'), and as one moved upwards bodies became progressively more clothed, until only hands and faces peeped out from the elaborate finery of the 'most evolved' folk.

Not surprisingly, perhaps, it is sometimes difficult to draw a clear line between disinterested anthropological enquiry and salacious intent. European men who had grown up in the company of women who were covered from head to toe were not indifferent to the semi-nakedness of native African women.[15] Mid-century pornographers quickly discovered that they could cloak their photography in a veneer of respectability if they justified it as science. On occasion this meant forcibly disrobing the women and coaxing them to adopt poses which would be read as sexually provocative.

Nineteenth-century military photography was more concerned with portraits of officers and views of disciplined ranks of privates than it was of actual engagements with enemy troops, and the occasional photograph which seems at first glance to be a true witness of active warfare generally proves to be a record of military manoeuvres. At the other end of the propaganda spectrum, advertising photography emerged in very tentative form. The body, male or female, is occasionally an important element in these pictures, though it is little more than a clothes horse – demonstrating the utilitarian function of an undergarment. Before-and-after photographs made their appearance in the last decade of the century, in the service of supposedly miraculous beauty treatments. Nineteenth-century advocates of healthier bodies also found photography a persuasive tool.[16]

Semi-nude photographs of male athletes and body-builders began to be hung in gymnasiums or disseminated on the popular *cartes de visite*, the larger cabinet cards, and even in cigarette packets. Very occasionally, women were depicted by propagandists of the body beautiful without the disfiguring and unhealthy corsets then in vogue. But fashion photography as we know it today – sensuous, elegantly contrived fantasies which are intended to appeal to the emotions rather than merely to table facts – simply did not exist before the twentieth century.

Hugely important for subsequent generations of artists as well as scientists were the sequential motion studies of Etienne-Jules Marey and Eadweard Muybridge. These corrected many preconceptions about human locomotion, showing how we *actually* walk, jump, run and so on, and military strategists were quick to adopt the medium to analyse the body's movements when marching, crawling and at rest in order to discover more efficient distribution of loads. Perhaps more importantly, the work of Marey and Muybridge convinced many that camera vision was, in one sense, *superhuman* – that the camera could see reality more intensely and more accurately than could the eye. Thereafter, critics would be less likely to dismiss photography as a mere validator of human sight.

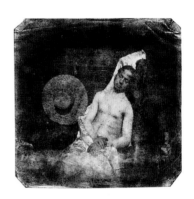

But all was not fact and documentation in nineteenth-century photography: there was room for imaginative fictions as well. Indeed, the earliest virtually naked body to appear in photography belonged to one of its inventors, Hippolyte Bayard; the title he chose for his self-image, 'Self-portrait as a Drowned Man', expressed his disappointment at being passed over while accolades were being showered on his rivals Daguerre and Talbot.[17] Thanks to its ironic title, the picture is rightfully considered photography's first true *mise en scène*.

Others followed in Bayard's footsteps. Oscar Gustav Rejlander and Julia Margaret Cameron, to name two of the most famous photographers, composed elaborate tableaux which often involved the nude or semi-nude bodies of infants and children, the nudity conveying both innocence and exclusion from society's corrupting ways. These genre pictures retain our interest more for what they tell us of the era's apprehension regarding the naked body than for their frank treatment of the subject.

The child nude was far less problematical in the nineteenth century than the adult nude, given the disturbing connotations of nakedness in general. Nude studies do appear in early photography, but few were intended as works of art in their own right, as the usual designation, *académies*, makes clear. These works were either produced as aids to painters and sculptors (they were cheaper than live models, and stayed still), or they were intended as pornography. The irony is,

17

Hippolyte Bayard
French, 1801–87
Self-portrait as a Drowned Man
1840
Direct positive

that to *our* eyes, the nude studies made for artists often *look like pornography* (as they are frontal and frank), while the nudes made expressly for pornography *look like art* (as they imitated painting in order to escape the wrath of the censors).[18] Only in the last decade of the century did the nude, in the sense in which we understand the term today, emerge as a bona fide aesthetic tradition.

That it did so was due to the efforts of a group of dedicated gentlemen amateurs in the wealthier countries around the world who were determined to prove that photography could be a true art. In the view of the Pictorialists, as they are often called, an elegant nude, devoid of all erotic titillation, was seen as proof that photography had a legitimate claim to the status of a fine art. To our eyes, Pictorialist nudes seem timid, prim and even sexless, but the very fact that they represented an end in themselves and not a means by which 'real' artists (that is, painters and sculptors) could attain their goals signalled a decided shift in sensibilities. Moreover, the Pictorialists were well organized, holding ambitious national and international exhibitions and publishing the most accomplished examples of their work. Criticism began in earnest, too, and issues of aesthetics began to be aired. National photographic societies were born, and reviews founded. Still, the nude was not yet a thoroughly respectable subject, nor a priority – landscapes, still-lifes and genre subjects were generally preferred. It is telling that the Société Française de Photographie did not permit nudes to be hung in their exhibitions until the end of the nineteenth century. Nevertheless, the stage was set for a great burst of creative imagery.[19]

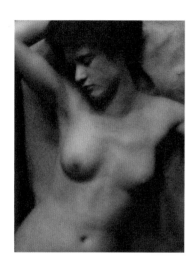

The early decades of the twentieth century marked a radical shift in attitudes to the body. The reasons – social, political, cultural and technological – are exceedingly complex and a full explication is obviously beyond the scope of this introduction, but some fundamental factors should be taken into account.

The rise of nudism and the cult of physical culture (which may be seen in large part as a reaction to the threat presented by an increasingly machine-dominated society) offered men and women a new perception of physical well-being. Medical breakthroughs in the understanding of disease and rapid progress in surgical techniques promised longer and healthier lives for increasing numbers of people. Pioneering dancers like Isadora Duncan and Vaslav Nijinsky championed a new freedom of bodily movement, and their art revealed a new capacity for emotional expression through unconventional movements and gestures. Early feminists argued vociferously for a greater role for women in society and for a more humane, 'demasculinized' social order. The First World War also changed

18

Clarence H. White and Alfred Stieglitz
American, 1871–1925/1864–1946
Torso
1907
Photogravure, 1909

perceptions of the body, and mankind took stock of the new vulnerability of 'flesh and blood' in a world increasingly dominated by powerful machines. Clothing designers, led by the great French couturiers, capitalized on these sensibilities, and, influenced by avant-garde art – in particular Cubism and Constructivism – began a radical overhaul of women's clothing, freeing the female body from restrictive and truly unhealthy garments.

Meanwhile, the invention and proliferation of hand-held cameras, a greater range of films and lenses, artificial lighting, an expanding range of high-quality printing papers and a host of accessories gave photographers a much greater degree of flexibility and freedom in dealing with their subjects, and this inevitably led to a new intimacy with the body. A photographer of the nude could get closer to the body, walk around it, and look down on or up at it. A photojournalist could hide his tiny camera and catch his prey unawares. A dance photographer could use one of the increasingly reliable flash guns to capture a moment of peak performance on stage. A sports photographer could get right up to the ring to register the moment of a knockout. Whole new specialities of photographic activity arose.

And photographers were not operating in a vacuum. They were, to widely varying degrees, aware of the revolutionary changes going on about them. A photographer like the Russian-born George Hoyningen-Huene, for example, whose *métier* was fashion photography, had been educated in a conservative environment to believe absolutely in the Hellenic idea of the perfect body. Both in studies with the Cubist painter André Lhote in Paris, and in his later work for *Vogue*, he clearly absorbed influences from Cubism, Constructivism and the cinema, and these came out in his work. Moreover, his direct experience with Cubism made him all the more appreciative of the great couturiers like Chanel and Alix, whose garments he had to portray convincingly.[20]

Hundreds of thousands – perhaps millions – of people were now seeing Hoyningen-Huene's images and those of other fine fashion photographers on a monthly basis, but many millions more were seeing journalistic photos on a daily basis via newspapers and magazines, and this steady diet of candid imagery (though often less candid than it appeared) had the effect of extending awareness of the extraordinary differences between bodies and of the equally astonishing range of things people could do with them: the visiting Bulgarian contortionist, who travelled from village to village with his amazing act, was now on view in the pages of the *Illustrated London News*. Even the artless family 'snapshot' taken with the newly proliferating hand-held cameras played a role in sharpening

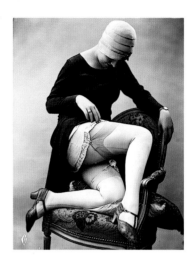

Anonymous
Untitled
c. 1920
Gelatin silver print

perceptions of the body. Its very artlessness was a strength: by shooting people unposed and unawares, the picture-maker depicted the body as it *actually* moved, rather than as it was *supposed* to move according to fine-art conventions.

The expanding market for photographically illustrated magazines (in all those areas where the body was predominant) meant that advertising imagery involving the body gradually became a staple in twentieth-century households. People grew accustomed to having pictures of partially naked bodies lying about on their coffee tables or next to their beds. And while photojournalists had been liberated by lightweight, hand-held cameras, advertising and fashion photographers were technically empowered by studios of great complexity, where seductive and utterly convincing illusions of reality could be fabricated.

It was a combination of such technological and cultural factors that encouraged early twentieth-century photographers with a creative bent to search for a vocabulary of forms appropriate to an improved understanding and awareness of the human body. In part this meant breaking with conventions which stipulated painting and drawing as the only models worth emulating. One key new, and very effective, strategy which owed nothing to fine-art precedents (but did clearly owe something to the cinema) concerned fragmentation of the body – the body seen up-close and in part. This stratagem would eventually be adopted by photographers of the nude, sports, dance and reportage. A fragment could have a striking visual and emotional impact, partly because it brought the viewer into an extremely intimate relationship with the physical subject and partly because there was an intriguingly abstract – and therefore ambiguous – aspect to it: a fragment simultaneously reveals and conceals. It is, in a sense, a piece of a puzzle, and because it is the only piece with which the viewer is supplied, an air of mystery is imparted. Art photographers quickly learned that fragments could be used in very different ways: the *realist* fragment brought a part of the body into close scrutiny without compromising a sense of the whole; the *surrealist* fragment disembodied – that is, it evoked something other than the real body from which it originated, 'becoming' a bizarre creature, a landscape, or wholly unexpected thing; the *formalist* fragment aimed for striking geometric abstraction to the point where all sense of flesh and carnality was lost. There was also something we might call the *literal* fragment: parts of bodies torn or cut out of photographs and pasted together – the collage and the photomontage. Together these approaches demonstrated that photography was not simply an inferior form of painting or drawing, but had an aesthetic terrain of its own. This vision greatly enriched and extended the tradition of the photographic nude.

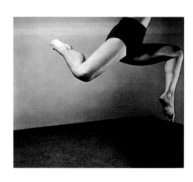

Barbara Morgan
American, 1900–1992
Valerie Bettis
n.d.
Gelatin silver print

It must be said that the vast majority of nudes from the first half of the twentieth century (and there are legions) are insipid. Curvaceous young women with demure expressions gingerly dip their toes in pools, sun themselves on (what must have been extremely uncomfortable) rocks, or dance with veils à la Isadora Duncan. Dance is a popular motif – the hope was that its 'high-art' connotations would thus be transferred to photography. But in the hands of supremely talented practitioners like Man Ray, Edward Weston and Imogen Cunningham, to name but a few, the photographic nude achieved a truly elevated status. The innovators of the twenties and thirties proposed a whole new gamut of visual tactics which would be eagerly taken up by photographers of the body. The 'New Vision' proposed shooting on the diagonal (tilting the subject to induce vertiginous sensations), worm's-eye and bird's-eye views, double-exposures, multiple printings, solarizations, negative prints, photograms (camera-less images), mirror distortions, even X-ray imagery and photomicrography. Surrealism also exerted a powerful influence – photography's clarity and verisimilitude made for particularly effective visual shocks when ordinary objects or parts of bodies were closely juxtaposed, and the ensemble could be invested with strange and disturbing meaning.[21] In the late 1920s, advertising photographers began to adopt this shock tactic in their 'campaigns' (the military analogy is apt, both for its strategy and its tactics) of mass persuasion.

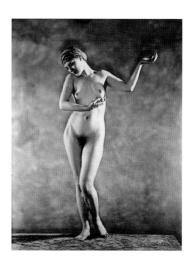

While the nude veered towards a fragmentary vision, politically motivated photography turned toward the *collective* body: 'the body politic'. Totalitarians and democrats alike proposed imagery which showed enormous crowds composed of like-minded individuals: the former preferred well-ordered military parades and rallies – the body as a cog in a well-oiled machine – while the latter favoured chaotically massed individuals – workers or voters exercising their hardwon rights. Vigorous, healthy bodies became a staple in Fascist photographic propaganda, tapping into the deep-seated Germanic ideal of the body in perfect harmony with nature.

If the nude blossomed into myriad forms in the first half of the century, 'art photography' was not always the high-minded practice it claimed to be. Pornographers reproduced erotic images by the millions, via the flourishing magazine industry. A subscription to what came to be called a 'girlie magazine' – a genre which cleverly found a niche between pornography and art – became part of a young man's rite of passage. There were many attempts to ban or discourage such publications, and victories on both sides. In 1949, for example, *Paris Pin-Up* won an appeal against a ban when the court ruled that the pictures were no more

Nickolas Muray
American, 1892–1965
Untitled
1925
Gelatin silver print

immoral than the city's statues, and stated that a ban would have the effect of placing '...an immoral and unhealthy character on the work of artists which can be seen in national museums, parks and art galleries.... The study of the human body, when it is conceived without an intent of obscenity, should be admitted as much for the photographer as for other artists.'[22] This small victory for art photography also benefited pornographers, who could now simply deny 'intent'.

When it was not art, the respectable 'disguise' of photography was nudism, or physical culture. In addition to bona fide subscribers to this movement's magazines were those whose primary interest was the scrutiny of male and/or female anatomy, of children as well as adults, for the purposes of sexual arousal. As for magazines which were more forthright about their worship of eroticism, sexuality had to be carefully managed. Heterosexual eroticism was on safe ground, generally speaking, if it did not cross certain boundaries (female genitalia, for example, completely vanished in shadow or under the retoucher's brush; sexual activity was forbidden). Homosexual eroticism, on the other hand, had to be disguised in order to avoid censorship and worse; wrestling, boxing and so on were among the codes which suggested sexual congress between men without triggering reaction on the part of hyper-vigilant moral authorities. Needless to say, however, there were millions of photographs (then as now) which stayed deeply underground and skirted the censorship issue altogether, while catering to every sexual taste imaginable.

Medical photography made great strides in the first half of the twentieth century, and was increasingly used as a pedagogic tool. Brilliant use of stereoscopic photography by the Scottish physician David Waterston at the turn of the century resulted in the production of three impressive atlases of human anatomy. Increasingly, hospitals and universities took on specialized photographers, who gradually developed imagery that was equal to, and finally surpassed, what the hand was capable of illustrating.

Scientists were also peering at ever more minute structures *within* the human body. Light microscopes were constantly being improved, although by 1920 they were nearing the limits of their resolving power (the ability to differentiate between structures), in fact, about one-thousandth of a millimetre. In layman's terms, this means that with the finest light microscope we can see objects and organisms, clearly, around one hundred times smaller than with the unaided eye. Happily for researchers whose needs lay in ever finer resolutions, the 1930s saw the introduction of two new kinds of microscopes, based on electronic imagery, one which could see structures clearly at magnifications *ten thousand times*

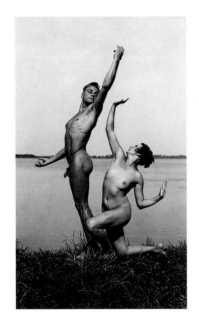

22

Gerhard Riebicke
German, 1878–1957
Untitled
c. 1925
Gelatin silver print

smaller than the unaided eye, and the other which could picture them *one hundred thousand times smaller*. Scanning electron microscopes (SEMs) and transmission electron microscopes (TEMs) heralded a new frontier of knowledge of the body which, despite instant success (pictures demonstrating the existence of viruses, in 1939, for example) would not be fully explored until the second half of the twentieth century.[23]

T h e S e c o n d W o r l d W a r brought an abrupt end to that innovative phase of modern photography known as the 'New Vision', and to a golden age. The disruptive effects of universal war were too widespread for art photography to find a safe haven; instead, photography's utilitarian functions came to the fore. The camera was employed for propaganda purposes by governments and their armies: to show victories and heroic acts by leaders, soldiers and civilians alike. But photographic imagery, which depicted the bodies that littered the streets of carpet-bombed cities or were stacked up like cordwood in the concentration camps, would only gradually seep into public consciousness, and then only in limited doses and mostly after war's end.

Just as the First World War had shifted attitudes to the body, so would the Second. Women, for example, were pushed back into the domestic sphere and had to abandon the political gains which had come about as a result of their diverse contributions to the war effort. The 'New Look' which burst upon the fashion scene in 1947 proposed a vision of femininity that reclaimed women's bodies as decorative and desirable objects. Rebuilding national economies, cities, and the like, and binding the psychological wounds were shared goals which also had the effect of dampening radical experimentation in photography; instead, photographers were encouraged to provide useful services. Only photographers who were associated with mass-media magazines had any real hope of finding a substantial audience for their efforts, in the absence of any significant gallery and museum support. Fashion photography, which gave a handful of photographers the necessary means and the encouragement to produce innovative work (after all, that 'new look' had to be sold to the public), is therefore one of the most vibrant fields of early postwar pictorial expression.[24] Photojournalism, now firmly established as a mass medium, also continued to provide work for large numbers of photographers, who in spite of the factual demands placed upon them often developed personal styles which had considerable élan, and sometimes even achieved a level of lyricism. Sadly, however, the moment coincided with the

emergence of television as a journalistic force, and photojournalism, despite its strengths, would inevitably be pushed into the shade by its glamorous rival.

Nonetheless, the war in Vietnam was covered by photography as no war had ever been covered before or has been since – freely, and in depth.[25] The dismembered and mutilated bodies of soldiers and civilians, including children, which seemed for a time a staple of newspapers and magazines, brought home to the world a new understanding of what war meant in its technologically advanced state. Photography held its own with television, too, and what one glimpsed rapidly on the moving screen in the evening news could be pondered over the next morning in the daily newspaper. The camera thus helped to turn the tide of personal opinion everywhere, including the United States, against the conflict. Nick Ut's celebrated photograph of a child, in agony from napalm burns, running down a highway, was not the message the American military wished to convey. The next generation of generals and politicians evidently learned the lessons well: the British, for example, made sure that no roving photo-reporters were on hand during the Falklands War to witness casualties on either side.

The photographs of Vietnam may well have been a contributing factor to the rise of a new art form in the 1960s and 1970s which is generally known today as 'Body Art'.[26] These artists turned to their own bodies – to draw upon (or even with), to cut into, to mutilate, to turn into 'inanimate' states – thus transforming themselves into art objects. But rather than aiming for a highly individualistic 'self-expression', body artists like Chris Burden and Carolee Schneemann sought, in shamanistic fashion, to confront their audience by mirroring its neuroses.

Thus, danger, risk, accident, chance and even symbolic death (in some cases with a real risk of accidental death) figured prominently in their art. Much work was done in performance, private and public, and as a result photography (and to a lesser extent video, at the time an unreliable and insufficiently developed medium) was called upon both to spread the message and to document it for posterity. Such photographs were often taken by amateurs – friends or spectators – and generally lacked technical sophistication, but this was seen as an appropriate treatment of the raw and often shocking subject-matter. Moreover, it was a way of proclaiming that the photographs were intended as documents rather than as artworks in their own right.

Other artists, like Dieter Appelt and Arno Minkkinen, have been equally concerned with staged performances of their own bodies before the camera, but see the resulting photographs as the artwork. For such performers, photography is a

highly expressive medium which offers unique capacities for self-investigation and/or self-expression (as the two are not necessarily the same thing). Photography is the means *and* the end as well for Cindy Sherman, who directs and stars in what has turned out to be an evolving masquerade in which the artist confronts her (and our) fears, prejudices and vanities.

Certain other photographers have preferred to let other artists do the 'expressing'. Photography of dance has a long tradition in the twentieth century, and while photography has all too often been merely a servile handmaiden to the dance,[27] in the hands of a few dedicated practitioners like Barbara Morgan, George Platt Lynes or, most recently, Lois Greenfield, it has achieved independence and maturity. And although contemporary dance attracts a limited audience, the photographs broadcast its 'messages' widely – messages which propose a rethinking of the human body.

In recent years the human body has become a principal interest of art photographers, though the interest is less on the traditional, formal 'nude' than on the corporeal, material side – the 'flesh and blood' body: vulnerable, individual, ephemeral. It nevertheless took courage for a middle-aged John Coplans to expose his naked flesh, in extreme close-up, to the relentless gaze of the camera eye. More female photographers have also approached the subject of the male nude in recent years, and, along with gay photographers, have helped transform it into a respectable subject. The infirm body, the handicapped body, the abused body and even the body in death are other subjects which have passed from taboo to acceptability. Sex has also entered the lexicon in ways unthinkable a half-century ago, when the depiction of genitals (male or female) would have landed a photographer in prison. Brilliant, if controversial, work by photographers like Robert Mapplethorpe and Jock Sturges has shown how sexuality, sensuality and sheer beauty are threads of the same rich fabric. Sexuality is increasingly depicted by art photographers with frankness and honesty, a necessary corrective to exploitative and ubiquitous pornography.

Frankness and honesty are not necessarily enough to engender art, however. The classic female nude has proved an extremely popular subject with amateurs and professionals alike, but few photographers of the nude manage to transcend banality and bring something new to the genre. Among those photographers of the second half of the twentieth century who have seen the nude with truly fresh eyes are Bill Brandt, Lee Friedlander and Joel-Peter Witkin. Interestingly, the best contemporary practitioners of the photographic nude show a keen awareness of its venerable history (not to mention the larger context of art history), and the discerning eye can gain much pleasure from uncovering such references in their work.

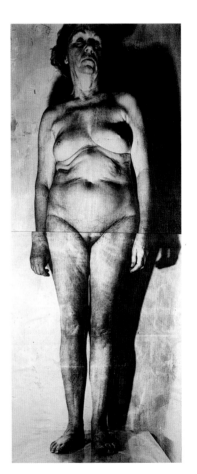

Melanie Manchot
British, b. 1966
Mrs Manchot, Standing Tall
1996
Gelatin silver print and mixed media on canvas

A number of contemporary art photographers continue in the tradition of the photograph as a highly personal document which records the intimacy of their family lives, or those of their close friends, trying to capture on film moments of intense, if fleeting and often hidden, emotion. Such works, by photographers like Sally Mann and Nicholas Nixon avoid the ubiquitous 'vernacular' vocabulary of family photographs – 'Stay still!', 'Look at the camera!', 'Smile!' – and do not shy away from nakedness and covert (and sometimes overt) sexuality. A number of amateur as well as professional photographers are currently paying a steep price for their child nudes, and are subject to attacks on their work and their reputations by outraged citizens who confuse intimacy (for example, family snapshots of a photographer's children in the bath) with tabloid accounts of child molesters and incest. Attacks by religious fundamentalists on the right, and severe 'critiques' by academics on the left (charging 'exploitation') are also successfully discouraging innovation in a long tradition of photography of the body in its infant and childhood phases.

Conventional ideas about beauty, gender, sexuality and personal identity are questioned by a number of contemporary photographers. Some resist or subvert the power of ubiquitous advertising and commercial photography, which they see as a dangerously persuasive force; others mock society's unwillingness to look directly at *real* bodies, its insistence on seeing them 'dressed up' in the clothing of social class or economic status. Still others attack the hidden prejudices of art photography itself, such as the long-standing preoccupation with female nudes, which all too often have about them a lingering odour of male chauvinism. Academia has played a role in sensitizing photographers to social and cultural forces which define, circumscribe and control the fabrication and dissemination of their work. Race, ethnicity, class, politics, disease (in particular the homosexual body ravaged by AIDS), big business and the environment are all seen as issues which impact upon the body in fundamental ways, and should be addressed by artists. By so redefining the body, postmodern discourse has greatly enlarged the terrain for photographers.

For all its insights and beauty, art photography still speaks to a limited audience despite the postwar gains effected by books, galleries and museums in the second half of the century. Far more people view images of bodies as they are diffused through newspapers and magazines, whether it be candid reportage of the news, coverage of sports events, or staged imagery in the service of commerce. This last category is by no means restricted to products directly associated with the care and grooming of the body; on the contrary, the body beautiful (highly,

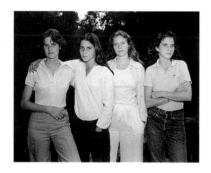

Nicholas Nixon
American, b. 1947
The Brown Sisters
1975
Gelatin silver print

Nixon photographed his wife and her
sisters once a year for twenty-five years
(see also opposite)

even ludicrously, idealized via manual and electronic retouching techniques) is used to sell a phenomenal array of products. Although some of the 'body beautiful' connotations of certain products are ludicrous (ice-cream, or computers, for example), the billions of dollars advertisers are willing to invest in their schemes are proof that the strategy works. A source of constant consternation to art photographers is that producers of publicity keep a close eye on independent artistic production and are not averse to stealing or – to use a more polite term – 'appropriating' ideas.

In the field of postwar medicine, photography continues to be enormously useful, having benefited from technical advances in cameras, artificial lighting, and film. Classical anatomical photography has become a highly specialized and exacting craft which is increasingly in demand for teaching purposes, especially as medical students are given less and less access to real cadavers.

Contrary to the seemingly obvious proposition that photography of anatomy must have been completed years ago, new surgical procedures and technologies require photographers to revisit sites of the body and see them with fresh eyes. As new regions or surfaces of the body attract interest (as the nose has for cosmetic surgeons, for example), anatomical photographers like Ralph T. Hutchings are called upon to issue new 'maps'. A whole new atlas of astonishing anatomical imagery is also available online in the form of the Visible Human Project. This comprises photographs of thin cross-sections, from head to toe (though the slices in fact began with the soles of the feet), of one complete male and one complete female cadaver. The photographs can be viewed individually, or manipulated by computer to assemble three-dimensional views of any particular region of the body.[28]

Endoscopic photography is also an extremely valuable diagnostic tool. Performed on the living body, it is minimally 'invasive', with the picture-making apparatus (a fibre-optic filament bearing a tiny lens and carrying its own light-source) inserted through a natural orifice or a tiny opening which has been surgically prepared. The first photographs of the foetus, taken by Dr Lennart Nilsson in the early 1960s, were greeted as a sensation when published worldwide. The primitive but tenacious idea that life began at birth was dramatically called into question, with profound implications for the debate over abortion. Conventional photography is also utilized to depict the complex disposition of internal organs and tissues exposed during medical operations and autopsies. In the hands of a master photographer like Max Aguilera-Hellweg, these pictures are both informative and surprisingly beautiful.

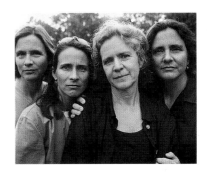

Nicholas Nixon
The Brown Sisters
1999
Gelatin silver print

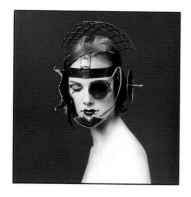

Postwar developments in 'hi-tech' medical imaging of the *living* body have been proceeding in quantum leaps, via computers, robotics and micro-engineering. Although many of the new techniques of diagnosis or research are *non-*photographic in nature (ultrasound, magnetic resonance imaging and computed tomography are only some of the key procedures), it is often via photographic *reproduction* of this imagery from an electronic screen that a scientist or physician is able to share the imagery with a patient, students, colleagues or the general public.

Scientific image-making and art photography seem to be worlds apart, but the very distance has prompted practitioners on both sides to look for a common language. A recent composite self-portrait by Gary Schneider may be prophetic in this regard. Schneider used a variety of diagnostic techniques (fundus camera imagery; X-rays; SEMs and TEMs, and so on) to probe the recesses of his own body, ending up with (among other things) a single sperm, 'portraits' of all forty-six chromosomes, and even pictures of individual genes. Schneider supplemented the mid- and high-tech imagery with conventional photograms of his hands and ears. His *Genetic Self-Portrait* challenges fellow photographers to appropriate the powerful 'eyes' of science.

Photographers are also turning to the computer as a creative tool, though with a certain ambivalence; on the one hand, it has superb capabilities as far as creative image-making is concerned; on the other, manipulation presents the danger of false-hood and misuse. A number of contemporary photographers, led by the pioneering Nancy Burson, have produced work which tries to warn of these dangers.

Photography as we know it, like the body itself, is evolving towards an unknown future. Perhaps, from the viewpoint of a visually sophisticated person in 2099, the vast archive of twentieth-century photography of the body may seem dated and peculiar, as exotic as Stone Age Venus figurines now seem to us. Nonetheless, this archive, overflowing with brilliant imagery and challenging ideas, will undoubtedly be appreciated as a great cultural achievement.

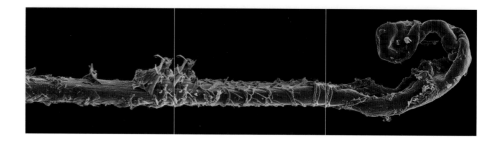

Nicholas Sinclair
British, b. 1954
Fia Berggren
1996
Selenium toned silver gelatin print
Gary Schneider
American, b. South Africa, 1954
Hair. From the series *Genetic Self-Portrait*
1997
Toned gelatin silver print from an SEM

The Photographs

This photographic plate, published for use in police stations throughout France, was the fruit of many years' research by Alphonse Bertillon, chief of the criminal identification bureau in Paris. It was based on a process of identification, invented by nineteenth-century anthropologists, called anthropometry, which allowed for a rational and systematic measurement of the body, whole or in part. Bertillon, whose focus was on personal identification rather than tribal and physical characteristics, developed a system which emphasized parts of the body, most notably the head, and particularly the ear. He invented a standard procedure which included frontal and profile photographs plus measurements of certain features. His method was subsequently introduced in all police services throughout Europe, where it was popularly known as 'the Bertillon system'. Unfortunately for its inventor, his reputation would be dealt a severe blow at the beginning of the twentieth century, when his handwriting analysis, used to convict Dreyfus, was exposed as erroneous. Bertillon's method shared with Francis Galton's earlier composite photography of criminal types the premise that individuals could be genetically or physically predisposed to criminal behaviour, a theory which would take root in the early decades of the twentieth century when it was applied uncritically by various racist movements, in particular the Nazis.

Politics

1.

Alphonse Bertillon
French, 1853–1914
*Synoptic Table of Facial Features. For Use
in the Study of 'Speaking Likeness'*
c. 1900
Gelatin silver print

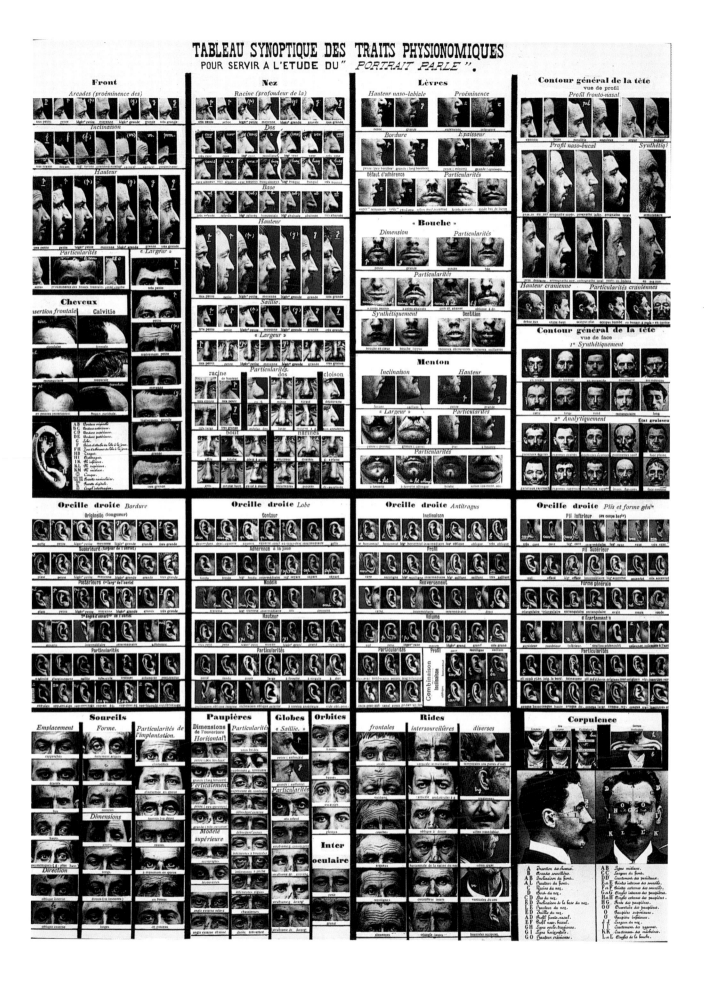

TABLEAU SYNOPTIQUE DES TRAITS PHYSIONOMIQUES
POUR SERVIR A L'ETUDE DU *PORTRAIT PARLÉ*.

The first fifty years of photography, with its cumbersome, expensive cameras and complex chemistry, belongs to the professionals, but with the invention of the hand-held Kodak in l888, photography became accessible to amateurs. In a number of the developed countries, new photoclubs sprang up, where enthusiasts could meet to discuss technical conundrums and debate how best to lay claims for photography as a fine art. Through their local, national and finally international exhibitions and the publications that accompanied the more important of these events, the Pictorialists, as they became known, established the foundations of an international movement and advanced the cause of art photography in myriad ways. Alice M. Boughton, one of a handful of women who would make names for themselves in an essentially male-dominated domain, was comfortable with the principles of Pictorialism, which espoused 'good taste' in the depiction of nature, domestic pastimes and the delicate subject of the naked body. Boughton's demure nudes, much influenced by Impressionist painting, were greatly appreciated by the public. What could be more gently maternal in spirit than this idealized and romantic grouping of naked children, set in a warm and hazy atmosphere? Published in Alfred Stieglitz's influential periodical *Camera Work*, the picture impressed Boughton's many admirers with its elimination of superfluous detail and its masterful modelling of the bodies in masses of shadow and light.

Icon

2.

Alice M. Boughton
American, 1866–1943
Nude
1902
Photogravure, 1909

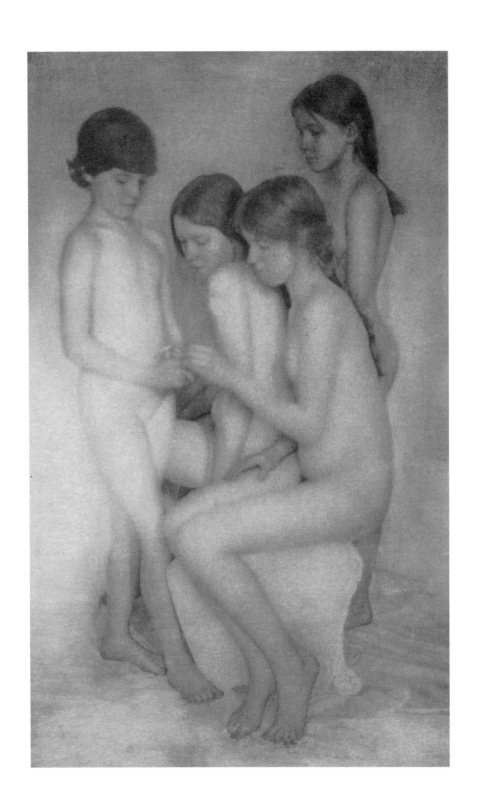

At first sight, this dark, sombre study evokes a sense of mystery. A closer look reveals that Edward Steichen has staged a nude in the purest Renaissance tradition of funerary sculpture: a young woman sits on a draped sarcophagus, where the nude allegorical figures that decorate tombs are usually found. Her attitude indicates grief, and the great cascade of hair seems to be pulling her further down into the depths of despondency. Clearly she is lamenting the death of a lover.

Before he abandoned the Pictorialist idiom for that of Modernism at the outbreak of World War I, Steichen was one of Pictorialism's most influential proponents. Like many of his fellows, he was highly receptive to the metaphorical and deeply emotional language of Symbolism. *In Memoriam*, however, seems to have been influenced by the sculpture of Rodin, with whom Steichen had forged a deep bond akin to that of mentor and disciple. Indeed, both the plasticity of the body, handled in such a way as to suggest sculpture, and the manner in which the solid dark masses of hair and plinth coalesce are much closer to the handling of *The Thinker* than to the evanescent nudes of most contemporary Symbolist painters. Though in terms of style Steichen's Modernist nudes and fashion studies of the 1920s and 1930s were poles apart from *In Memoriam* and the other nudes of his Pictorialist period, they owed an evident debt to the skills in lighting and composition he had mastered in the early years.

34

F o r m

3. **Edward Steichen**
American, 1879–1973
In Memoriam, New York
1904
Photogravure

In 1865 London's *Photographic News* prophesied for photography 'a very foremost place among the scientific appliances of the age'. Ten years later, the same magazine could write that 'the camera is already freely used by medical men', and that the medical profession was 'fully alive to the value of photography'. Nevertheless, for the rest of the century the most influential atlases and manuals were still obliged to use drawings because photographs could not yet be produced at reasonable cost. David Waterston's impressive atlas, with its pairs of original photographs glued in position to achieve a stereoscopic effect, represents a valiant but ultimately impractical solution to the problem of reproduction, and once half-tone printing was firmly established, original photographs would disappear from printed material. This development in fact represented a real loss of information because photomechanically printed photographs could never hold all the detail of the originals. Only in the twentieth century would photomechanical reproduction come close to matching the quality of a gelatin silver photograph.

Stereoscopic photography was introduced in the 1850s, and the medium became immensely popular as a form of domestic entertainment. Waterston's publishers could rightly assume that their clients would have no problems finding a viewer, mentioning in the preface that the cards were designed 'to fit any of the numerous stereoscopes on the market'. The appeal of stereographic images was evident: where one tissue differed from another was not necessarily clear in ordinary black-and-white photographs, but in three-dimensional imagery the difference was immediately apparent. Several such atlases were produced in the period, the most important of which were *Anatomy for the Anesthesiologist*, published in Springfield, Illinois, in 1903, and *The Anatomy of the Eye*, published in Oxford, England, in 1912.

Enquiry

4.

Anonymous
Thorax No. 1 (Anterior view of the thoracic wall)
Published in *The Edinburgh Stereoscopic Atlas of Anatomy*, edited by David Waterston
1905
Gelatin silver print

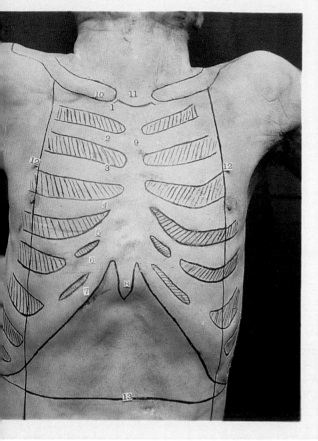
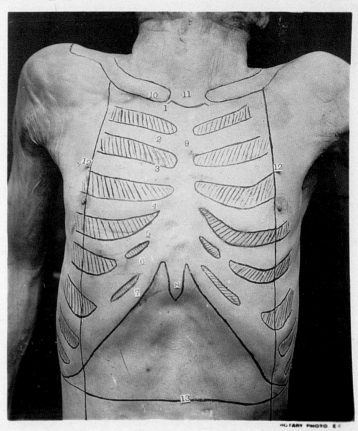

Turn-of-the-century Italy saw the development of a *plein air* style of nude photography which turned out to be highly profitable for photographers like Wilhelm von Gloeden, his cousin Wilhelm Plüschow and Vincenzo Galdi. All three men – the first in Sicily, the others in Rome – specialized in nude photographs of very young men and women (including pubescent and prepubescent boys and girls) in a Classicist vein full of references to an Arcadian past. Like his rivals, Galdi posed his subjects against mottled walls in full sun, their bodies entwined by vines or fishing nets, their heads garlanded with flowers, their hands cradling Greek amphoras, vases, doves or sprigs of eucalyptus. Following the Greek ideal, the models' expressions were serene, and their languid poses suggested that their bodies were in perfect harmony with their 'timeless' surroundings. Sometimes the young female models – no doubt under instruction from the photographer – made gestures of modesty, as we see here, though never to an extent that would have prevented Galdi's clients from enjoying an unobstructed view of their nakedness. Such sensitivity to 'good taste' allowed Galdi to sell his erotically charged photographs to worldly Northern European tourists who imagined Mediterranean people to be closer to nature and more at ease with nudity than they were themselves.

D e s i r e

5.

Vincenzo Galdi
Italian, dates unknown; active 1900–1914
Untitled
c. 1905
Gelatin silver print

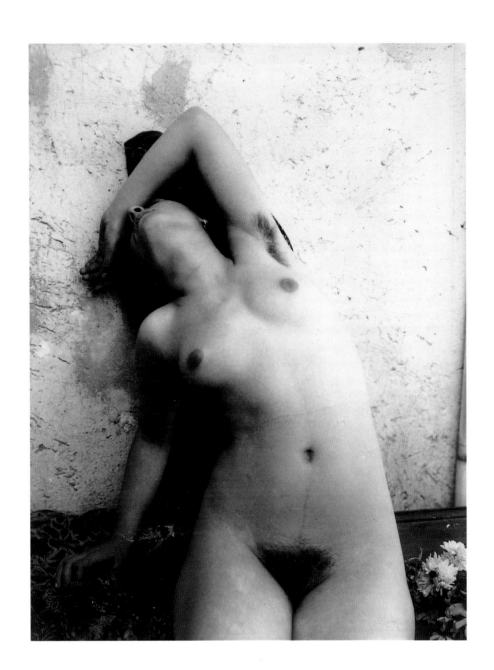

Wilhelm Konrad Röntgen's discovery of the X-ray in 1895, for which he would win a Nobel Prize in 1901, would usher in a new era of corporeal knowledge which would transform medicine. Röntgen demonstrated the potential of the new device by asking Bertha, his wife, to hold her hand against the sensitive plate for fifteen minutes, a gesture which earned her a place in medical history but probably had the effect of shortening her life.

X-ray imaging, or radiography, is non-invasive in terms of actual bodily intervention. It directs particles through opaque objects and these are subsequently registered on silver halide film. Flesh is easily penetrated, but the rays are absorbed by bone or other objects, leaving their relatively clear outlines on the film. After the discovery of the X-ray, researchers and physicians would no longer be required to dissect the dead to understand the living.

In August 1896, one of Röntgen's assistants made what he claimed to be the first X-ray image of a complete human body, but in fact it was composed of the bodies of several people. A *true* full-body X-ray, like the one by William Morton shown here, made in 1907, was probably done for the purposes of 'entertainment', which is to say, to demonstrate the wonders of the technique to a general audience; a doctor or researcher would normally be far more interested in imaging a particular part of the body with maximum detail and clarity. Not much is known of Morton's actual motives in making this picture, but the fact that high button-boots and a whalebone corset were worn, in addition to hatpin, bracelet, necklace and rings, suggests a voyeuristic delight in seeing the body stripped of its clothes. We do know that the power for the X-ray was supplied from a New York street mains connection, and that Morton's female subject was exposed to radiation for about thirty minutes. We know too, that as far as can be ascertained, this image represents the first whole body X-ray ever made of a living person.

E n q u i r y

6.

William Morton
American, dates unknown
X-ray of an Entire Human Body
1907
Silver halide film

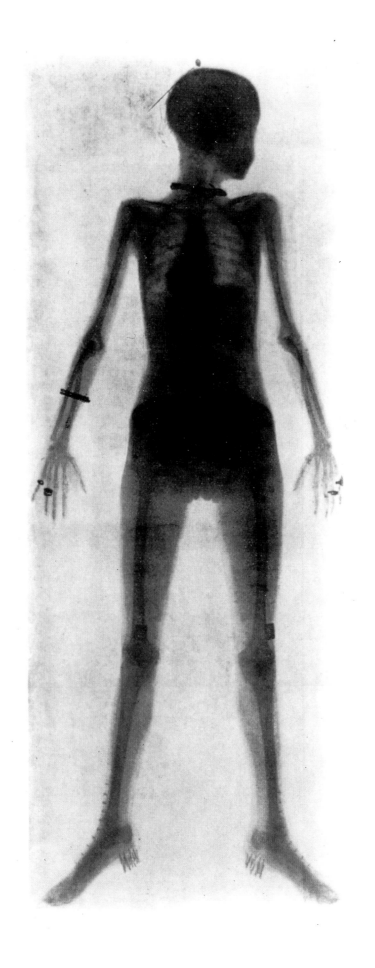

In children, osteomyelitis is a devastating but frequent complication of tuberculosis, dissolving joints and contorting limbs. Infection eventually breaks through to the skin, and joints and bones become riddled with holes. Drs Carl and Emil Beck, orthopaedic surgeons at the North Chicago Hospital in the early part of the twentieth century, developed a treatment which involved filling the cavities in the joints and bones with a paste of bismuth subnitrate mixed with petroleum jelly. This had two advantages: X-rays showed the internal destruction, and the heavy metal bismuth acted as a chemotherapeutic agent, directly destroying the tuberculosis organisms themselves. This photograph of a seven-year-old boy suffering an advanced stage of the disease is fairly unusual for medical photography in that it includes the doctors. According to Dr Stanley Burns, a keen collector of early medical photographs, the Becks' procedure was, before the advent of antibiotics, 'a drastic treatment for a drastic disease', so perhaps it is pride in their achievement that explains the physicians' presence in the picture.

42

P a i n

7.

Dr Emil Beck
American, dates unknown
Boy with a Tubercular Abscess of the Hip Joint
1909
Gelatin silver print

Result In Hip Joint Disease By Prophylactic Method.
[Stereo 18.]

¶ This boy, seven years old, developed a tuberculous hip joint at the age of two years. An abscess followed and was incised and drained four years ago. A shortening of three and one-half inches resulted and the sinus continued to discharge for two years, until I made the first injection of bismuth paste in April, 1908. The sinus then closed, and with the aid of a high shoe the boy could run about just as his healthy comrades could. In September, 1909, sixteen months after closure, he fell from steps, and within three days developed a very painful swelling in his hip, with a temperature of 103°. For three weeks he was treated with liniments, but the fever persisted, and the boy became very much emaciated and feeble.

¶ In October, 1909, he was brought to me for the bismuth treatment. The prophylactic method was carried

Stereo 18. **Serial N?** 252

Through their work and often through their lifestyles, painters and photographers have made a major contribution to the liberation of the body. Edvard Munch, for example, painted in the nude, and photographed himself doing so. In the intimacy of their studios, nineteenth-century photographers of *académies*, or artists' aids, often invested their imagery with eroticism. The early years of the twentieth century, however, saw a significant new development in the representation of the body which bore only a distant relation to the Symbolist depictions common in art photography or the positivist, factual approaches found in medical and scientific imagery. 'Naive' nakedness – involving a quest for naturalness – suddenly made an appearance. Unlike their forebears, twentieth-century photographers could work easily outdoors, and could therefore replace the cultural signifiers of the studio – classical pillars, oriental carpets and so on – with natural motifs. From the turn of the century, naked men, women and children, in pairs or as a family group, became accepted subjects in photography, especially in Northern Europe, where the practice of naturism had a particular hold. Such images, which were often devoid of sentimentality or apparently titillating intentions, became vehicles for a new kind of morality, the sources of which are rooted in various fanciful ideas about the origins of man: Nature is close to the Garden of Eden, and Man is close to Nature; Christian myth fuses with paganism in rejecting puritanism.

44

Icon

8. **Anonymous**
 Untitled
 n.d.
 Postcard. Reproduction of unknown
 original print

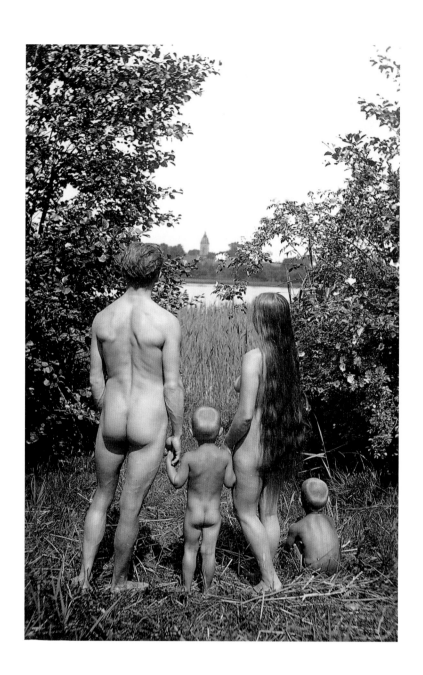

Baron Wilhelm von Gloeden completed his studies in classical painting in Germany before travelling to Italy for reasons of health, settling permanently in a villa above Taormina, Sicily. There he was introduced to photography by a distant cousin then living in Naples, Wilhelm Plüschow. Surrounded by the romance of ancient ruins, von Gloeden began with landscapes, but soon shifted his focus to the naked human body. His nudes, predominantly of boys and young men (young girls were a secondary subject, possibly included to disguise the force of his own homoerotic interest, and certainly because a market existed for naked adolescents of both sexes), were photographed on his magnificent terrace overlooking the sea or in natural surroundings nearby. Plaster casts, vases and columns, or leopard skins, shepherds' crooks and flutes lent antique flavour to the supposed innocence of the models.

Von Gloeden's highly theatrical staging was extremely popular in Europe, and his fame was such that a number of well-known personalities visited him, among them Anatole France, Richard Strauss and Oscar Wilde. For those whose interest was homoerotic, von Gloeden's male nudes were 'respectable' in that they hinted at an ancient Greek custom of older men enjoying sexual relations with younger ones in return for helping them become established in society. Others admired the work as evidence of the 'natural state' of 'primitive Mediterranean folk' who were as yet unspoiled by civilization. Thus myth and desire were skilfully interwoven with the undeniable realism of photography.

Desire

9. **Wilhelm von Gloeden**
 German, 1856–1931
 Untitled
 c. 1910
 Gelatin silver print

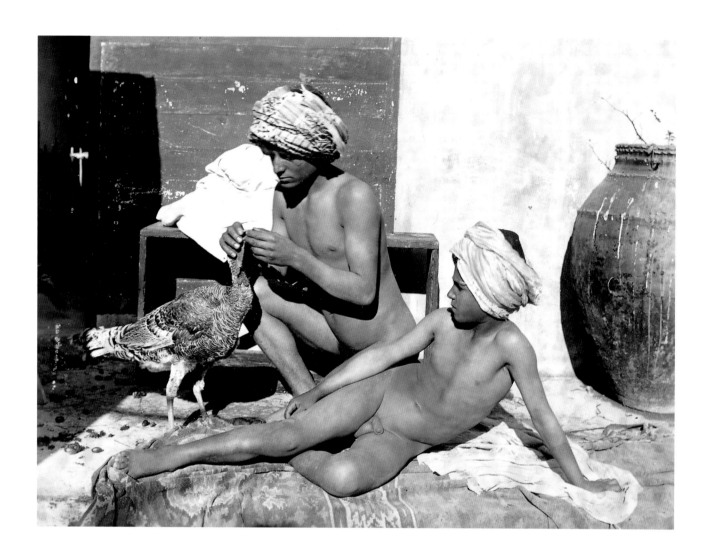

During the second half of the nineteenth century, photographers who tried their hands at nudes were obliged, for one reason or another, to imitate the nudes of the *beaux-arts*, particularly those in the Symbolist vein. Photographic nudes were made as aids for painters and sculptors, or they were made as pornography, clothed in respectable themes to outwit censors (biblical motifs and mythological scenes were effective in this regard). Late in the century, nudes that were bona fide artistic attempts continued to incorporate the conventional subject matter of the fine arts – that is to say, those same biblical and mythological motifs. Looking back today at such pictures, in the almost total absence of documentation (most photographic nudes bear no indication of maker, place or date of production), we can only guess at their makers' intentions. This photograph has a decidedly erotic charge, but it may well have been meant as an artist's aid, since it was published in *Le Nu esthétique*, to which many painters and sculptors subscribed. The Greek myth of the centaur – a man with the body of a horse; brutal, cruel and quick to ensnare women – had a distinctly erotic and violent charge. The scene shown here represents the virgin Atalanta slaying Rhoecos, after an attempted rape. At the turn of the century, sexual congress with animals was a fashionable idea in intellectual circles, though not a topic for discussion in polite society. This image was made in or before 1910, but compared to the 'modern' Pictorialist nudes being produced at the same time it has a strongly decadent flavour which suggests the late nineteenth century.

Fiction

10. **Anonymous**
 Centaur
 c. 1910
 Gelatin silver print

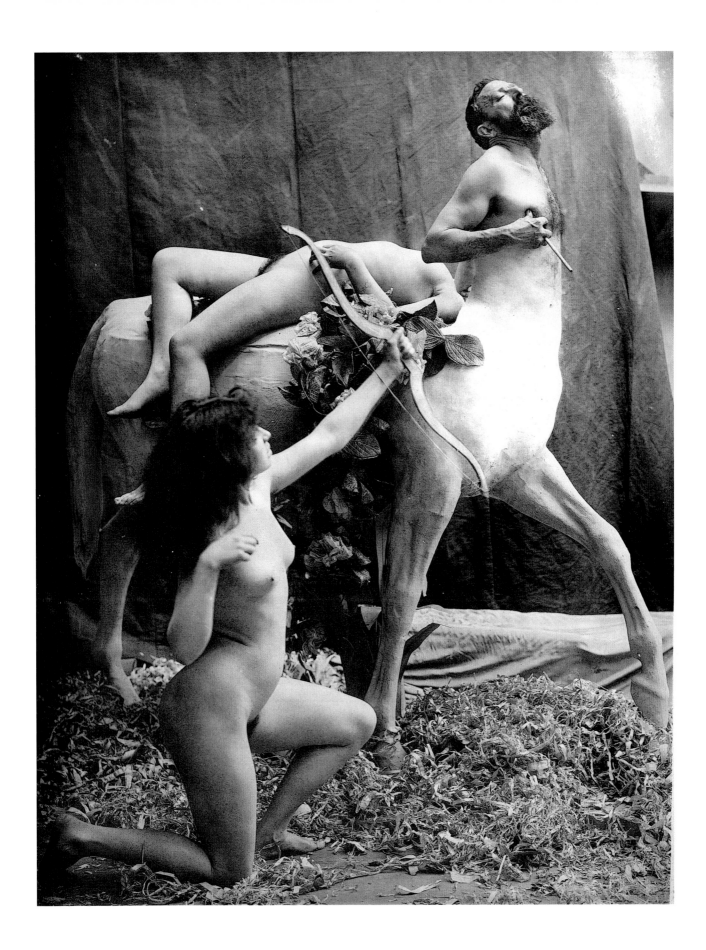

In the nineteenth century, photographers often used prostitutes and out-of-work actresses as models for pornographic images which were then sold profitably on the black market. The photography of Ernest James Bellocq, however, remains something of a mystery. Little is known of Bellocq's life except that he was a commercial photographer who specialized in industrial work. Less still is known of his intentions during the period around the turn of the century when he took portraits of prostitutes in the brothels of Storyville, New Orleans' notorious redlight district. Discovered in 1958 by the American photographer Lee Friedlander, and subsequently published to acclaim, Bellocq's Storyville portraits show an exceptional eye, yet remain deeply perplexing. Why were they made? Why are a number of the faces scratched out on the negatives, and by whom? Could it be that Bellocq was making a catalogue for wealthy clients? If so, and assuming that he had the permission of the women (a fair guess, judging from their poses, not to mention the fact that he had secured access in the first place), why would someone have felt the need to efface their identities? To ensure anonymity, almost certainly. But surely this could have been accomplished more elegantly at the time of the shooting by coyly masking the face with a glove or a fan. We can only surmise that someone feared that the material might escape Bellocq's quarters. Bellocq himself? One of the women? In the absence of documentation, all is speculation.

Desire

11. **Ernest James Bellocq**
 American, 1873–1949
 Untitled
 c. 1912
 Gelatin silver print

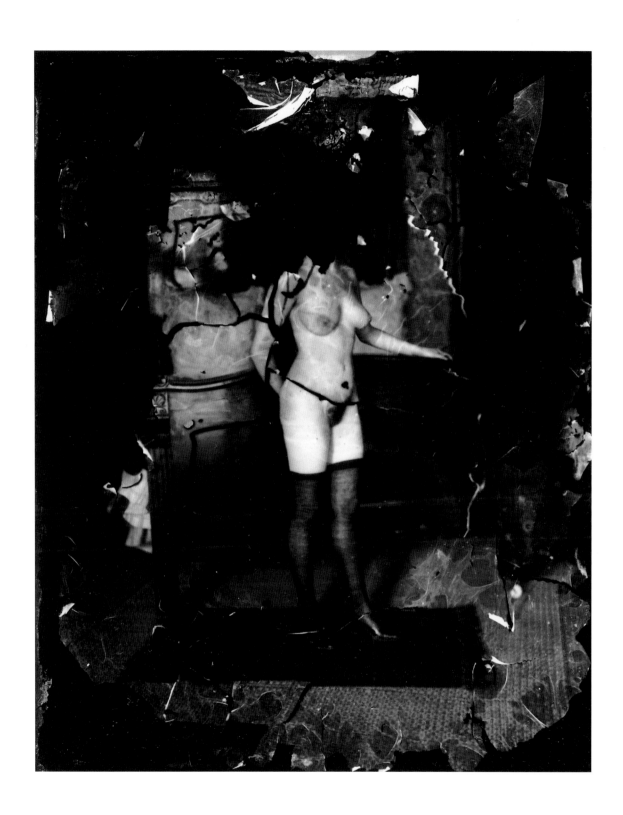

Rudolf Lehnert and Ernst Landrock, who settled in Tunisia in 1904, soon made their names known to the Western world through the widespread distribution of photographic prints, photoengravings, albums and postcards produced from original photographs that Lehnert brought home from his frequent travels. From 1904 until the beginning of the First World War, Lehnert worked indefatigably in Algeria and Tunisia while Landrock managed the business side of the partnership from a rented storefront. Each man had his own Arab palace in the old quarter of Tunis; in his, Lehnert produced nudes which would be coveted for their heady scent of oriental eroticism. After Napoleon's Egyptian campaign of 1799 and Champollion's discovery of the Rosetta Stone in 1822, and in the Romantic wake of Byron's death in 1824, an abundant volume of literature helped nurture a certain myth about the Orient which persisted throughout the nineteenth century. This was composed of a lively mixture of scientific research (fed in particular by many archaeological excavations), genuine interest in different cultural practices, colonial prejudices and a wealth of erotic fantasies. Between the dramatic imagery evoked by the Bible, and the sensual imagery conveyed by the *Thousand and One Nights*, there was more than enough stimulation for a flood of paintings, novels, poems and, finally, photography.

Desire

12. **Rudolf Lehnert / Ernst Landrock**
Bohemian, 1878–1948 / Saxon, 1878–1966
Tunisia
c. 1912
Gelatin silver print

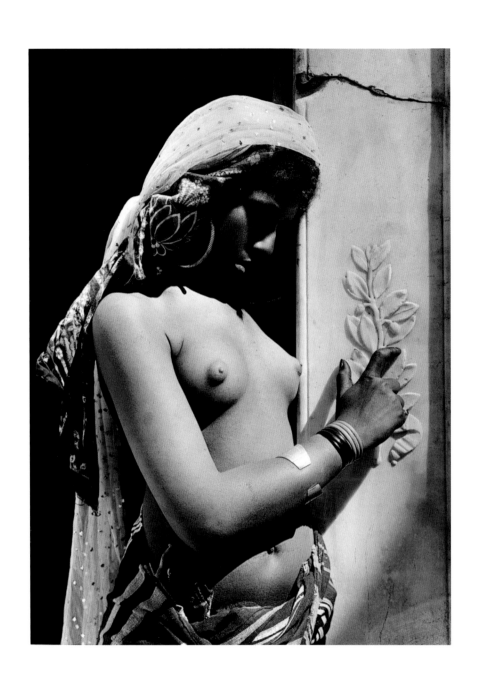

In 1915, thirteen years after bringing the most inventive American Pictorialists together in the Photo-Secession – a movement that essentially stood for independence from the academic establishment – Alfred Stieglitz remained the undisputed leader of one of the movement's two factions: the first championed painterly subjects and treatment while the second – Stieglitz's group – focused on purely 'photographic themes and textures'. The critic Charles H. Caffin had divined that Stieglitz was 'by conviction and instinct an exponent of the "straight photograph", working chiefly in the open air, with rapid exposures, leaving his models to pose themselves, and relying for results upon means strictly photographic'. This perfectly describes the study shown here. In this reworking of the theme of the female bather – a traditional subject in painting and sculpture if not yet in photography – Stieglitz creates a richly atmospheric vision of the body. He captures with consummate skill the brilliant sunshine of high summer, the attraction of the cold waters of the lake, and the attitude of a woman at ease in her surroundings. At the same time, he treats the body as a kind of natural sculpture – rounded, solid, yet beautifully balanced on its 'pedestal' of straight, strong leg. It is a clever balancing act pictorially as well: an image that is part portrait, part classic female nude, part sculpture, part abstract form. Yet the whole resists pure abstraction, and is kept within the bounds of realism by a small though significant touch: the softly focused vegetation of the far shore. As Stieglitz said to the young Edward Steichen on the occasion of their first meeting: 'You see my prints, the eye is able to wander all over them, finding satisfaction in every portion… nothing must be unconsidered.'

54

F o r m

13. **Alfred Stieglitz**
American, 1864–1946
Ellen Morton at Lake George
1915
Gelatin silver print

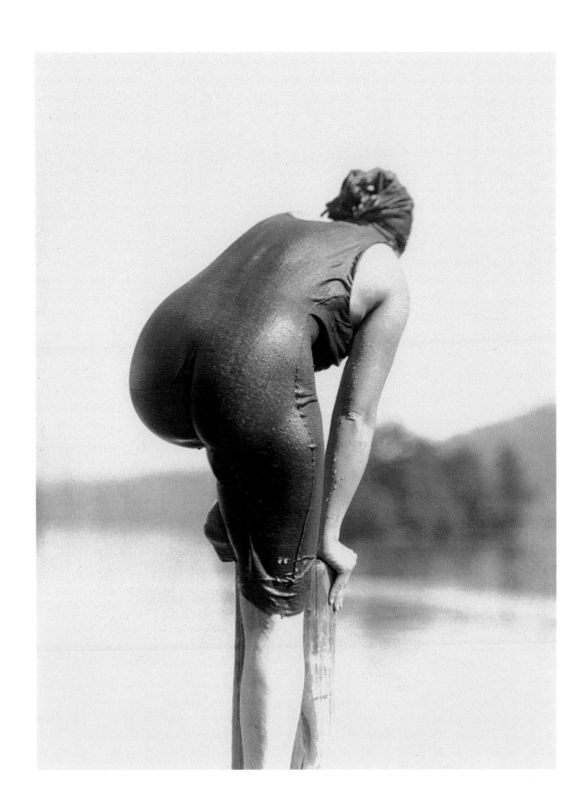

First World War soldiers returned from the trenches with
terrible wounds, none of which were more problematic
than those on the face, both for victims and for society as
a whole. Missing limbs could sometimes be disguised or
replaced, however primitively, but facial disfigurement was
there for all to see. The military authorities had an interest
in doing their best to patch up soldiers' faces wherever
possible, both for 'public relations' purposes, and because
rehabilitated men could be sent back into battle. Masks
were often employed in the most horrific cases, and a number
of well-known sculptors devoted years of their lives to their
production. German and Austrian surgeons were leaders in
the field of facial surgery, though various techniques were
practised by both sides in the conflict. At the German Fourth
Army Dental-Maxillofacial Unit in Lublin, Poland, where
procedures were particularly advanced, wax models were
made of wounds in their preoperative states. Each stage
of the process of reconstruction was photographed, though
no more dramatic contrast could be imagined than this
'before and after' version showing the triumphant final
result next to the model of the damage. For obvious reasons,
the military and political authorities had no desire to have
such photographs fall into the hands of antiwar protestors,
for whom they would have been a powerful weapon, but
this risk would have been balanced against the importance
of medical documentation, not to mention the very human
wish to celebrate the success of pioneering surgery.

P a i n

14.

Anonymous
German WW1 Soldier, Posing with Wax
Model of Original Wound, Lublin, Poland
1917
Gelatin silver print

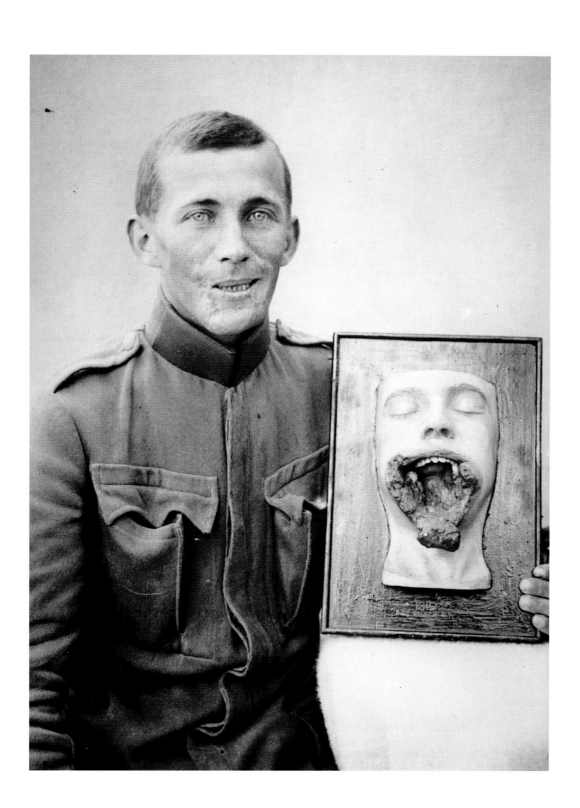

Edward Steichen began his brilliant career as a Pictorialist photographer, creating dark, moody compositions which he hoped would win the status of fine art for the upstart medium of photography. By the 1920s, however, he had long put Pictorialism behind him, opting instead for a crisp, bold Modernism which dispensed with extraneous detail. To Steichen, the pioneering Isadora Duncan represented, as photographic historian Dennis Longwell has put it, 'a symbolic revolutionary whose bid for liberty was likened to [Steichen's own] struggle for the acceptance of photography as a valid medium of artistic expression'. Duncan went to the root of the malaise in classical dance – the precious world of points and tutus. She danced barefoot in a simple tunic, seeking inspiration in the nobility of classical Greece and trying to find movements and gestures to express her deepest longings.

Steichen had been invited to accompany Duncan and her disciples to Athens, where early each morning they ascended the Acropolis. According to the photographer, Duncan was in a truculent mood one day and refused to perform, though the dancer herself maintained that she was too overwhelmed by the site to do anything more than simply pose. In any event, it was enough that she was willing to make one significant, noble gesture, as if to say: 'Here I claim my true heritage.' Steichen has made a masterful study by choosing to show the dancer as a tiny figure framed by the grandeur of the stones. The way he builds up the picture as a rhythmic contrast of light and shade, with particular brilliance accorded to the 'stage' on which Duncan stands, and with marvellously nuanced textures of stone and dress, shows to what extent he had mastered the expressive possibilities of his medium.

58

Expression

15. **Edward Steichen**
American, 1879–1973
Isadora Duncan at the Portal of the Parthenon
1921
Toned gelatin silver print

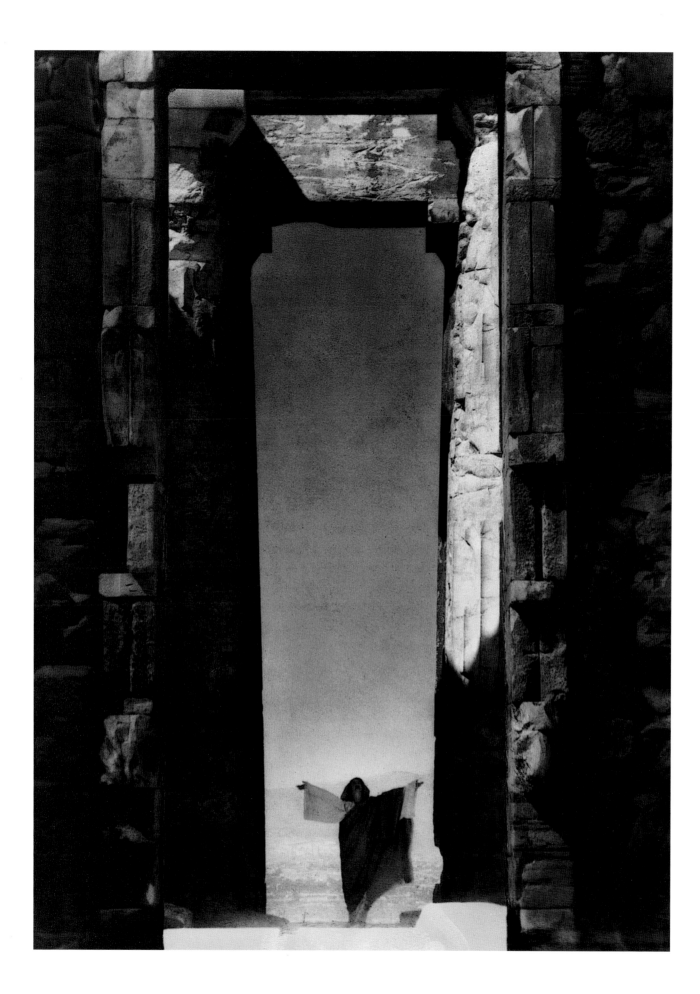

A pioneer in portrait photography of celebrities of stage and screen, James Abbe was able to create an original style at a time when photographers worked mainly in their studios. He frequented Hollywood film sets and New York theatres, and revolutionized the genre by showing artists in the working environment of the set. Under a low-angled light, these cabaret dancers seem to have been caught unawares by the photographer behind the scenes at the Folies-Bergère. But while purporting to show the casual intimacy of life backstage, Abbe has in fact composed his image meticulously – even the seemingly startled expressions and poses of the models are carefully contrived.

Famous for his photographs of movie stars like Gloria Swanson, Mae West and Rudolph Valentino, Abbe settled in Paris in 1923, when the city was the fashion capital of the world, and published his pictures in the *Saturday Evening Post*, *Motion Picture Classic* and *Harper's Bazaar*. A rapidly imitated photographer, he was the first to import into Europe the glamorous imagery of the New York and Hollywood entertainment worlds.

Desire

16. **James Edouard Abbe Sr.**
American, 1883–1973
At the Folies-Bergère
1924
Gelatin silver print

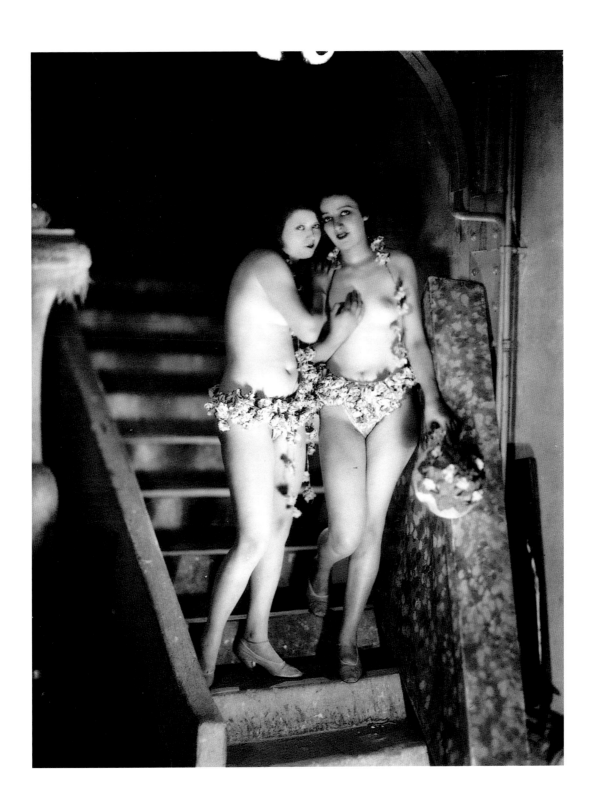

Most of the early nude photographs that were made for
voyeuristic purposes were taken in studios, partly to hide
the naked models from prying eyes (this was important if
the photographer pursued a respectable portrait business
during daylight hours), and partly because the high demand
for such pictures meant that they had to be produced rapidly
and in large numbers. Given that the weather in most
of Europe and the United States restricted such outdoor
photography to certain months of the year, and even certain
days of those months, it was only logical that the preferred
setting for what was indeed a form of industrial production
was the studio. In studios various props and decorative
elements could also be added, such as sculptures of nudes,
which enhanced the erotic atmosphere or gave the image
the veneer of art. Dance was another motif which allowed
photographers to show naked female bodies – albeit
with non-existent genitalia – while claiming the purest of
intentions. The anonymous photographer who posed these
'three graces' wished to situate them within the tradition
of the classical nudes of antiquity, hence their heroic poses
and noble gestures.

Icon

17. **Anonymous**
 Untitled
 n.d.
 Postcard

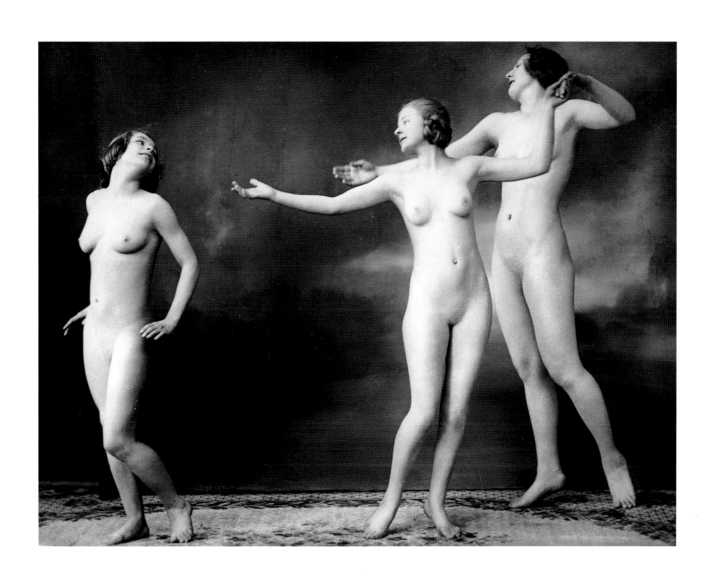

Despite his American beginnings, Emmanuel Radnitzky was more comfortable in his European reincarnation as Man Ray, a name rich in Modernist associations. Settling in Paris in 1921, he became a leading light in the Dadaist and Surrealist movements. He was a painter and a photographer who detested convention, arguing that 'There are better things to do in life than copy.'

Man Ray made photographs not only with the camera, but also without the use of any photographic apparatus at all – these he called 'Rayograms'. He underexposed, overexposed and made positive, negative and combination positive/negative prints. He exposed his prints to white light in the course of development, having discovered by accident how the Sabattier effect, more commonly known as solarization, could be put to aesthetic use. In *Violon d'Ingres*, he used photomontage to commandeer a highly recognizable motif in painting – an odalisque, posed in the style of Ingres' 1807 *Nude from the Back* – and subtly transformed it with the addition of the instrument's f-shaped sound holes. The violin was Ingres' second passion (for this reason the term 'violon d'Ingres' denotes a hobby), but Man Ray's punning image suggests that Ingres' love of the violin and his love of the female body were two sides of the same coin. Judging from Man Ray's many nudes, portraits and eroticized fashion photographs made for *Harper's Bazaar*, it is fair to conclude that he too was fascinated by the bodies of women. 'The awakening of desire', he wrote, 'is the first step to participation and experience.' *Violon d'Ingres* is therefore a homage to art, to woman, and to the quintessentially modern medium of photography, with its unique powers of synthesis.

Fiction

18. **Man Ray (Emmanuel Radnitzky)**
 American, 1890–1976
 Violon d'Ingres
 1924
 Gelatin silver print

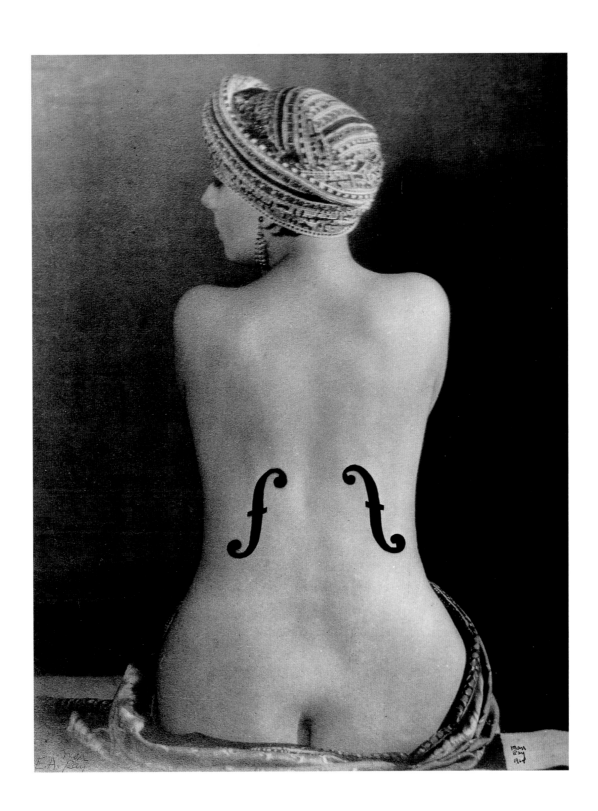

The early life of Albert Rudomine suggests a certain restlessness. Born in Russia, he emigrated first to France and then to the United States, before returning to Paris in 1917. Two years later we find him at work as a fashion illustrator. In 1921, evidently attracted to photography, he opened his own studio, where he specialized in portraiture and the nude. Rudomine's style represents something of a paradox: a Modernist in composition and framing, he liked to light his subjects with a drama more akin to the Pictorialist idiom, and to print his images in the bromoil process favoured by late-nineteenth-century practitioners. His nudes are highly stylized and dramatic. The part-portrait/part-nude shown here is evidently meant to represent an exciting sporting moment – the start of a race, when muscles are tensed to the limit and the outcome is unsure. We are not told the athlete's name: it seems that Rudomine's interest is in celebrating the athletic male body as an icon rather than an individual – a beautifully conditioned machine, the muscularity of which is emphasized by the interplay of light and shadow. Rudomine has succeeded in marrying the dynamism of sport with the sensuality commonly associated with the nude.

Icon

19.

Albert Rudomine
French, b. Russia, 1892–1975
Olympic Winner
1925
Gelatin silver print

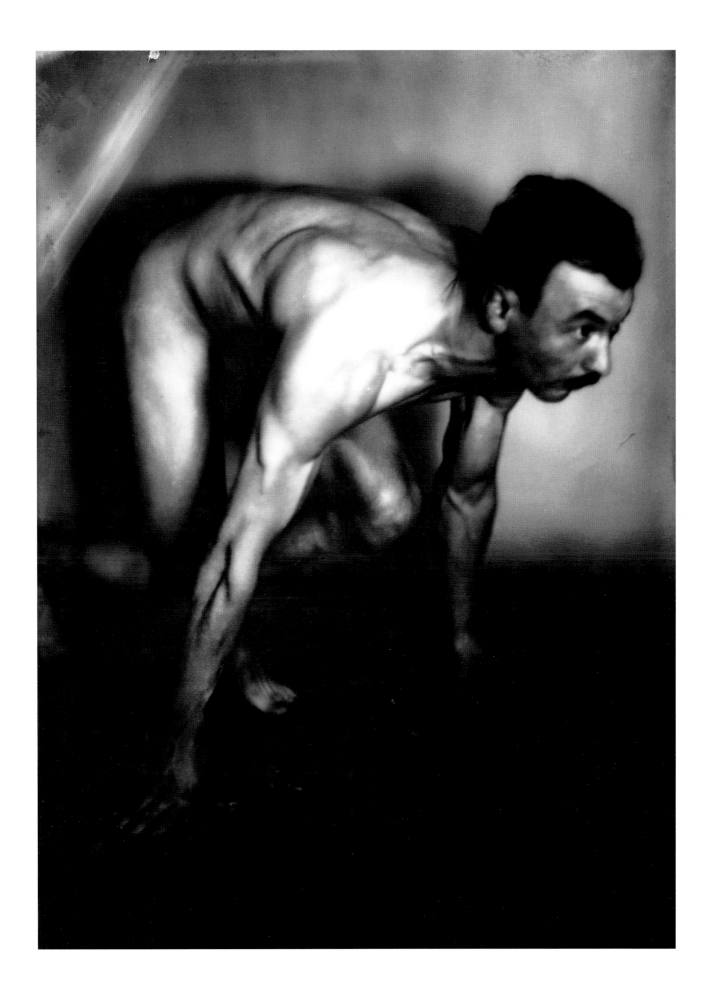

Photography has always felt the lure of magic, the super-human and the paranormal: the conjuror, the astrologist, the circus strongman, the elephant man, the smallest woman in the world. With the advent of photography, the magic of the circus and the freak show could be delivered to the home. For those with absolute faith in the verisimilitude of the medium, a photograph was incontrovertible proof that such-and-such a person actually existed or that a certain event had actually occurred.

Such faith is suggested by the photograph shown here. Nothing is known for certain about it, save for the fact that someone wanted it taken: both its maker and its subject are anonymous, the place and date are unknown, and the act remains ambiguous: are we looking at a magician's illusion, darkroom trickery or a real pin passing through a real arm? We note that the performer betrays no pain; either he has learned to control his response to it, or he knows how to perform the act painlessly. Certain clues suggest that he is a cabaret-type entertainer who has commissioned the image for publicity purposes. The man's makeup, his exaggerated, cruel features, and the way in which he presents the feat – face in profile, arm raised – are well within the theatrical tradition, while the style of lighting, the precise framing (note the penumbra), and the superbly modelled neck muscles indicate that the photograph was made in a studio by an accomplished professional. Sadly, neither photographer nor subject took the time to jot down his name on the back of the picture.

Expression

20. **Anonymous**
 Untitled
 c. 1925–1930
 Gelatin silver print

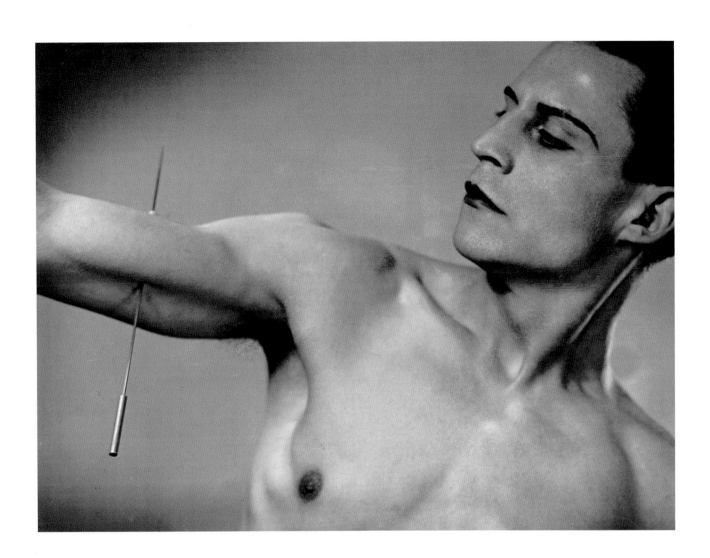

Technology extends the body's powers in myriad ways. Microscopes and telescopes afford our eyes superhuman vision. Telephones and radios enable us to hear across vast distances. Inspired by the technologies of his age, Otto Umbehr, or Umbo, as he preferred to be known, proposes a unique portrait of the 'New Reporter' – Egon Erwin Kisch – to correspond to the 'New Vision' which marked innovative photography of the era. The lens of a lightweight camera serves as a device for enhanced vision (though Umbo retains a natural eye, either out of nostalgia, or a lingering distrust of machines). Modern hearing devices extend the range of his hearing. His right arm and hand holds an old-fashioned pen, but, significantly, it is not being used; the other hand, meanwhile, is hard at work at a typewriter, the results of which will be 'digested' and expelled by the printing press which forms his lower torso. One foot rides in an automobile, the other leg terminates in an aeroplane. So equipped, and virtually strangled by time, the new phototextreporter takes to the air, traversing mountain ranges and skyscrapers, profiting from his bird's-eye view of the seething urban crowds below. However, a cigarette shows that new-style professional life comes with old-style stresses.

The composite study has much in common with that great hymn to modern life, *Berlin – Symphony of a Big City*, by Walter Ruttmann, for whom Umbo worked as a camera assistant before taking up photography in 1927. Umbo had a deep understanding of what modern photojournalism entailed. In or around the time this montage was made, the young man was appointed studio director of the first-ever cooperative photo agency, Dephot (Deutscher Photodienst), in which he also worked as a photojournalist. Considered the most versatile member of the group – no small honour given that Robert Capa and Felix H. Mann were also members – he took on assignments on street life, film, theatre and dance, often contributing texts as well. The breadth of his interests can be partially explained by his student experiences at the Bauhaus, where he witnessed innovation in every art form and first experimented with the techniques of collage and photomontage.

70

Politics

21. **Umbo (Otto Umbehr)**
German, 1902–1980
The Roving Reporter (Egon Erwin Kisch)
c. 1926
Gelatin silver print. Photomontage

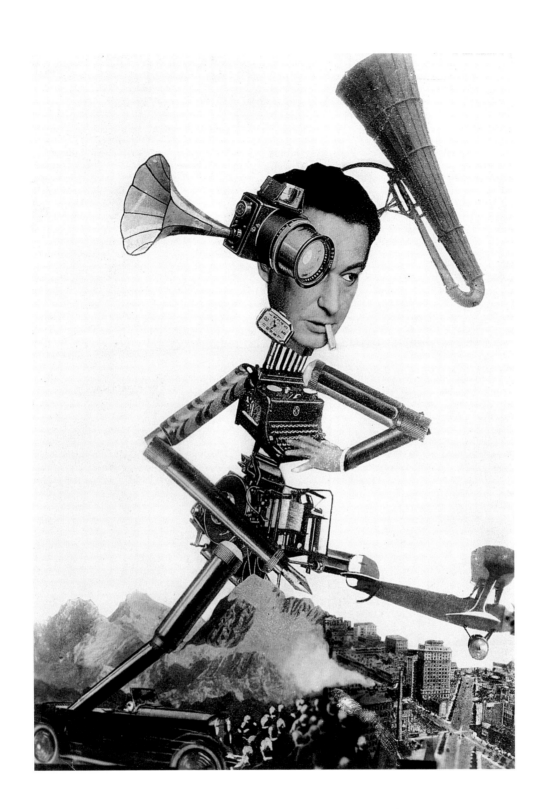

The extraordinary, recently discovered work of Claude Cahun foreshadows one of the core problems of contemporary social life – ambiguity and ambivalence in the matter of identity. A photographer, actor, writer and militant eccentric, Cahun specialized in the photographic self-portrait for almost forty years. With her urchin looks and innovative stagings, she was a pioneer who continually called her own self into question by constantly transforming her representation. Although she was by no means the first photographer to play with notions of self-identity, no one before her had exploited the genre with such singlemindedness. In 1923 she exchanged her real name, Lucy Schwob, for the pseudonym Claude Cahun, and under this new identity presented intimate pictures of her own body, in most cases opting for an androgynous figure.

In this portrait of herself as a fairground gymnast posing against an obviously artificial background, the character of Cahun appears with a short, boyish hairstyle, in sporting gear, and holding dumb-bells. The femaleness of the body is indicated by the mouth, which is made up in the shape of a heart, and by two nipples sewn on to a top bearing the words 'I am in training – don't kiss me.' Through her extreme theatricalization, Cahun explores the tricky terrain of sexual markers, and questions society's codes of representation. By alternating between masculine and feminine genders, but allowing the viewer to see clearly the theatrical element involved, her self-portraits foreshadow investigations of gender in later decades by artists such as Pierre Molinier and Cindy Sherman.

Politics

22. **Claude Cahun**
French, 1894–1954
Self-portrait
c. 1927
Gelatin silver print

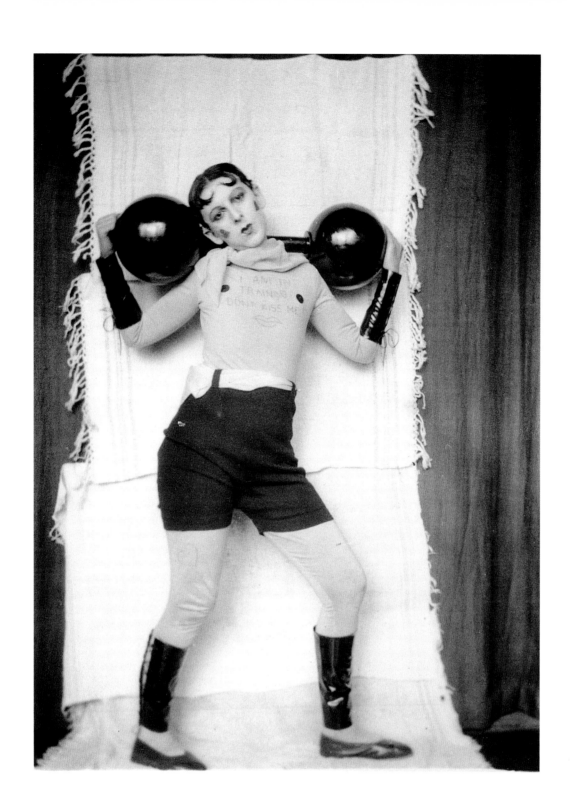

We associate August Sander with full-length portraits, and few would dispute that his are among the finest examples of portraiture in the twentieth century. They are particularly appreciated for their richly detailed settings. The photographer was convinced that the environment – natural and social – was a fundamental influence on a person's character, and his subjects – men, women and children – are almost always set against (or rather set into) their homes or places of work. One exception to this rule seems to be his portraits of intellectuals and artists, who for the most part are seen against blank walls, as if, in Sander's view, they carried their homes and places of work within them. It comes as less of a shock, therefore, to see Sander's 'self-portrait' depicted in a similar way.

Sander made many fragmented studies of the body, in which an eye, an ear or a mouth was usually shown in extreme close-up, filling the frame. In this study of his hands, he has allowed the cuffs of his shirt and the sleeves of his jacket to show, as if to emphasize the professionalism of his work. When Sander made the picture, between 1927 and 1933, he had every reason to be optimistic and thankful for his lot in life. He had a wife and three children; his studio was a commercial success; he had exhibited nationally and internationally (and won medals), and he had just published or was about to publish (1929) *Antlitz der Zeit* (Face of an Epoch), the first part of his ambitious project documenting 'Men of the XXth Century'. Sander's vision was acute, so it is initially surprising that he pays homage to his hands rather than to his eyes. But the photographer knew that mastery of technique was as fundamental to his art as keenness of vision. Furthermore, if he were indeed taking stock of his life, Sander might well have been counting his blessings: he had not followed his father into the mines, where his hands would have served a lifetime of hard labour.

Expression

23. **August Sander**
 German, 1876–1964
 My Hands
 c. 1927–1933
 Gelatin silver print

Like so many other photographers of his generation, Frantisek Drtikol had two creative lives, first as a Pictorialist, deeply influenced by the Secessionist principles he encountered as a student in Munich, and later as a Modernist, having absorbed ideas from Expressionism and Cubism. His obsession with women, however, never wavered. Moreover, unlike other Pictorialists-turned-Modernists, Drtikol was reluctant wholly to abandon symbol and myth in his Modernist phase, and we can still hear distant echoes of Salome and Cleopatra in the nudes he produced in the late 1920s and early 1930s. No other subject claimed his attention to the same degree as did the female body, other than the portraits he was required to make for a living. In Drtikol's nudes the body is seen whole, in the manner of the nineteenth century, or close-up, in keeping with the fragmented imagery of the modern era, but both approaches share his passion for rhythmic geometry, sometimes animated by a stylized Cubism, sometimes by the softer contours of Art Deco. The drive for perfection, of both picture and body, often required Drtikol to paint in his backgrounds and retouch the flesh. Occasionally, seeing an intriguing geometry within a portion of a photograph, he would use selective cropping to make an entirely new picture. Late in his working life, Drtikol's search for perfect form led to disenchantment with real bodies and he began to cut idealized versions out of cardboard and wood, but the creative spark was somehow excised in the process. His art photography, like his commercial studio business, would end with the economic crisis of the 1930s.

Form

24. **Frantisek Drtikol**
Czechoslovakian, 1883–1961
Untitled
c. 1928
Pigment print

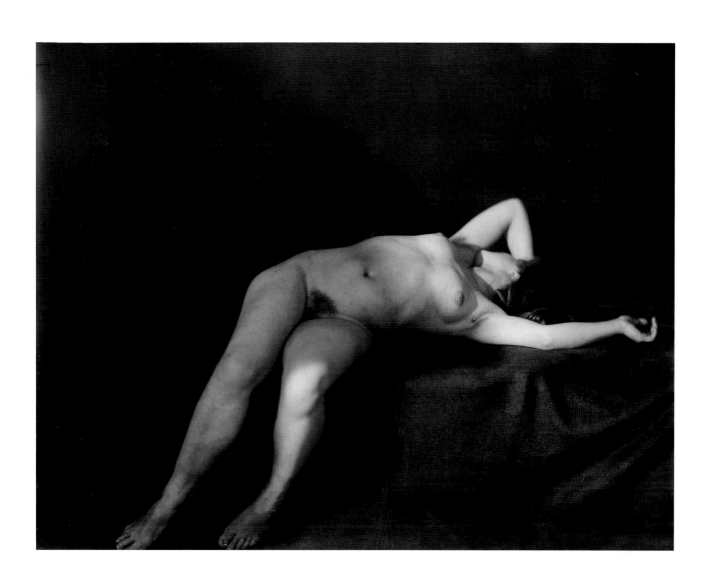

Like a number of other highly creative photographers who began with the soft-focus style of Pictorialism, Paul Strand transformed himself into a Modernist. Undoubtedly this development was influenced by Alfred Stieglitz and the restless spirits associated with him. From 1907 Strand had been following European developments in painting and sculpture via the Little Galleries of Stieglitz's breakaway group, the Photo-Secession, and was thereby exposed to the ideas of Picasso, Braque and Brancusi. When, in the years 1915 to 1917, Strand produced a body of sharp-focus work with a marked shift from naturalism to abstraction, Stieglitz heralded him as the most important photographer of the period, and honoured him with extensive publication in the prestigious journal *Camera Work*.

When Strand made this nude, in 1930, he had long been established as one of the foremost exponents of 'straight photography', advocating the use of the large-format camera with a sharp lens, contact printing (in other words, without enlargement), and attention to the full range of tonalities in the negative material. This imposing nude, photographed outdoors in the New Mexican sun, skilfully combines realism with a transforming abstraction: there is no idealizing tendency disguising the fact that this is a real woman (even the pores of the skin are clearly visible), but the deep shadows falling under the breasts shift the contours of the body significantly, evoking sculpted form. In its monumentality and attention to texture, the Taos nude shows strong similarities to Strand's imagery of the Ranchos de Taos Church, which he was photographing at the time. But there is also a hint of Stieglitz's famous nudes of Georgia O'Keeffe, which had impressed Strand a decade earlier.

F o r m

25.

Paul Strand
American, 1890–1976
Torso, Taos, New Mexico
1930
Gelatin silver print

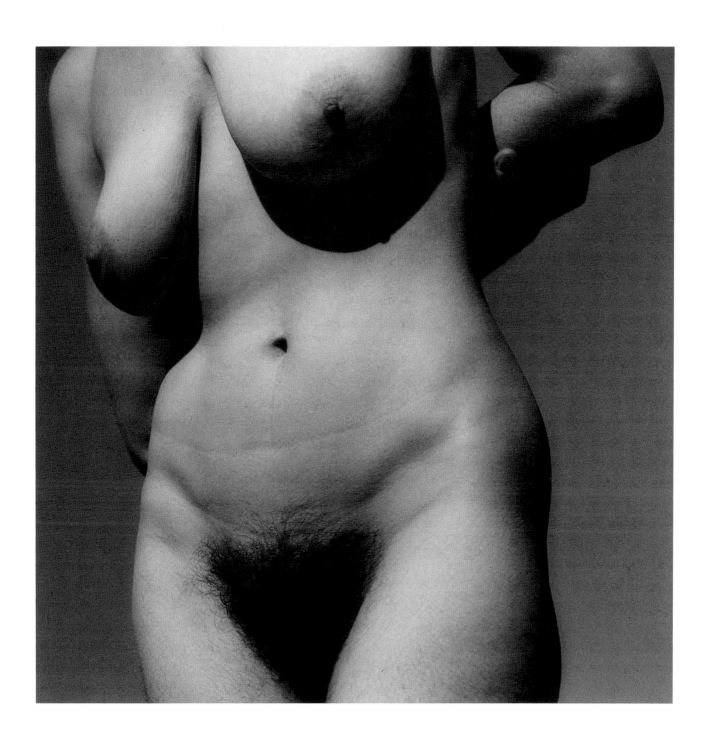

The 1930s provided excellent opportunities for many photographers interested in social events to see their work in print. Lothar Jeck found a ready market for his dynamic sports pictures in the influential Swiss magazine *Schweitzer Illustrierte*. Jeck covered many sporting events in and outside Switzerland, including the 1936 Olympic Games in Berlin. His photograph of an oarsman shows a keen grasp of the tenets of the 'New Objectivity' which was transforming European art photography at this time. Reducing the image to essentials, he composes it with exquisite equilibrium: the athlete's head is perfectly centred; the body and oar are aligned along a powerful diagonal; the whole moving 'machine' is silhouetted against a sky, and the craft itself functions as a solid pedestal for what might be seen as a heroic, living 'sculpture'. In this extremely stylized portrayal of the body, we can discern a cult that worshipped beauty, youth, strength and discipline. Sculpted for performance, Jeck's oarsman may be seen as a symbol of a society striving to outdo itself, a society in which sport and its idealized representations could and would be used to embody nationalistic and militaristic sentiments.

Form

26.

Lothar Jeck
Swiss, 1898–1983
From the series *Sport in the Thirties*
1930
Gelatin silver print

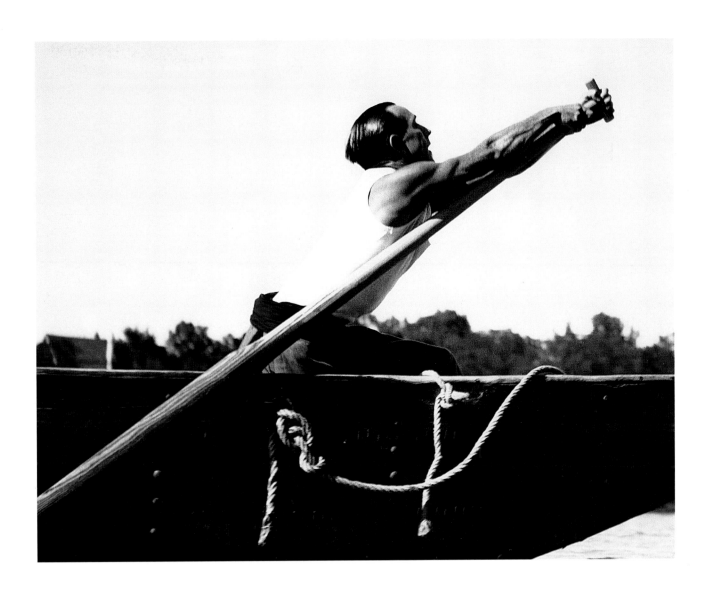

On a fine summer's day in 1931, the young Modernist
photographer Imogen Cunningham took up an invitation
from the pioneering modern dancer Martha Graham to
photograph her at work. The event took place at Graham's
mother's residence in Santa Barbara, California. Graham
seems to have performed half a dozen 'works', judging
from the number of changes of clothing – a slip in one series
of images, a dress in another, bare breasts in yet another,
and so on. It is not clear whether she was rehearsing
polished movements of what would be larger works,
working out ideas, or searching within herself for something
new. But the images do seem to express some inner conflict
or torment, as if the dancer were wrestling with troubling
emotions. Certainly the slip and the semi-nakedness convey
the sense of a very private moment. Cunningham must have
felt the same way, as she chose to focus on close-up views
for most of the studies. Rarely is the dancer's body seen
whole; instead, the photographs concentrate on the hands,
the feet, the face or the tightly cropped torso. These
pictures are far removed from typical dance photography
of the day, which was painstakingly staged in the studio,
with the dancers' movements and gestures rendered to
technical perfection, but with little spirit retained. The very
rawness of the Graham images comes as a thrill: we, like
Cunningham, are glimpsing, however briefly, a formidable
artist in the making.

Expression

27. **Imogen Cunningham**
American, 1883–1976
Untitled
1931
Gelatin silver print

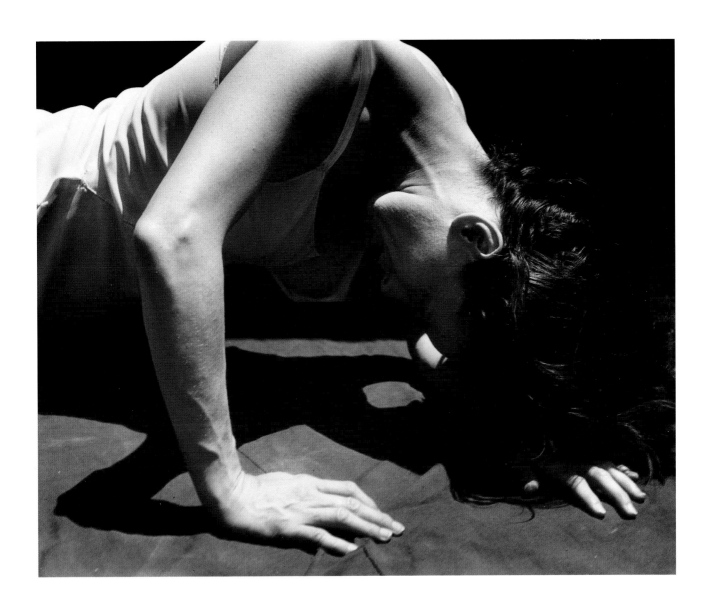

Conventional notions of beauty or eroticism were clearly
of no interest to Roger Parry when he narrowed his camera's
field to a pair of fleshy lips. Like other practitioners of the
New Vision in France, Parry wanted to look at things in fresh
ways. To achieve this, he employed a number of strategies
used by progressive photographers of the time: negative
printing techniques, vertiginously tilted horizons, bird's-eye
or worm's-eye views, or, as we see here, extreme close-ups.
The game was to unsettle the complacent viewer by isolating
a feature of the body that does not normally come under
close scrutiny. Mouths in photographs are usually set within
faces, where we pay them far less attention than we pay to
eyes. Moreover, mouths are rare in photography in comparison
to eyes, which have long been considered a window on the
soul. Here, because of the orifice's solitary, monumental
appearance, we have no choice but to give it our full attention:
Mouth is presented as brute fact. Yet Parry's interest does
not seem to be clinical description, since he has not given
sharp definition to the features. Perhaps he thought that
too much information – a close-up of a close-up, as it were –
would have seemed too literal a fragment of reality, whereas
here, the very lack of clarity heightens our unease. To
photohistorian Christopher Phillips, these lips suggest 'two
undulating slugs'. It was, Phillips concludes, 'the animal
within' the human body that intrigued the photographer.

<u>F l e s h</u>

28. **Roger Parry**
 French, 1905–1977
 Mouth
 1931
 Gelatin silver print

By means of a Surrealistic photomontage, Herbert Bayer evokes the solitude of the individual in the big city. Against the facade of a building, open hands reflect the image of a face which is reduced to two eyes. This fantastic scene may be read as the artist's self-portrait. Looking at his palms, as if trying to read his future, Bayer is confronted, in a kind of mirror effect, by his own gaze. The self shown here is composed of the hand and the eye, the organs of touch and sight – two distinct parts of the body which, interacting together, represent the essence of the photographer's creativity. This mysterious work clearly synthesizes the radical changes in photographic imagery during the period between the two wars. The photomontage technique creates a visual interplay by bringing together on the same plane objects detached from their context and showing them without any reference to their real scale. Bayer, a versatile artist trained at the Weimar Bauhaus, was greatly influenced by the ideas of the Surrealists.

Fiction

29. **Herbert Bayer**
American, b. Austria, 1900–1985
Lonely Metropolitan
1932
Gelatin silver print

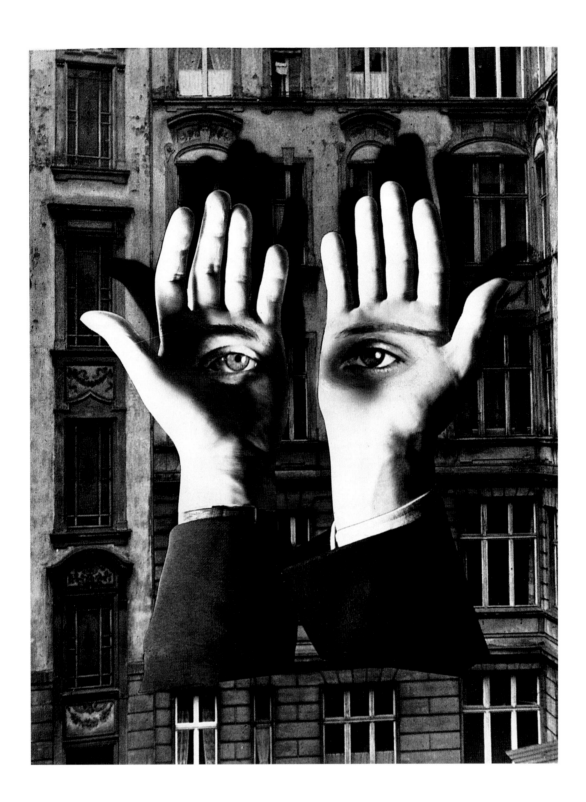

This luminescent figure seems not quite flesh and blood. It could be an artfully crafted sculpture, left momentarily in the street. And in fact, in the period between the two World Wars, Brassaï did photograph sculpture, at one point collaborating with Salvador Dali on a series of 'sculptures involontaires' for the Surrealist review *Minotaure*. But *The Gilded Warrior* is of course a real person, a simple partygoer mimicking the supple, sensual ideal proposed by the actor Johnny Weissmuller. He is on his way to one of the more famous balls that so delighted Parisian artists and socialites. The Surrealists celebrated nightlife as a glamorous, otherworldly sphere, where bizarre encounters could open doors to new experience. Brassaï, who described himself as 'saturated by the beauties of the Parisian night', was fascinated by the exotic mix of fauna that came out after dark – prostitutes, actors, cabaret dancers, homosexuals, lesbians and other species of café-dwellers who preferred the company of strangers to the solitude of their homes. He paid them homage in his celebrated book *Paris by Night*. In the same publication he also paid tribute to the artificial illumination of his adopted city, delighting in the extreme contrasts of dark and light and the way in which lit objects, forgotten in daylight, appeared at night to glow from within. Perhaps it was this quality of interior illumination that attracted Brassaï to the urban warrior he waylaid long enough for his glow to register on film.

I c o n

30.

Brassaï (Gyula Halász)
French, b. Hungary, 1899–1984
Le Bal des Quat'z Arts. The Gilded Warrior
1932
Gelatin silver print

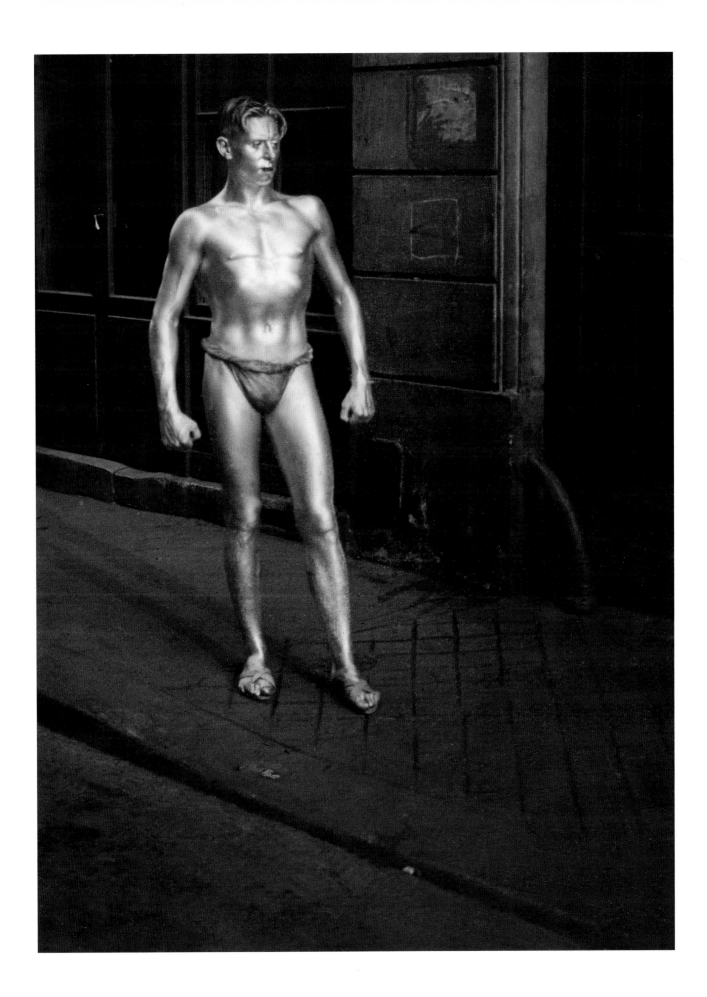

Like her great friend and fellow photographer Edward Weston, Imogen Cunningham shifted her style from Pictorialism to Modernism, and, like Weston, never entertained a moment's doubt as to the richly expressive powers of the photographic medium. Cunningham's nudes, like her plant studies, are marvellous examples of the pure, unmanipulated photography that had a particular resonance on the West Coast of the United States in the period between the wars. The almost cult-like group, 'f.64', to which Cunningham, Weston, Ansel Adams and several others belonged, believed that their pictures should be sharply focused – f64, the smallest possible aperture, allows for maximum depth of field. They also insisted that large-format negatives should be used, and that contact prints rather than enlargements should be made from those negatives, so that no information was lost. In short, the group stood for a crystal-clear depiction of reality, but reality seen with a vision so acute that the photograph would strike the viewer with the force of a revelation. The vehemence of their beliefs can be partly explained as a reaction to the pervasiveness in mainstream amateur photography of the old Pictorialist thinking, with its penchant for vague outlines and idealized subject matter.

Cunningham was able to mitigate the rigid rules of 'f.64' with a sense of poetry. She had a gift for seeing things in abstract terms, and was particularly adept at transforming nudes and plants into almost pure geometric form without losing her way in abstraction. As we see here, the body is not fragmented in the usual Modernist manner but is seen relatively whole – even portions of the head and the feet are visible. Nor does Cunningham attempt to gloss over the imperfections of the skin in favour of perfect form. Rather, by posing the body in such an unusual manner and tilting her camera down at it so that the sunlight falls squarely on the back, she throws everything but the body into deep shadow. Thus she presents the female nude as a beautiful, rhythmically rounded object floating in a black void.

Form

31. **Imogen Cunningham**
American, 1883–1976
Nude
1932
Platinum print

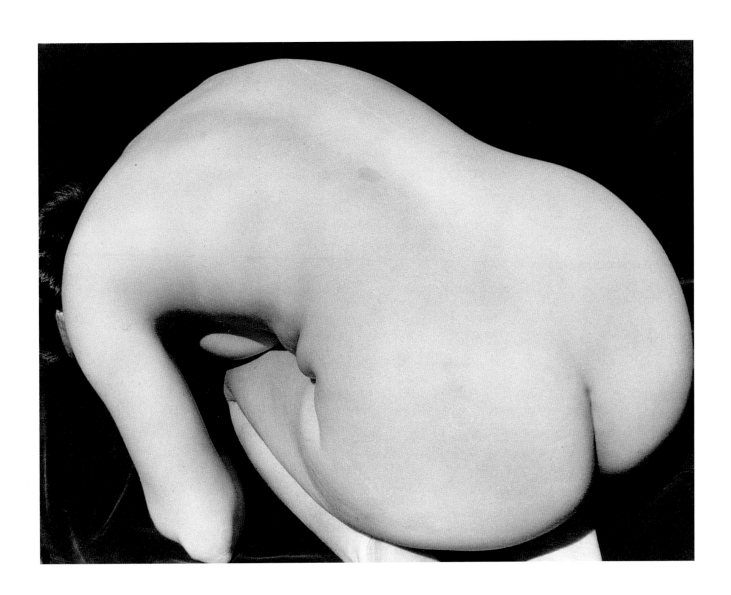

Erwin Blumenfeld found fame as a fashion photographer, but this represents only one aspect of his achievement. A period of Dadaist collage, a brilliant early period of portraiture, superb nudes made throughout his life and acerbic writing which would be published posthumously in the form of an autobiography flesh out our appreciation of the artist. Blumenfeld's prophetic *Hitler* of 1933 was only one of the many photomontages he made during his self-imposed exile in Holland, where he had gone to join his fiancée, Lena. His experiences with the German army during the First World War, when he served on the Western Front as an ambulance driver and saw at first hand war's inanities, filled him ever after with a loathing for authority figures, be they the Kaiser, army officers, teachers, bosses, or even the concierge of his Berlin apartment building (while killing vermin he had trapped, the man would say, 'This is the way those Jewish rats should be exterminated!'). Blumenfeld's intuitive dislike of Adolf Hitler took a decidedly downward turn when his fledgling leather goods business failed because, being Jewish, he was prevented by new German laws from obtaining the necessary credits for the purchase of raw material. Small wonder then that Blumenfeld saw Hitler as a bloodsucking monster. Another of the photographer's satirical images, *The Dictator* – the head of a calf mounted on a draped classical bust – had almost fatal consequences for its maker when it was seen by the German ambassador at an exhibition in Paris in 1937. Outraged, the ambassador demanded that the piece be withdrawn, and when the gallery's windows were subsequently smashed, the organizers complied. According to Blumenfeld, these events resulted in his being targeted for capture when the Germans occupied Paris, and he was lucky to make a last-minute escape.

Politics

32.

Erwin Blumenfeld
American, b. Germany, 1897–1969
Hitler
1933
Hand-coloured gelatin silver print

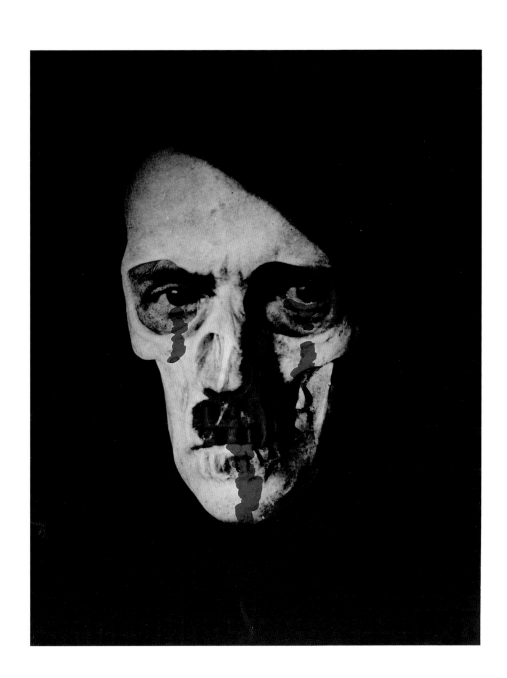

This striking image shows just how far the female nude had come since the turn of the century, when women were inevitably shown as passive beings, in a veritable swoon, unconscious of the male gaze feasting upon them. Sasha Stone's model is a curious and unsettling mixture of eroticism and menace. Verging on the androgynous – the mouth is unquestionably female, but the breasts are ambiguous (female, certainly, but far from the pendulous forms which characterized the nudes typically found in publications of the day), and the pose is more that of the muscleman. This body speaks of sexuality and confidence, even defiance. But it is a body that *projects* its sexuality, ready to meet the viewer's gaze on its own terms. And should an overture be unwelcome, that readied arm and 'claw' would serve as a vicious weapon of defence.

Roland Barthes famously proposed the term *punctum* for a tiny, apparently insignificant aspect of a photograph which nonetheless imbues it with power. The mouth in Stone's nude is such a detail. While the photographer has cleverly hidden the face, which would otherwise draw the interest of the viewer away from the body, he has retained this one highly sensuous aspect of it which speaks of the 'person' inhabiting the flesh – without it (as the viewer can verify by masking that part of the picture) – the image would be reduced to lifeless sculpture, at best a study in form alone.

Desire

33. **Sasha Stone**
Russian, 1895–1940
Study of the Human Body
1933
Photogravure

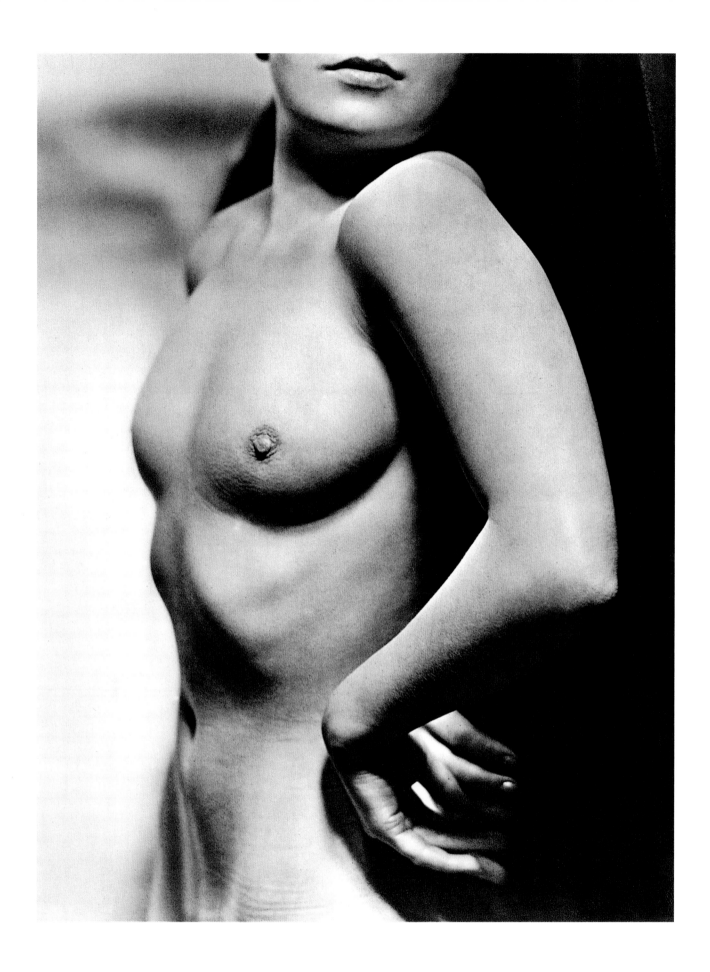

Contrary to first appearances, this photomontage-like image, made sometime around 1933, is not an example of staged photography, but the product of chance – that element so dear to the Surrealists. Visiting a mannequin factory, Werner Rohde's eye was caught by this strangely graceful ballet of supple arms. Sculpted by light, the proliferating forms look more alive than artificial. No doubt they reminded him of the work of Picasso, Dali and Léger. Rohde was a painter on glass as well as a photographer and was a friend of the Surrealist Paul Citroen. In the laboratory of the avant-garde, the body was feverishly dismantled, then reassembled – according to a logic based on playful tinkering and chance on the one hand, and machine order on the other. The Cubists were fascinated by such transformations, making use of simple geometric volumes such as cubes or pyramids as heads, torsos and limbs. The Surrealists, for their part, delighted in unusual effects inspired by dream, delirium and other expressions of the unconscious, grafting men's heads onto women's bodies or animals' heads onto human bodies. They shared Giorgio de Chirico's predilection for mannequins, which they popularized as a motif and often fetishized.

Form

34. **Werner Rohde**
German, 1906–1990
Arms
c. 1933
Gelatin silver print

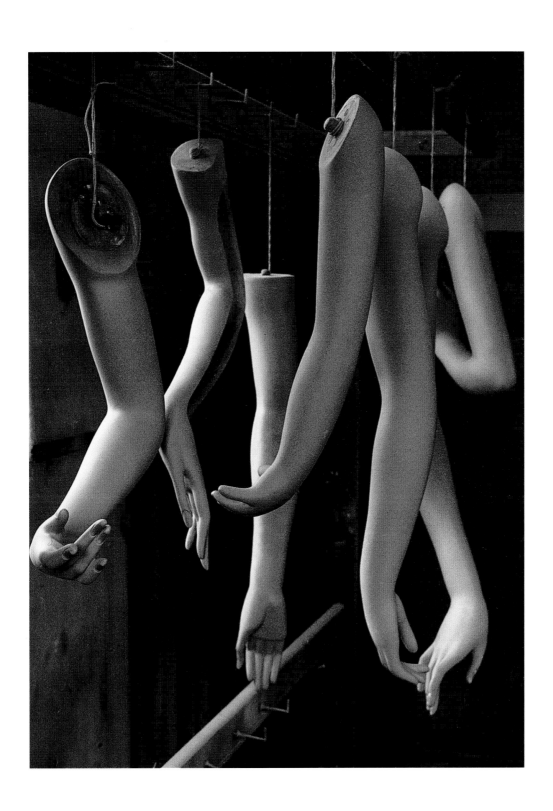

The high style of 1930s art has been characterized by the art historian J. P. Sembach as a mix of 'precision, luminosity, transparency, immediacy, sensitivity to material, logic, and freedom from sentiment and dogma'. There could be no better description of the expertly composed fashion photographs of George Hoyningen-Huene which graced the pages of *Vogue* and *Harper's Bazaar* from the mid-1920s to the mid-1940s. Few fashion photographers of the twentieth century could match Hoyningen-Huene's spare elegance. His training as a painter gave him a twofold advantage over many of his contemporaries: it made him acutely sensitive to the importance of every detail in the frame, no matter how minute (the glint on a fingernail; the tiniest fold in a dress), and it enabled him to quote from Cubism, Constructivism, Surrealism and Art Deco. The font of his creativity, however, was more ancient: the art of classical Greece.

In *Toto Koopman, Evening Dress by Augustabernard*, we observe Hoyningen-Huene at his minimal best. His carefully modulated lighting crisply defines every fold of the garment while allowing the viewer to sense the supple body beneath the sensual fabric. Although Koopman – Hoyningen-Huene's favourite model – appears natural and at ease in her magnificent gown, the photographer has, in fact, arranged her pose meticulously. The ever-so-slight lean of her body from bottom left to upper right is counterbalanced by the opposing diagonals of the folds of the dress, which slope downwards from the centre of the image to the right, and which are arranged so as to terminate in a neat curl which mimics the raised arm. The curl of the dress at bottom left also reflects the shape of the thumb and forefinger on the model's right hand.

Despite Hoyningen-Huene's artistry, his work was not immune to outside interference. The slight blur travelling down the model's right hip is evidence of dot etching, a retouching tool. Hoyningen-Huene and his fashion-photographer colleagues had to contend with hypercritical fashion editors, for whom even the beautifully proportioned Koopman was not slim enough.

98

I c o n

35. **George Hoyningen-Huene**
American, b. Russia, 1900–1968
Toto Koopman, Evening Dress by Augustabernard
1933
Gelatin silver print

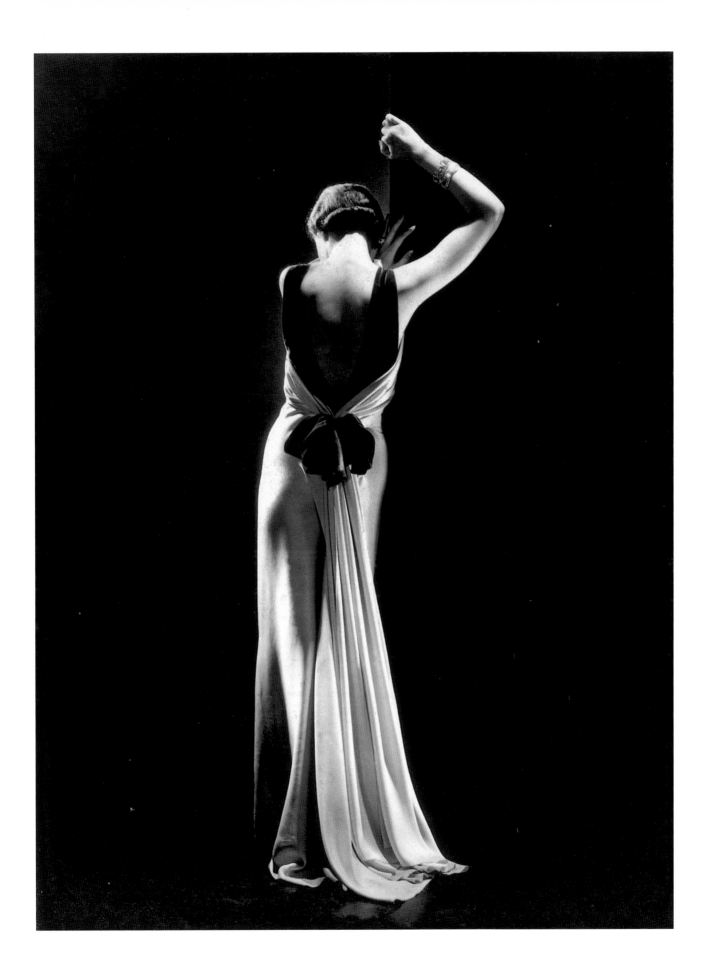

Hans Bellmer achieved notoriety in the twentieth century for his obsessive reworking of a single theme: the figure of a quasi-human female doll, which he fabricated in an extraordinary variety of forms. Before becoming an artist Bellmer had been an engineer, and his training is evident in this vision of a robotic doll which might have stepped straight out of Fritz Lang's cinematic masterpiece *Metropolis*. The creature does not hide the fact that she is part-automaton, part-human – indeed, she seems perfectly at ease with her condition. Despite our unease with this colonization of the human body by the machine – which is heightened by Bellmer's reversal of positive to negative – we are forced to admit that 'it/she' is somehow... *beautiful*. Later, Bellmer's dolls would be more explicitly fleshy and erotic, though their contorted forms and multiple limbs mocked nature's forms: one headless torso, for example, was endowed with four legs. What strange needs motivated Bellmer's fetishistic creations? These dolls delighted the Surrealists, who saw Bellmer as a member of their family, a master of the imagination who was willing to battle openly with his demons.

Fiction

36. **Hans Bellmer**
 French, b. Germany, 1902–1995
 The Doll
 1934–1935
 Gelatin silver print

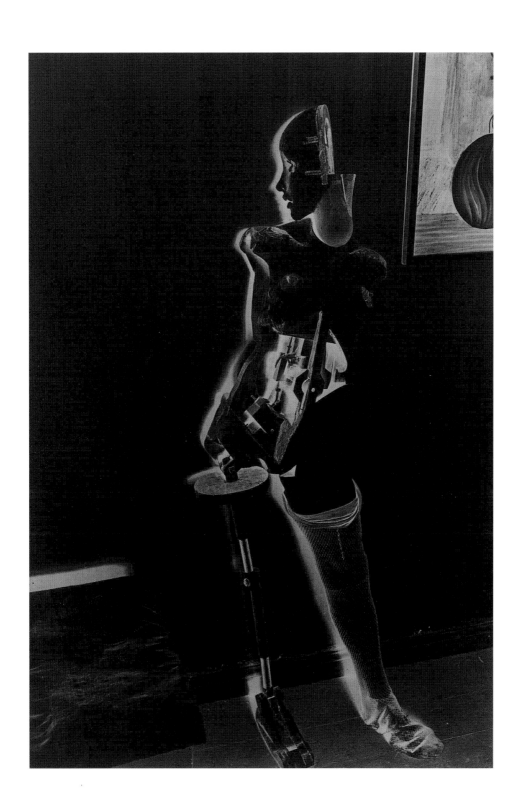

William Mortensen was a master at what is today widely dismissed as kitsch. During the 1920s and 1930s, when he was busy producing his moralistic allegories, Mortensen enjoyed a reputation among a wide circle of American amateur and professional photographers as a figure of some importance. The author of a dozen books with titles such as *The Command to Look* and *Mortensen on the Negative*, he directed the Mortensen School of Photography in Laguna Beach, California, for thirty years. Today, Mortensen's photographs are still much appreciated, though not for their moral platitudes. We derive pleasure, rather, from his refined graphic sense and from the transparency of his motives – behind the highmindedness lay an obviously lascivious intent.

Here, a naked young woman flirts shamelessly with a peacock – the male of the species, widely accepted as a symbol of beauty marred only by a surfeit of vanity. The girl stands on tip-toe as if preparing to kiss her lover. Mortensen has cleverly added some touches to suggest that the two players are, as it were, of the same species: her hair and his tail, for example, are similar both in texture and in the manner in which they are depicted. The spectator (or, more to the point, the voyeur) is treated to a profile of her almost too neatly proportioned nubile body. The great pole that stands rigidly in the centre of the photograph (thus commanding the image, pictorially and psychologically speaking) is instantly recognizable as a phallic symbol, terminating in a perfect knob which finds its counterpoint in the woman's modest-sized nipple. Cecil B. De Mille was often cited by Mortensen as an influence, as was Mortensen's teacher, Arthur Kales, known as 'The Bromoil King'. Not surprisingly, perhaps, moral instruction and theatricality, leavened by sexual titillation, became the hallmark of Mortensen's style.

D e s i r e

37. **William Mortensen**
American, 1897–1965
Mutual Admiration
c. 1934
Gelatin silver print

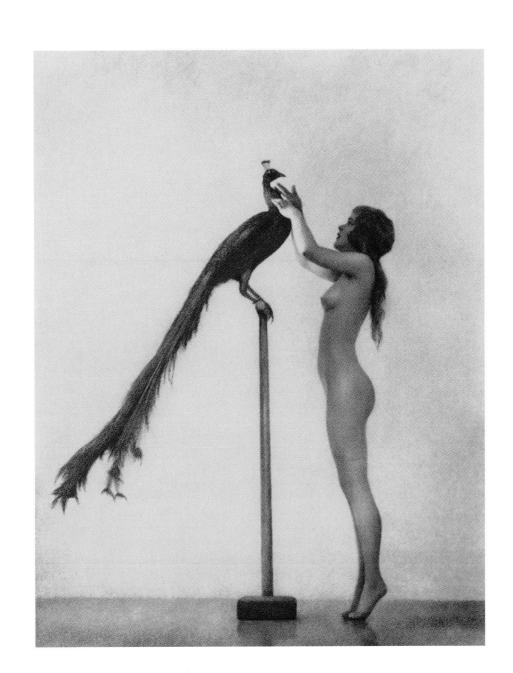

Sleep, and in particular its accompanying dreams, are a valued source of inspiration for those photographers who are more interested in fiction than in documenting what can be seen with the eye. George Platt Lynes's sleepwalker recalls the world of French Surrealism, with its unsettling fragmentation of the human body and its underlying fascination with Freud's notion of the unconscious. *The Sleepwalker* is as enigmatic as any painting by de Chirico or Dali. Curled up in a foetal position, a naked man sleeps on a tray or table. Below, supporting the table, is a 'half-man', comprising muscular legs and buttocks. This figure is strongly built, confident and relaxed with the load he bears. Perhaps he represents the unconscious, and the body he carries is his own; if so, then at night the unconscious is conscious and vice versa. As dawn breaks on the horizon, he, the 'conscious unconscious', waits patiently for the customary exchange of roles. The half-man may also refer obliquely to Lynes's own sexual orientation, which was never allowed full expression. At a time when homosexual acts were proscribed, and it was best not to state homoerotic sentiments too directly, the beautiful bodies of *The Sleepwalker* spoke covertly of desire.

Fiction

38.

George Platt Lynes
American, 1907–1955
The Sleepwalker
1935
Gelatin silver print

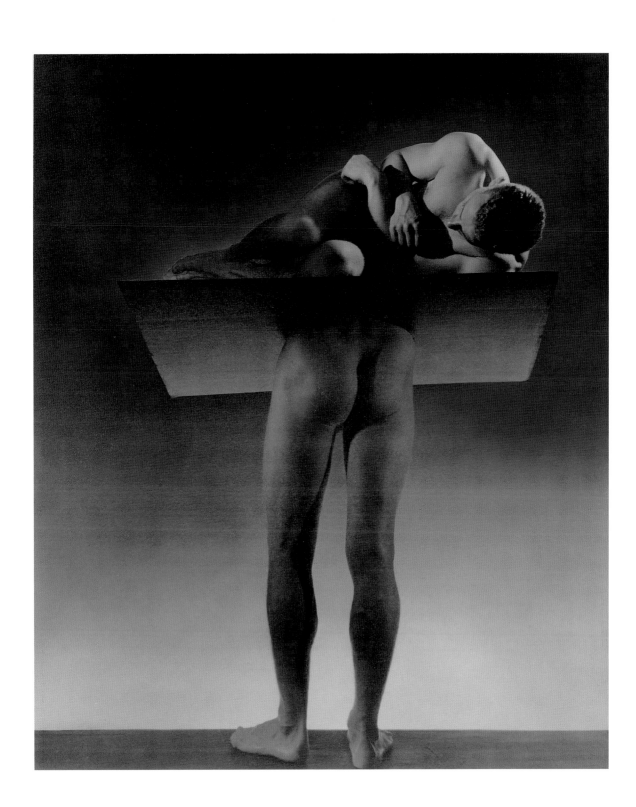

Alexander Rodchenko is considered to be one of the great pioneers of Modernist photography. A central figure, first in the Russian Constructivist movement, and then in Productivism, his influence extended to avant-garde photography wherever it was practised, East or West. The body was a difficult subject for Soviet artists in the 1920s and 1930s because images were automatically interpreted in ideological terms. Depictions of the body were therefore pregnant with meaning for society as a whole, whether in political affairs or those which concerned social relations, in particular sexual love. During the period when Russian artists enjoyed creative freedom – before the Communist regime put an end to the avant-garde in 1932 – Rodchenko made many photographs involving the body, chiefly of female subjects, in the bold new language of Constructivism, but once the crackdown had begun his independent vision was increasingly attacked, first by rivals and critics and then by the Party. Thereafter, he produced his fair share of propaganda photographs, some to help boost industrial production, others to promote a vigorous picture of the military, of which the image shown here is an example. Rodchenko's photographs were often taken during mass sporting events or parades, with bodies depicted as cogs in a glorious, forward-moving machine. Such photographs were meant to celebrate a collective identity, to the detriment of individuality and intimacy, and were intended to present to the world an image of a youthful, strong country and an unstoppable social force – Communism.

Politics

39.

Alexander Rodchenko
Russian, 1891–1956
Ready for Work and Defence
1936
Gelatin silver print

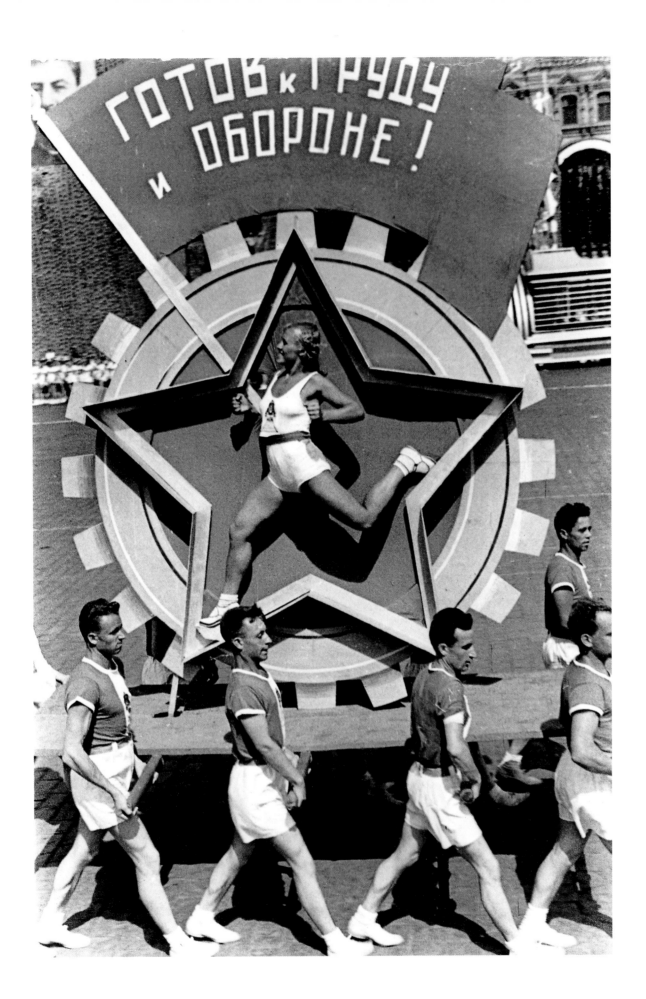

In 1936 Nazi Germany hosted the Olympic Games, which were conceived by the Fascists as a vast exercise in nationalist propaganda. Leni Riefenstahl, already a celebrated photographer, was commissioned by Hitler himself (against the advice of certain ministers) to cover the event in depth and produce both a film and a book of photographs. The book, *Schönheit im Olympischen Kampf* (Beauty through Olympic Struggle) – was a masterpiece of propaganda in form and content. Many of the formal inventions associated with avant-garde photography in the 1920s are to be found here in the idiom of sport: strong diagonals, bird's-eye and worm's-eye views, abstraction and geometric form. The book itself is laid out in a somewhat cinematic, narrative fashion, beginning in Ancient Greece, where the naked bodies of athletes are seen in the context of unspoiled nature. This is followed by the long and majestic progress of the Olympic Torch to Berlin, culminating in its entry into the stadium, where the taut muscles of individual athletes are juxtaposed with the excited masses. Finally we are shown the heroic contests, with their split-second victories. The impression builds that human power reaches its maximum potential only when harnessed by an efficient state.

But there was a grain of sand in the well-oiled machine: to Hitler's intense displeasure, the Black American athlete Jesse Owens stole the spotlight, walking away from the Games with four Gold Medals. Even worse for Nazi propaganda was the discovery by enterprising journalists that the fastest man in the world had been a puny, sickly child. Although Hitler refused to shake his hand, Owens was included in Riefenstahl's book, no doubt because his achievements could simply not be ignored. When asked later about the handshake incident, Owens replied laconically that he had never been invited to the White House to shake hands with the American President either. Owens would prove to be a forceful spokesman for antiracism as well as an international icon of Black achievement. It is ironic that Hitler's preferred photographer, with her portrait of the runner in action, should have contributed to the legend.

Politics

40. **Leni Riefenstahl**
German, b. 1902
Jesse Owens, USA, Takes off for
His World Record Jump
1936
Gelatin silver print

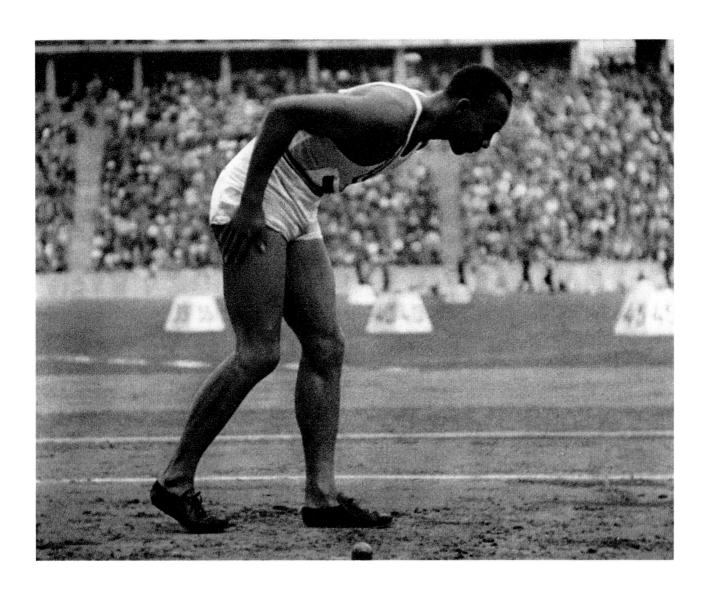

Like other leading lights of the Pictorialist movement, Edward Weston abandoned soft-focus photography for the crisp clean lines of the Modernist aesthetic which took hold in Europe and America after World War I. Weston was a founding member of and a vigorous spokesman for 'f.64', a group of American West Coast photographers, established in California in 1932. Believing in straight photographic seeing, devoid of darkroom trickery, Weston spoke of his quest for 'the quintessence of things… an image more real and comprehensible than the actual object'. This phrase is often misconstrued as a plea for a kind of hyper-realistic rendering which leaves room only for pure fact, but Weston's method actually allowed for a great degree of lyricism, as we see in this justly famous nude. A close look shows us that the entire visible surface of the body is clearly delineated – no part of it is actually abandoned to shadow. But the eye nevertheless *perceives* the image in semi-abstract, quasi-geometric terms: note the two ovals, the one formed by the head, the other by the arms as they wrap around and envelop the body; note, too, the triangles, rectangles and other angular shapes formed by shadows within the body's interstices, and the V-shaped dark-toned walls which so effectively frame the body's whiteness. Weston made more than one hundred nudes, which are best appreciated in conjunction with the nautilus shells and green peppers he was photographing during the same period, objects to which he gave a distinctly erotic character, as if the naked body alone were not enough to express everything he wanted to say about the sensuality of the material world.

110

F o r m

41.

Edward Weston
American, 1886–1958
Nude
1936
Gelatin silver print

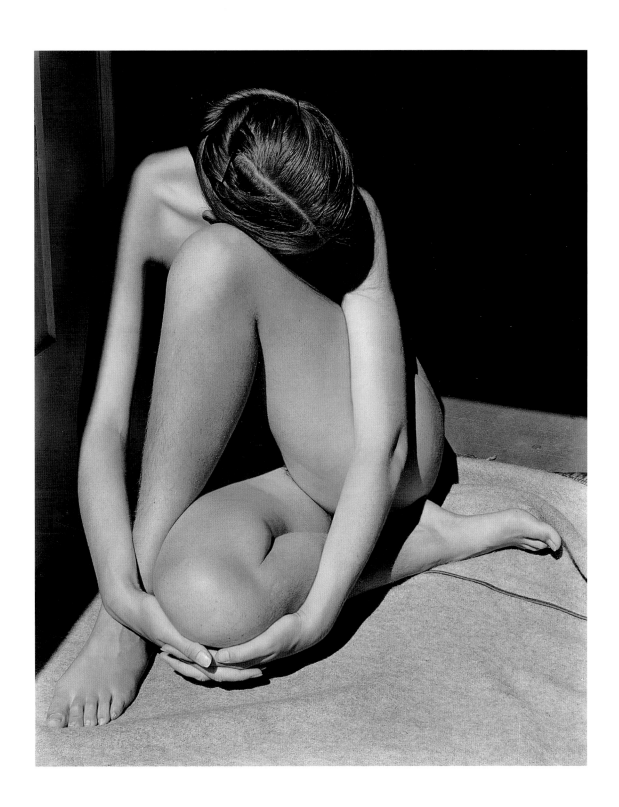

The concept of 'the total work of art' (known in Germany as the *Gesamtkunstwerk*), meaning a synthesis of music, theatre, dance and so forth, was perfectly in keeping with the totalitarian aims of the Third Reich. The operas of Richard Wagner were, to Hitler, exemplary in this regard and should serve as models for all the arts. Architecture, and, even more so, scenography and choreography, were rapidly developed by the Nazi regime as essential tools of persuasion. While it cannot be denied that political power has always concerned itself with its own representation, the Nazis took the art to new heights, as much to convince themselves as others of their indomitable strength and the inevitable success of their cause; after all, a spectacle had to be worthy of a country that was destined to rule the world for one thousand years. With this aim, the Reich's principal architect, Albert Speer, modelled the night-time spectacle of the Nüremberg Rally on the design of a Gothic cathedral, with beams of light pointing heavenward like pillars of infinite height. In all other forms of Nazi spectacle as well, the individual was made to feel minute and insignificant in relation to the mass. When it came to the obligations of the individual, it was made clear in every way that the human body was no more than a cog in a well-oiled machine. Hans Bittner's celebratory image of Nazi power is perfectly in keeping with this formula; its tight cropping of an absolutely homogeneous mass suggests that the military machine extends *ad infinitum* beyond the confines of the frame.

112

Politics

42. **Hans Bittner**
 German, dates unknown, active 1930s
 SA Parade, 12 September 1938, Nüremberg
 1938
 Gelatin silver print

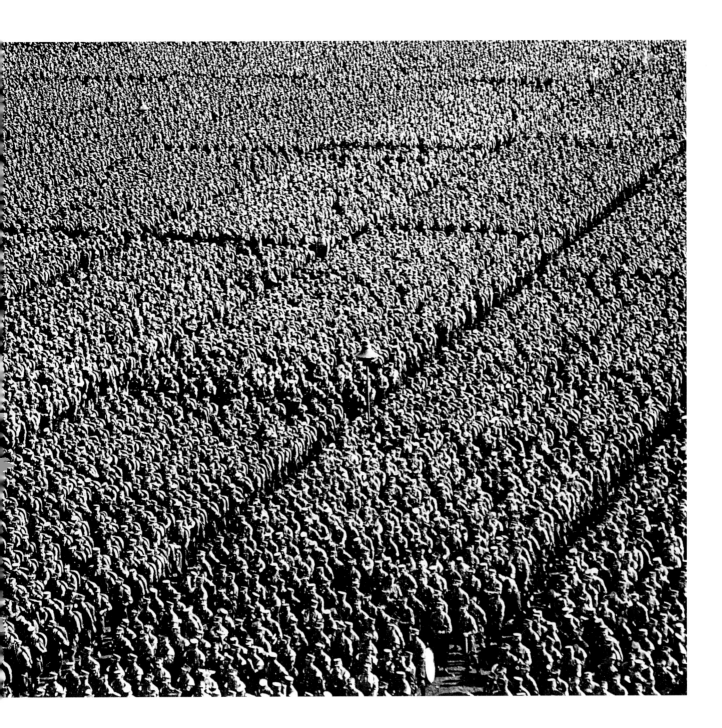

Few twentieth-century photographers of fashion can match the long career of Horst P. Horst. A protégé of George Hoyningen-Huene, for whom he had posed as a male foil in impromptu fashion sittings, he was soon moved to try his own hand at the fabrication of images. He quickly mastered the essentials of Hoyningen-Huene's spare, neoclassical approach and proved himself more versatile stylistically, absorbing treatments and motifs from a variety of art styles of the day. His eclecticism embraced the ideas of rival photographers as well, though he could never be accused of outright imitation. Few of his fashion photographer colleagues could keep pace with Horst, and his work did not suffer from the uneven patches of many of his contemporaries. *Mainbocher Corset, Vogue* is rightly considered a tour-de-force of the genre, and indeed transcends it. It is a picture of perfect equilibrium and economy of signs, with a touch of Old Master painting and Dali-like Surrealism. It must be admitted that the picture has seen the intervention of the retoucher's brush – the model's waist has been reduced significantly on the left side – but in fairness to Horst this was done not to improve the picture but to maintain the illusion of an exquisite body, thanks, supposedly, to the corset. Most black-and-white photographs published in *Vogue* and *Harper's Bazaar* were retouched for such purposes since the models were often society women rather than professionals, and their bodies seldom conformed to the conventional ideal.

114

Icon

43.

Horst P. Horst
American, 1906–1999
Mainbocher Corset, Vogue
1939
Gelatin silver print

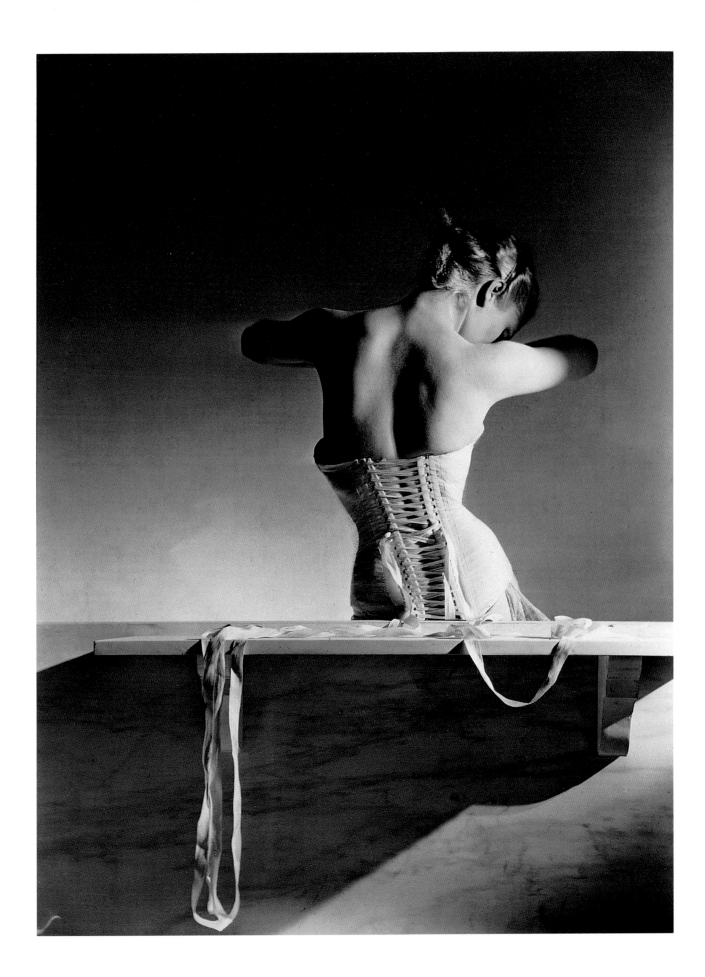

John Phillips, a photojournalist associated with *Life* magazine from 1936 to 1959, is best known for his reports on the Anschluss, Tito's maquis, and the final days of the writer-pilot Antoine de Saint-Exupéry, who disappeared during a reconnaissance mission over Occupied France. The American war correspondent accompanied the U.S. Army on its campaigns in North Africa and Italy, then followed the liberators as they battled their way through Germany. Like his colleagues Lee Miller and George Rodger, Phillips was able to witness at first hand the consequences of Nazi barbarity. The documentation provided by these photographers helped precipitate an awareness of the extent of the horror unleashed by Hitler, just as the public, relieved that the conflict was over, was turning away from the brutal facts. The harrowing scenes of mass graves and piles of ashes from the ovens are echoed here in this almost unbearable close-up of human remains, thrown into a container as so much industrial raw material, ready for transformation into soap. 'As a final insult', notes Phillips, 'a dead monkey had been tossed in with the bodies.' Phillips knew that *Life* would not – 'could not', in his words – publish such images, but he took them all the same, knowing he had a responsibility to history. In later years, he could draw satisfaction from the fact that he had contributed concrete evidence of Nazi crimes to counter revisionist claims that the Holocaust itself had never happened.

P a i n

44.

John Phillips
American, 1914–1996
The End of the War Stopped the
Transformation of Bodies into Soap,
Danzig, Poland
1945
Gelatin silver print

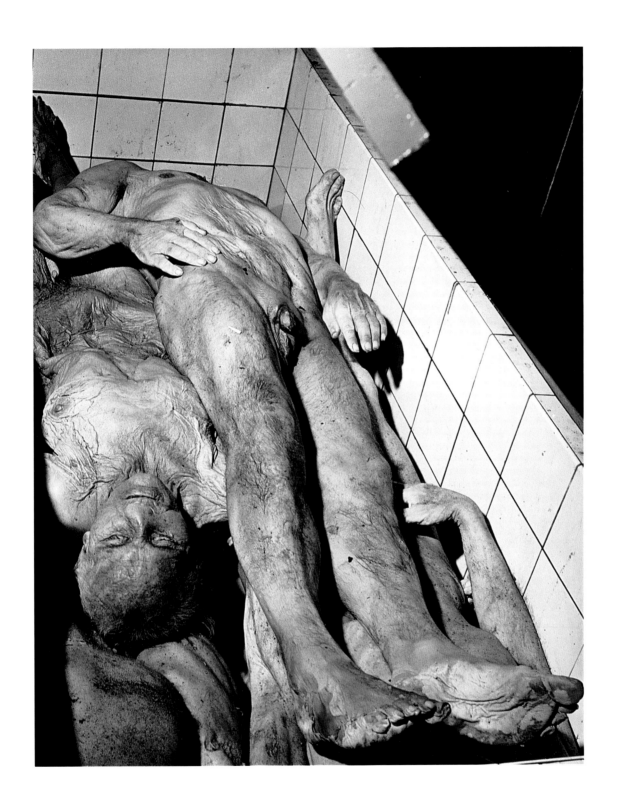

In 1931 Karel Teige spoke of a new kind of pictorial photography: '...which does not wish to be more than a play of shapes, lights and shadows, a photogenic poem'. Teige believed that 'the new images of quite commonplace realities have considerably enriched our cognisance of reality, of matter and its structure – in short, they have enriched our visual experience and sharpened our ability to look and see.' Although he expressed the opinion that the new movement had already achieved what it had set out to do, and risked sliding into Mannerism, Teige nonetheless continued to practice his version of what he called 'free photography'.

Teige's art had been forged in pre-World War II Prague, when the city was an extraordinarily fertile ground for artistic creativity, and photography was the object of much experimentation. Teige, a leader in avant-garde photography circles, absorbed influences from cutting-edge painting as well as from architecture and film. Theorist as well as practitioner, he argued for art photography's independence from painting of both the past *and* the present, and cautioned his fellow photographers not to ignore the exciting microscopic and telescopic imagery being produced by scientists.

In this stylized representation of the female form, rounded and tube-like fragments of the body are set against arc-shaped and triangular zones of light and dark. Teige manages the difficult feat of keeping the figure distinct (that is, we never lose sight of 'the nude') while managing to integrate its component parts into an abstract geometric scheme; the image is kept from dissolving into *total* abstraction by the solid anchor of leg and thigh, and the anatomically correct placement of the breast.

F o r m

45.

Karel Teige
Czechoslovakian, 1900–1951
Untitled
1947
Gelatin silver print

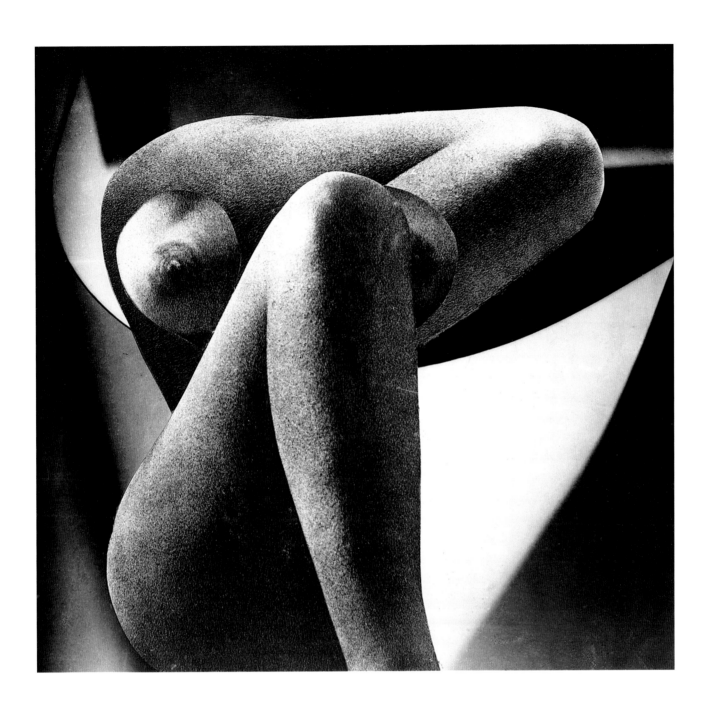

George Rodger was on the verge of giving up photography in 1945, after having been one of the first witnesses to Nazi criminality at the Bergen-Belsen concentration camp. As a young man, he had embarked on a career in photo-journalism with great enthusiasm, and when war broke out in 1939 *Life* magazine lost no time in sending the talented photojournalist to cover hostilities in North Africa, the Middle East, the Far East and Western Europe. His love of Africa, acquired during his many visits there, was to be rekindled by his troubling discoveries at Bergen-Belsen. In the light of that horror, the peoples he had glimpsed on the African continent seemed to him to be endowed with a natural beauty and a purity of soul of which Europeans were no longer capable. From 1947 on, he devoted himself entirely to his new passion and began amassing images of the fast-disappearing world of tribal Africa. The romantic enthusiasm which fired his endeavours is reminiscent of Rousseau's myth of the 'noble savage', an idea that has proved surprisingly tenacious in the Western world-view. Though the concept has long been discredited intellectually, Rodger cannot be faulted for wishing to preserve a record of cultures which are fragile and most certainly in the process of vanishing.

Expression

46. **George Rodger**
 British, 1908–1995
 Dinka Boys from Duk Fadiat, South-Sudan
 1948
 Gelatin silver print

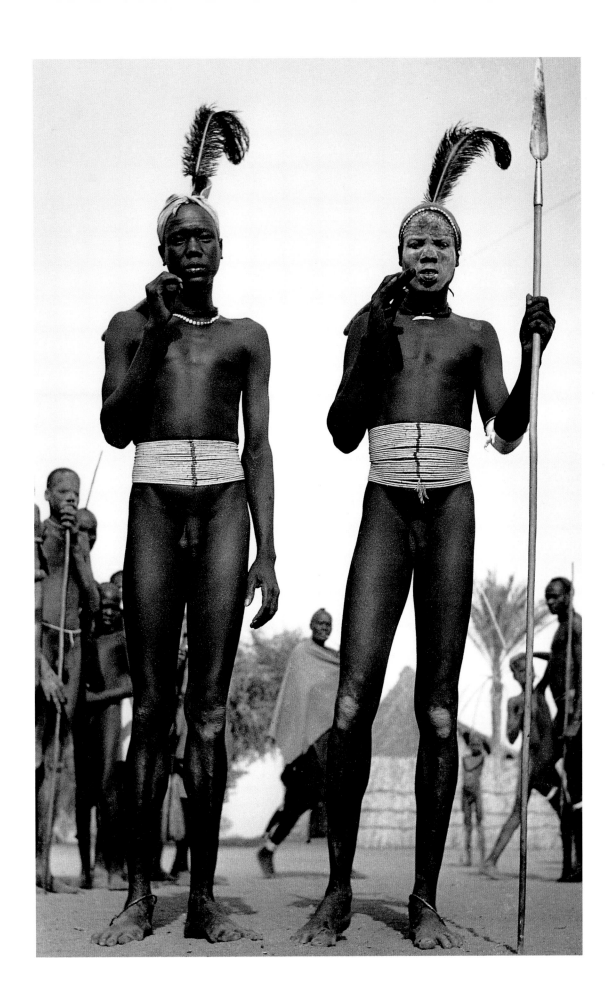

The postwar period promised to be an era of wellbeing, in which wealth and leisure would be in abundant supply. Fashion magazines actively encouraged this dream, hoping to expand their middle-class readership with visions of a chic lifestyle which could be available to anyone with relatively little effort. *Vogue* and *Harper's Bazaar*, the leaders in the field, instructed women on how they should dress and behave if their ambitions were to be realized. Care of the body itself, however, had not yet become the obsession it is today; at this time the accent was decidedly on clothing, though the cosmetic industry was growing rapidly and its interest was primarily the face. Nude or semi-nude female bodies, promoting beauty products of various kinds, are seldom seen in magazines of the period.

During her twenty-two years as photographer for *Harper's Bazaar*, Louise Dahl-Wolfe excelled in a matter-of-fact approach to her subject. Dahl-Wolfe's women are relaxed and unhurried, confident in themselves, their clothes and their surroundings. Natural though they appear, however, the settings were meticulously composed, and were lit with extreme attention to detail. Dahl-Wolfe's *Nude in the Desert*, while alluding to the famous nudes on sand dunes made a decade earlier by Edward Weston, stakes out a terrain of its own. Whereas Weston's nudes are unashamedly erotic – the body in the photographs was, after all, that of a lover – Dahl-Wolfe's nude belongs to a privileged world of leisure, where the body is pampered and coddled. In female nudes by male photographers, the body is 'an object of desire' in the sense that the male viewer imagines himself taking possession of it; in Dahl-Wolfe's nude, the body is 'an object of desire' in a very different sense: the female viewer, it is hoped, will want to achieve a similar degree of physical perfection. Commerce, rather than art, ultimately dictates the rules here.

Icon

47.

Louise Dahl-Wolfe
American, 1895–1989
Nude in the Desert
1948
Gelatin silver print

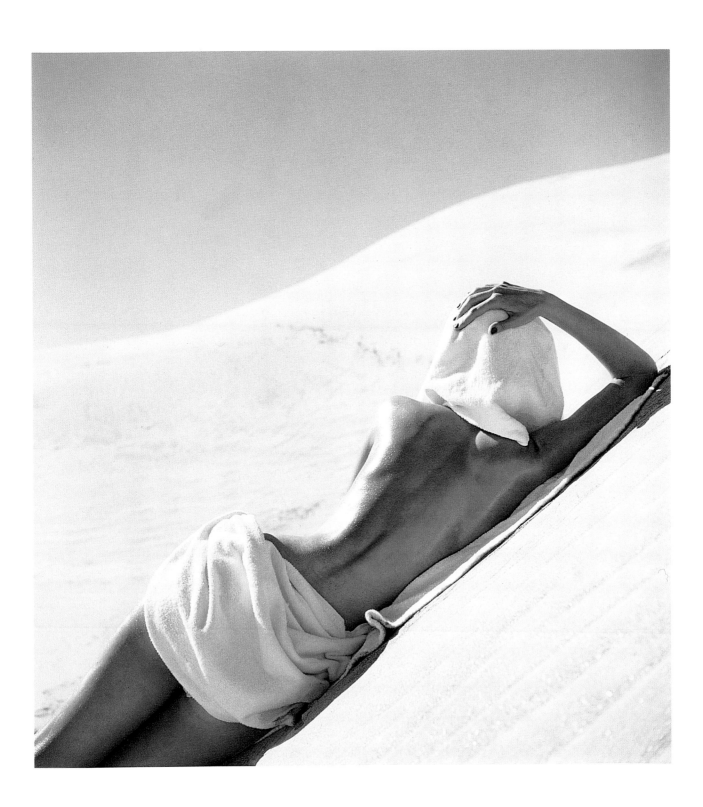

In 1952 Gerhard Kiesling, then a young photojournalist, visited the Zwickau coal mine, accompanied by a female journalist. Heavy industry and its workers played a key role in the planned economy of East Germany, a contribution that the regime wished to exalt in the name of Communism. As the two reporters approached a depth of 1200 metres and encountered the suffocating heat and deafening noise of the galleries, they found themselves among naked or next-to-naked men wresting the coal from the rock both manually and with heavy machinery. Kiesling had heard of the practice of men working naked, and wanted just such an image to dramatize his report, but he was concerned that the men might cover themselves up in the presence of a woman. Despite some ribald bantering, however, no such attempts were made. Ironically, it was in the *published* version of the photograph that this worker was seen wearing shorts – thanks to the intervention of the photo agency's retoucher. Despite the 'noble' and 'heroic' aspects of the work, the Party could evidently not countenance any image that suggested that Communist workers, however willing to sacrifice self-interest for the common good, were forced to labour in such hellish heat – which nakedness would inevitably imply. Kiesling's personal disappointment did not stop him from continuing to produce documents which showed life for workers and peasants as *he* saw it rather than through the rose-tinted glasses of official ideology.

F l e s h

48. **Gerhard Kiesling**
 German, b. 1922
 Miners at a Depth of 1200 Metres in
 the Martin-Hoop Mine, Zwickau
 1952
 Gelatin silver print

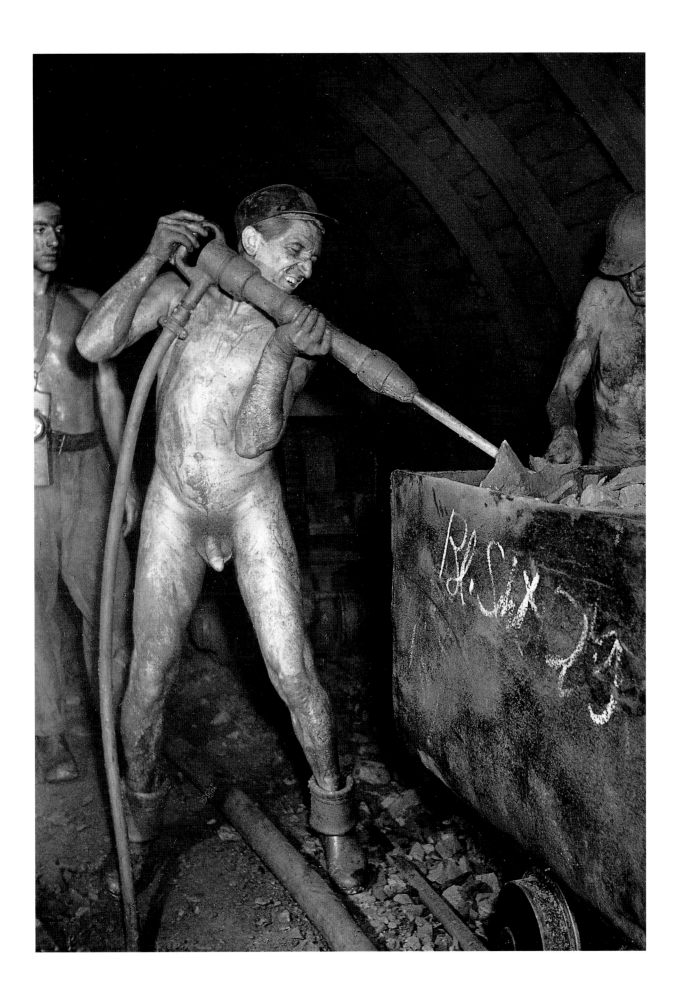

A conventional scene, and a motif with a long artistic tradition – the naked body of a woman lying on a beach; yet, seen through the eyes of Bill Brandt, the theme takes on a new vigour. Indeed, at first glance we are not even sure that we are looking at a nude at all: rather a bulbous creature washed up from the deep, crowned at its far end by a mop of seaweed, in the process of being worn down by the waves. The biomorphic forms of Henry Moore and Jean Arp spring to mind.

Brandt had gained recognition for both his perceptive studies of English social life and his brooding landscapes before he turned his attention to the nude at the end of the 1940s. His first nude studies were made in large, next-to-empty rooms in London townhouses, where impassive young women were depicted as prisoners of a strange malaise. Later he posed his models outdoors, on the beaches of Sussex and Normandy, where they proposed a different sense of enigma. Here they were shown fragmented: an ear lying in the foreground like an abandoned tyre; a pair of hands resting like a beached walrus on the pebbles; a mass of giant entwined fingers standing sentinel… Part of the observer's thrill comes from the realization that no darkroom or postdarkroom trickery was involved in making these pictures – that is to say, parts were not cut out of photographs of bodies and glued on to landscapes. Save for the intentional distortions produced by the lens, these photographs were conceived entirely in the viewfinder. The illusion of fragmentation comes from the ingenious poses in which Brandt arranged the models, and the photographer's ground-level point of view. Creating the illusions in the camera gives the image a seamless quality that could never be achieved by collage or photomontage. And, paradoxically, this seamless 'reality' enhances our sense of mystery and evokes the realm of dreams.

Fiction

49. **Bill Brandt**
British, b. Germany, 1904–1983
Nude, East Sussex Coast
1953
Gelatin silver print

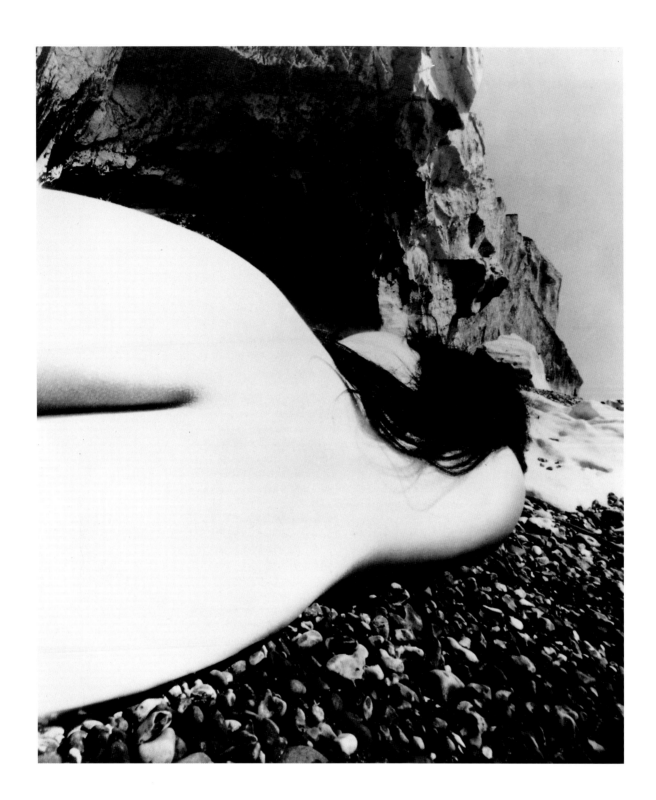

Leon Levinstein was known as 'a street photographer',
one who roams the city in search of quotidian drama. Unlike
other celebrated photographers of what has come to be
called the New York School, like Arthur Fellig (a.k.a 'Weegee
the Famous'), for whom urban drama meant murder and
mayhem, or Helen Levitt, who delighted in the world-unto-
itself of street urchins, Levinstein was primarily interested in
the human figure in physical relationship to its surroundings.
The psychological or social aspects of the situations he
observed were of much less interest to him than were modern
pictorial concerns: the human body as unwitting sculpture,
constantly transforming itself. His quest often took him to
Coney Island, the immensely popular beach-cum-fairground
where New Yorkers of every nationality flocked to escape the
oppressive heat of the metropolis in summer. There his eye
could roam unobserved, finding in simple gestures or forms
potentially compelling pictorial material. In this photograph,
a simple male back serves his purposes. The back is not
intrinsically beautiful, nor attractive because it is young and
slim, nor interesting because it is strong, and its owner is
perhaps concerned only with the trouble it increasingly
gives him as he grows older. He is almost certainly unaware
of its fascination for the stranger lurking closely behind him.
But in Levinstein's eyes, this massive, egg-shaped object has
all the monumental presence of an Easter Island statue.

Flesh

50. Leon Levinstein
 American, 1908–1988
 Coney Island
 1955
 Gelatin silver print

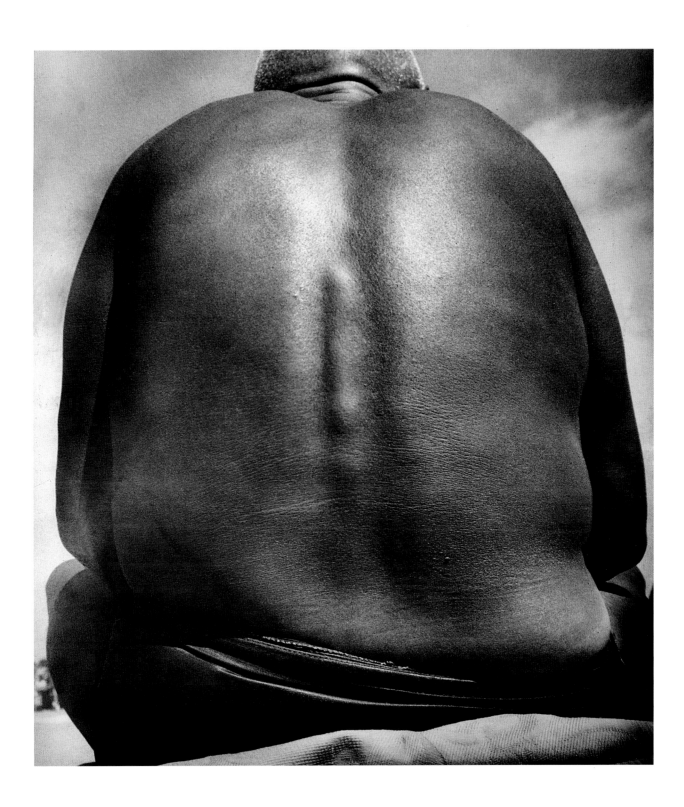

Carolee Schneemann's performances, happenings, installations and multimedia works were at the cutting edge of artistic experimentation in the 1960s. Like other artists who believed that painting had become a purely intellectual exercise, and had lost contact with the visceral and emotional aspects of human existence, Schneemann turned to her own body both as raw artistic material and useful artistic tool: canvas and brush.

Schneemann's Body Art was fundamentally feminist in nature. Her performances, sometimes in public and sometimes in private with only the camera as witness, were intimate and animal-like. *Eye Body*, which consisted of a series of black-and-white photographs, was her first Body Action, made expressly for the camera (and photographed by her friend Errò, the Icelandic artist). In 1968, in her 'Naked Action Lecture' at the Institute of Contemporary Arts in London, Schneemann dressed and undressed herself, at the same time asking questions such as 'Can an art istorian [the absence of the 'h' is intentional] be a naked woman?' 'Can she have public authority while naked and speaking?' For *Interior Scroll* in 1975, she pulled a long scroll of paper out of her vagina.

Unlike her male counterparts, who were more interested in the vulnerability of flesh, the nature of pain, and power relations, Schneemann focused on the pleasure that might be derived from the body if Westerners were to recognize their animality and accept the wisdom of other cultures with less repressive practices than their own. Over the years she has collected imagery relating to foreign cultures and is constantly comparing this iconography with that of her own performance documents. Surprised at the number of striking 'equivalences' between 'archaic configurations' and her own 'lived actions', she has concluded that her performances were unconsciously driven by the same fundamental forces that inspired other artists distant in time and place.

P o l i t i c s

51. **Carolee Schneemann**
American, b. 1939
Eye Body: 36 Transformative Actions for Camera (photograph by Errò)
1963
Gelatin silver print

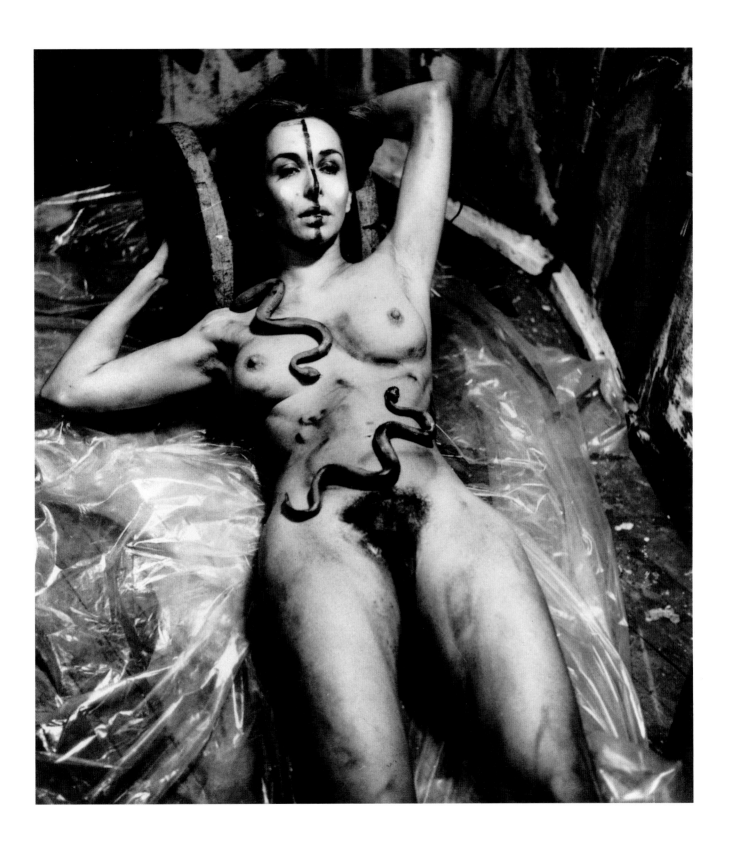

After World War II, Austrian writers and artists often adopted a position that was confrontational and shocking. In Vienna, 'Actionists' put on public performances that were intended to bring humankind's baser instincts to the surface. The Actionists, in the tradition of Viennese Expressionist painting of fifty years earlier, made works of great vehemence and even savagery. Young artists who had been trained as painters – Hermann Nitsch, Günter Brus and Otto Mühl among them – used the physical body as their preferred medium of expression, even to the extreme of 'painting' it with blood and excrement.

Rudolf Schwarzkogler joined their ranks in 1964 and participated in group action-happenings. The following year, however, he began to work in a very private manner, directing five or six (the records are unclear) photographic works he called *Actions with a Male Body (Aktion mit einem menschlichen Körper)*. Using his friend Heinz Cibulka as the 'body-object', and employing the photographers Ludwig Hoffenreich and Angelika Hausenblas to document the work, Schwarzkogler set up extremely disturbing scenarios involving dismembered and mutilated bodies. The horror his images evoke may explain the myth surrounding his early death; it is widely believed that he died as a result of successive self-amputations, including castration. In fact, he committed suicide, not by self-mutilation (which in any event was acted out by his model), but by plunging from the second-storey window of his apartment. His partner at the time, Edith Adam, has speculated that he either fell from the window (he had been disoriented and hallucinatory for some time), jumped (due to depression) or actually attempted to fly (he had become increasingly obsessed by Yves Klein's photomontage *Leap into the Void*). Given the terrors the human body held for Schwarzkogler, the idea that he might want to soar away from the earthly realm does not seem farfetched.

Expression

52.	Rudolf Schwarzkogler
	Austrian, 1940–1969
	4th Action (photograph by Angelika Hausenblas)
	1965–1966
	Gelatin silver print

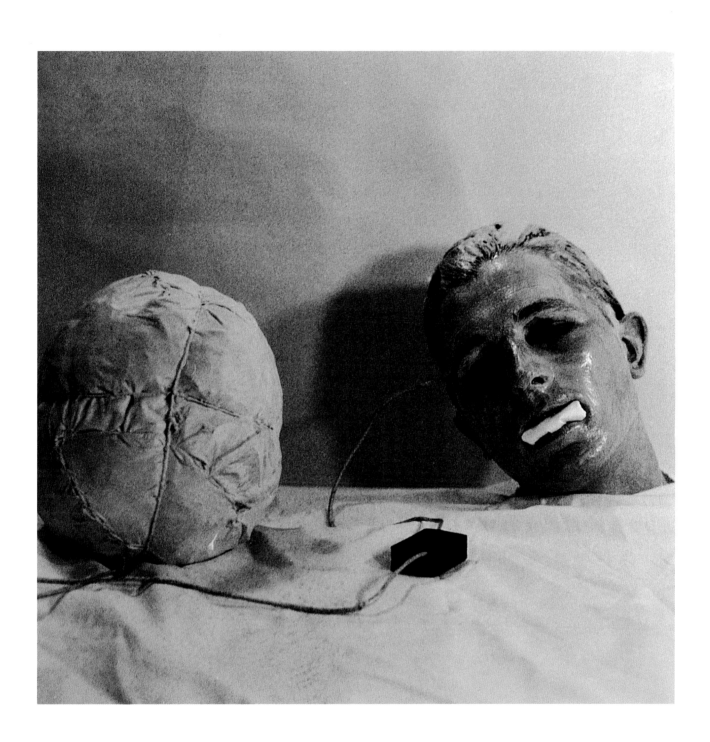

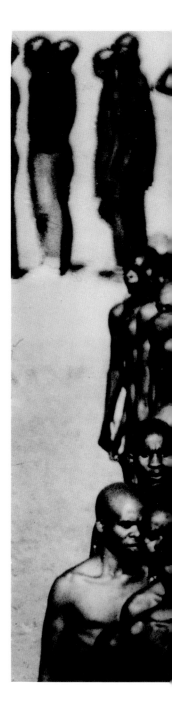

In 1958 Romano Cagnoni left his native Tuscany for London, where he trained as a photojournalist. From 1962 he travelled widely on assignment for the *Sunday Times*, *Life*, *Stern* and other major international publications. The homeless, the poor, the displaced and the desperately lonely figured prominently in his work, but he particularly excelled in his coverage of war and its effects on soldiers and civilians alike. He was the first independent Western photographer admitted to North Vietnam – where he had the distinction of photographing Ho Chi Minh – and wars in the Middle East, Biafra, Bangladesh, Afghanistan and the Falklands followed.

This image focuses on the training of recruits during the civil war in Biafra, as the province struggled to secede from Nigeria. Cagnoni looks down on the would-be warriors from a distance with a telephoto lens, which has the effect of compressing the men closer to him into a taut mass; when joined, compositionally speaking, with the frieze-like array of figures along the top of the frame, a kind of organic sculpture is suggested. The photographer evidently wished to emphasize the homogeneity of the group, as the young soldiers were stripped of individual identity and prepared for their role as cogs in the machine of war. The expression 'geometry of pain', the title of his 1984 publication, is a fitting description of Cagnoni's strong graphic style, which strikes the viewer forcibly through its bold contrasts, rhythms and borderline abstraction.

F o r m

53.

Romano Cagnoni
Italian, b. 1935
Civil War, Nigeria
1968
Gelatin silver print

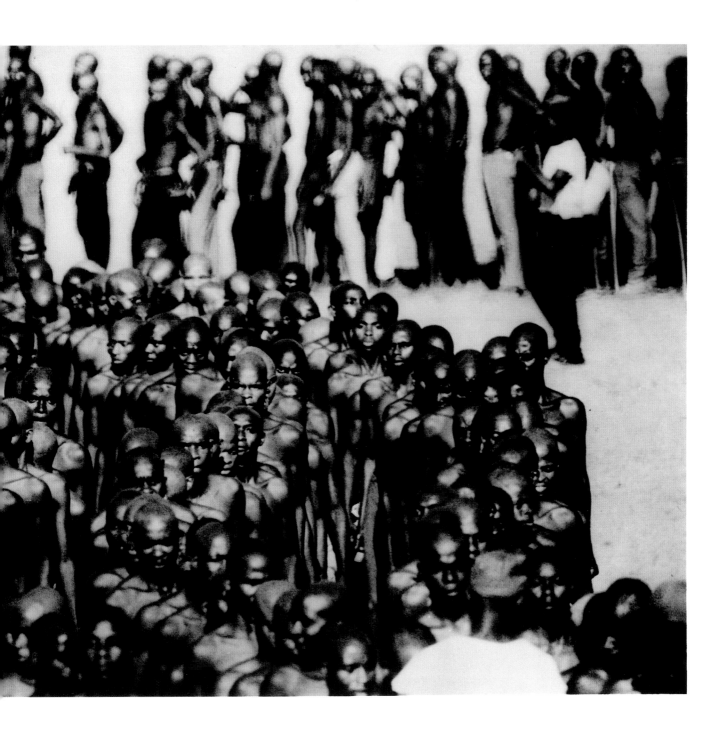

Kishin Shinoyama seems to have found in Surrealism
the inspiration for his own musings on the mysteries of the
unconscious. Although no photomontage or collage was
involved in its making, *The Birth* looks like an image extracted
from a perplexing dream, and it has something of the quality
of frozen time that is a feature of paintings by Dali and
de Chirico. Filling the sky like a great storm cloud, a huge,
birdlike woman hovers protectively over her 'newborn',
her senses attuned to danger... Further afield, naked bodies
– only one of which is clearly a woman – dot the sand, all
looking in different directions as if in anticipation of some
imminent and significant event. Naked before nature,
Shinoyama's figures appear as vulnerable and isolated
as any other creatures to be found in the animal kingdom –
powerless, it seems, to come together in mutual support.

This, of course, is only one hypothesis; alternatively,
the image may represent the same woman (though clearly
four models were involved) at various moments of the day
– awake, asleep, immobile, on the move – a kind of multiple
exposure. Perhaps multiple readings are Shinoyama's
intention. However the picture is interpreted, one can only
admire the graphic eloquence with which the photographer
skilfully blends reality and fiction.

Fiction

54. **Kishin Shinoyama**
Japanese, b. 1940
The Birth
1968
Gelatin silver print

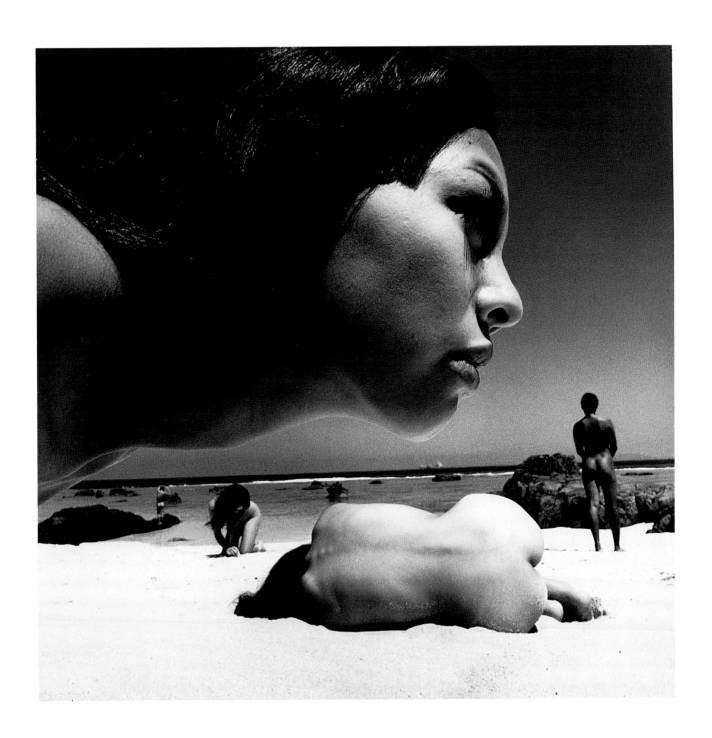

While some photographers treat the single image as a world unto itself, others feel the need to express their ideas in multiple imagery. Duane Michals uses photographic sequences, which allow narratives to be developed, sometimes accompanied by words. His stories take varied forms – sometimes jokes, sometimes parables, sometimes poems. In *The Spirit Leaves the Body*, we observe the 'soul' of a dead person as it rises up from the corpse and calmly departs. Though a ghostly form, the soul – we note with some relief – is still very human in appearance, and apparently subject to the same laws of gravity that bound its former shell to earth. The spirit of Eternal Youth, it leaves behind the body of Old Age. And, as it departs, it gradually expands to fill the frame, all the while dissolving and, by implication, expanding infinitely once beyond the frame. The images evoke the old 'spirit photographs' so expertly conjured up by nineteenth-century quacks, and at the same time playfully poke a finger in the eye of die-hard realists who continue to believe that photography can only document what can be seen by human vision. Perhaps more than any other photographer of the second half of the twentieth century, Duane Michals has championed the role of poetry and play in photographic practice.

F i c t i o n

55. **Duane Michals**
American, b. 1932
The Spirit Leaves the Body
1968
Gelatin silver prints

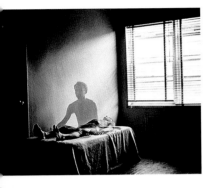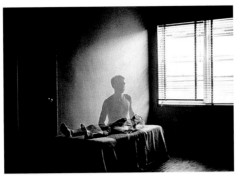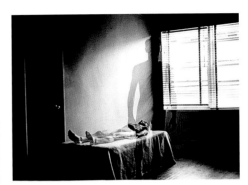

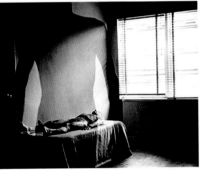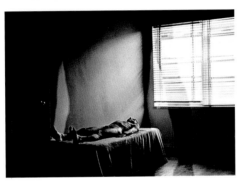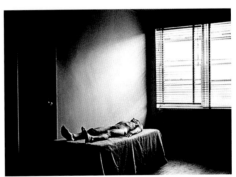

Valie Export was a Viennese artist of the post-Actionist period whose guerrilla-style performances were among the first feminist 'actions' to take place in Europe. If the word terrorism can be applied to art, Export's performances would qualify for the term. Her intention was to provoke violent reactions from her public, by which she meant people in the street, rather than the sophisticated art crowd. The point of departure for several of her works was a denunciation of both conventional sexual morality and the objectification of women's bodies.

Here we see the artist posing after one such 'action' carried out in an X-rated Munich cinema. She had entered the auditorium carrying a machine gun, and wearing pants that left her crotch entirely exposed. Having announced to the audience that 'real', off-screen genitalia were available, she invited them to do whatever they desired with them. She then moved along each row, pointing the gun at the heads of the people in the row behind. Each row, she noted, got up silently and left the cinema as she moved on to the next. She observed that when genitalia were divorced from the context of pornographic film, the audience connected with them in an entirely different way.

Given that the gun is usually thought of as the phallic symbol *par excellence*, the association of female genitalia with such a weapon is highly provocative. Export continued to use such symbols in performance despite the evident danger to her own person because she saw that they provoked many deep-seated fears and prejudices. Though the photograph shown here is all that remains of her bold act, it still retains its power to shock.

Politics

56.

Valie Export
Austrian, b. 1940
Action Pants: Genital Panic
1969
Gelatin silver print

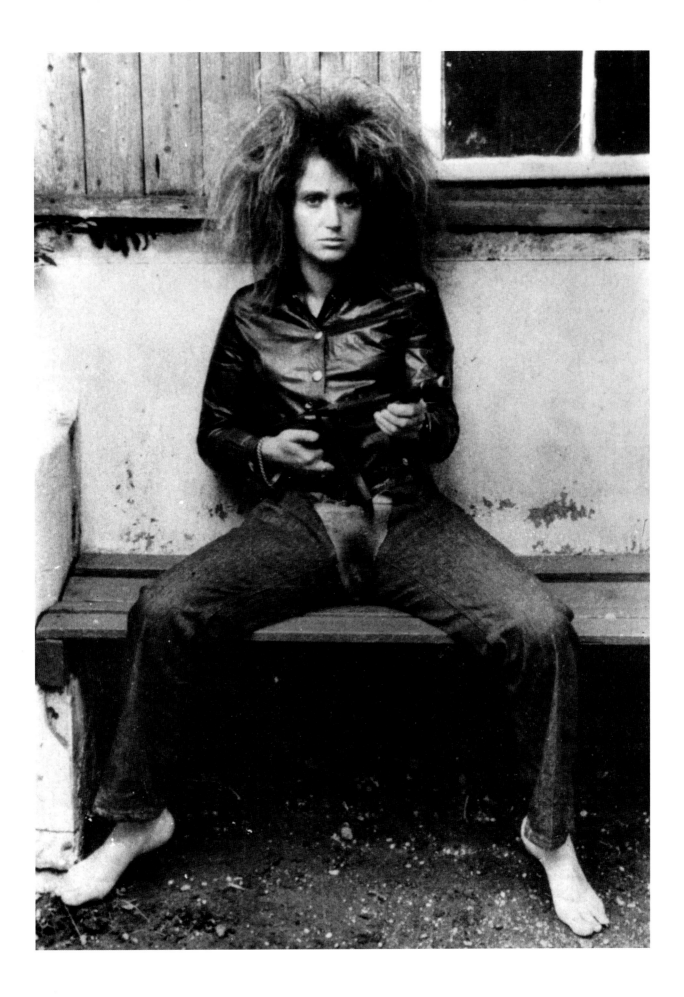

This almost unbearable image is a record of twofold suffering: a sick, exhausted Nigerian child leans against a wall in a camp where he, with hundreds of other children, is dying of hunger. The boy holds an empty can. The cross he has to bear, we are reminded by Don McCullin's caption, is all the heavier because of his pale skin; as an albino, he is shunned by his fellows. The civil war caused by Biafra's attempt to secede affected McCullin profoundly. Initially sympathetic to the province's goals, he gradually lost faith in the rebels' cause as the magnitude of their own brutality became apparent. McCullin had begun his career as a war photographer believing that his prime responsibility was to cover what happened to soldiers, but his experiences with the civil wars in Cyprus and Nigeria made him realize that the most significant stories involved the suffering of civilians, the innocent men, women and children caught up in violence. This photographer's great gift was to be able to make pictures whose 'beauty', or aesthetic – difficult terms to use in the circumstances but valid nonetheless – draws the viewer into the image before the true horror makes itself apparent; the strengths of *form*, in other words, guard against an otherwise overpowering *content*. McCullin, wounded twice while on assignment, no longer practises war photography, and observes – with some irony – that his photojournalism is much in demand by museum curators and book publishers at a time when magazine editors are holding back on serious stories. 'Lifestyle' and celebrity features are, he notes, what the public craves, and except for the occasional sensational image of suffering, extensive war coverage finds few outlets.

P a i n

57.

Don McCullin
British, b. 1935
Albino Boy in a Camp of 900 Dying Children,
Biafra, Nigeria
1969
Gelatin silver print

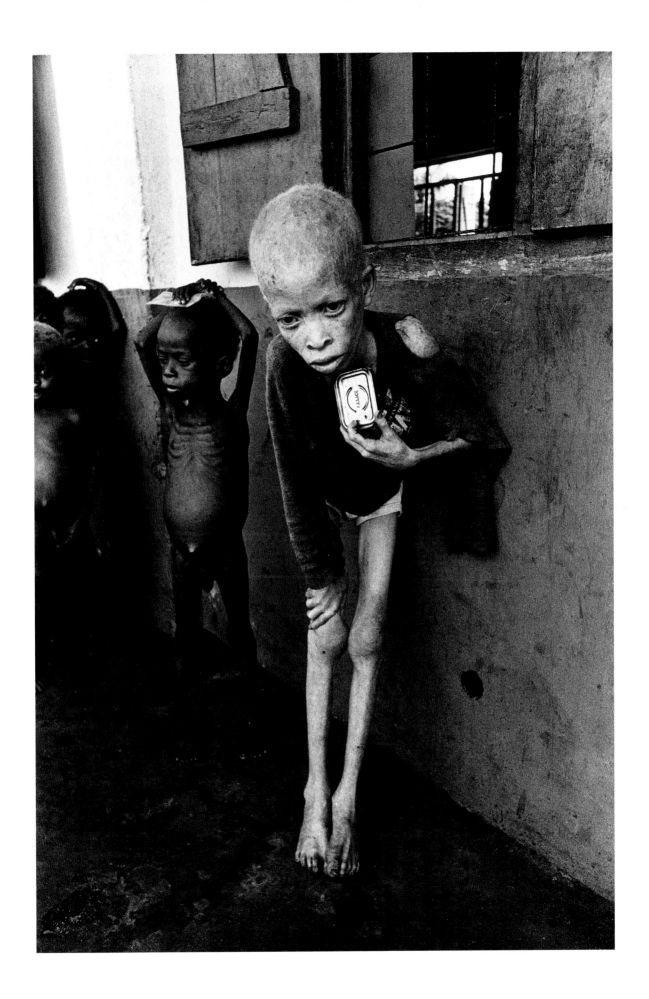

This anti-Vietnam-War poster was published two years after the massacre at My Lai on 16 March 1968, when over 400 villagers – old men, women and children – were killed in cold blood by a battalion of the United States Army, under the command of Lieutenant William Calley. Ron Ridenhour, a GI who had heard about the massacre from other soldiers, wrote to Congress that something 'dark and bloody' had taken place in this small village. The inquiry carried out by the Government of South Vietnam concluded that the attack was an 'act of war' and a propaganda operation by the enemy. But the army photographer Ronald L. Haeberle had been on the spot and in December 1969 he released his photographs to a Melbourne newspaper which opposed the sending of Australian troops into the conflict. The report that accompanied the images described how a baby, shown in this photograph wearing just a shirt, had crawled back to its dead mother across a pile of corpses, and had taken her hand. At that moment a GI knelt down, aimed at the child and shot it.

When a soldier who had been present at the massacre said later in a television interview that Calley had ordered all the villagers to be killed, the interviewer asked: 'Men, women and children?' 'Men, women and children,' came the reply. 'And babies?', asked the interviewer. 'And babies,' answered the GI. It is from this exchange that the poster's laconic but extremely powerful title derives. Some photographs have enormous ideological power. Combined with text relating to the circumstances in which a photograph was taken (as is the case with this poster produced in 1970 by the Art Workers' Coalition), such images become a formidable instrument of persuasion.

Politics

58. **Ronald L. Haeberle / The Art Workers' Coalition**
Q: And babies? A: And babies.
1970
Colour offset lithograph from
chromogenic print

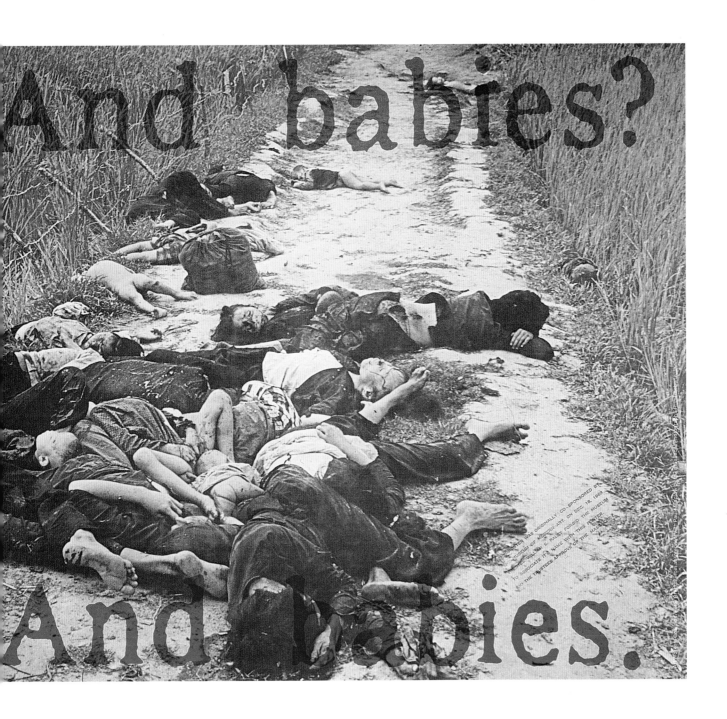

For some artists, treating the human body as a subject engaged in a variety of fantasies and provocative actions is a way of overcoming the restrictions of sexual identity. Between 1960 and his suicide in 1976, Pierre Molinier created an astonishing repertoire exclusively devoted to games of self-representation. At a time when self-portraits of photographers had become ubiquitous – in fact, such portraits began to be made as early as the 1840s – Molinier's took an unusual approach in which the artist, through a meticulous process of photomontage, tried to erase his 'given' appearance and sex and replace it with a female *alter ego*. In this elaborate *mise en scène*, he has employed different poses in front of the lens. His face is made up and his body fetishized. He wears the stereotypical paraphernalia of femininity: suspenders, fishnet stockings and high heels. This is a seductive, orgiastic image: the crown of feet and legs reveals here and there the face of Molinier – man and woman, or, rather, neither man nor woman. In their play on the codes of sexuality, Molinier's pictures reflect the fascination with cross-dressing that took root in art in the 1970s.

146

Desire

59.

Pierre Molinier
French, 1900–1976
La Grande Mêlée
c. 1970
Gelatin silver print

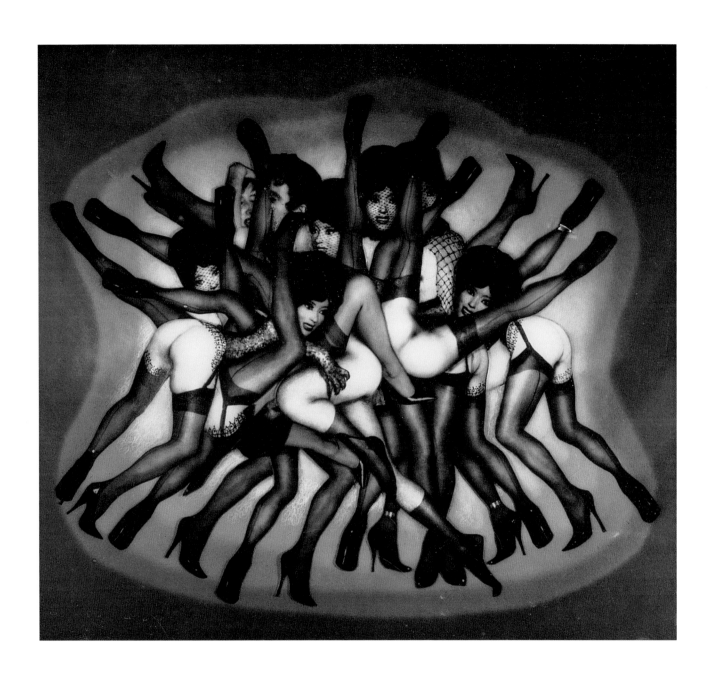

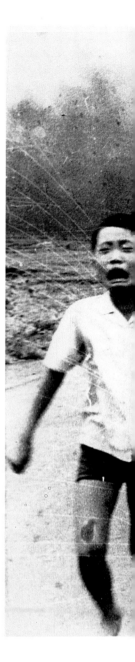

Nick Ut, who was born in the Mekong Delta, Vietnam, has been a photographer with Associated Press (AP) since 1965. He followed in the footsteps of his elder brother, who was killed covering a military operation. Ut won a Pulitzer prize for this tragic picture of Phan Thi Kim Phuc, aged nine, running away in terror after a napalm attack. In a period of apparent calm, on Route No. 1, at Trang Bang, to the north-west of Saigon, bombers had suddenly appeared in the sky. Within a few seconds the drama unfolded – there was barely enough time to take three startling images: the bombs being dropped, the fiery explosion and the civilian victims fleeing. Kim Phuc had ripped off her burning clothes and her vulnerable nakedness makes her distress all the more harrowing. The photograph is particularly powerful because Ut has chosen to position her alone in the centre of the frame. All the children seem fragile in comparison to the soldiers in their helmets and army uniforms. Nick Ut relates how he rushed to help the girl and took her to the nearest hospital in the AP van, along with many other civilian and military victims. Still reeling from the shock, but perfectly conscious that it was the right thing to do, he immediately transmitted his pictures to his agency. This photograph, which appeared on the front pages of almost every major international newspaper and magazine, is now seen as one of the most emblematic images of the physical violence inflicted on Vietnam.

148

Pain

60.

Nick Ut (Ut Cong Huynh)
Vietnamese, b. 1951
Napalm Bomb Attack, Vietnam
1972
Gelatin silver print

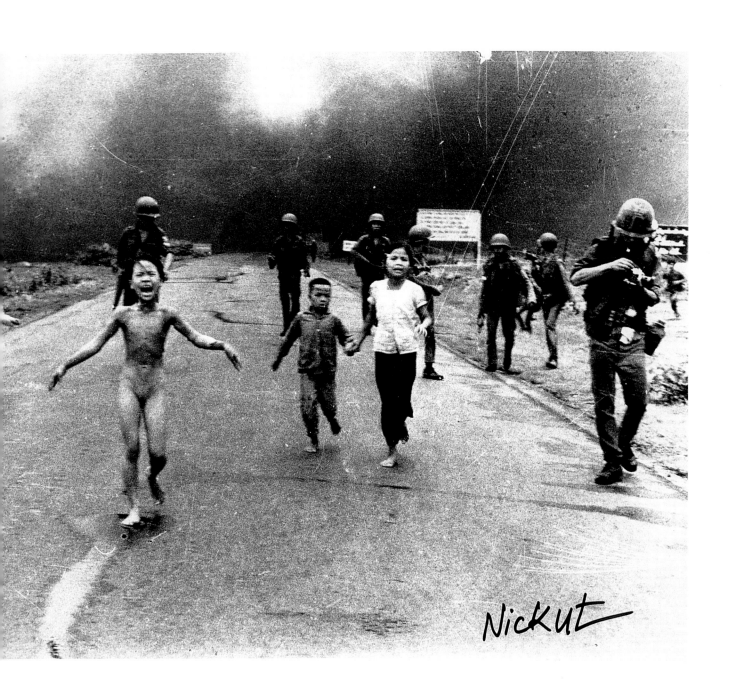

When the work of Henriette Grindat, a twenty-six-year-old
Swiss photographer living in Paris, came to the attention
of Man Ray in 1949, he was sufficiently impressed by her
Surrealist leanings to arrange for her to exhibit at La Hune,
the celebrated Parisian bookstore. Thereafter her work
appeared often in important international photographic and
cultural magazines such as *Du, Arts et métiers graphiques* and
US Camera. Grindat soon discovered a taste for collaborative
work with writers, and her photographs accompanied many
important publications in France and Switzerland. Albert
Camus and René Char admired her vision enough to ask her
to submit photographs which would inspire their own texts.
The result of their collaboration, *La Postérité du soleil*, was
published in 1965.

The fragmented nudes of Bill Brandt, with their unusual
and lyrical distortions, came as a revelation to Grindat, and
in the 1970s the body became her principal theme. She made
numerous female nudes and was especially intrigued by the
'naturally' deformed bodies of pregnant women, which she
liked sometimes to depict as fruit. She had already taken
many photographs involving the fragmentation of the body
by the time she turned her attentions to her husband, the
painter and printmaker Albert Yersin. Grindat obviously felt
him as a powerful physical presence, often depicting his
physiognomy in fragments which suggest the forms and
features of landscape. Here Yersin's head appears as a great
weatherbeaten block; its ear, given great prominence, suggests
an antenna which is acutely sensitive to the sounds of the
world. Situated between sculpture and photography, the
portrait is also proof of the intimacy bonding photographer
and model; after Yersin's death, one year later to the day,
Grindat would take her own life.

150

F l e s h

61. **Henriette Grindat**
 Swiss, 1923–1986
 Yersin. Study
 1972
 Gelatin silver print

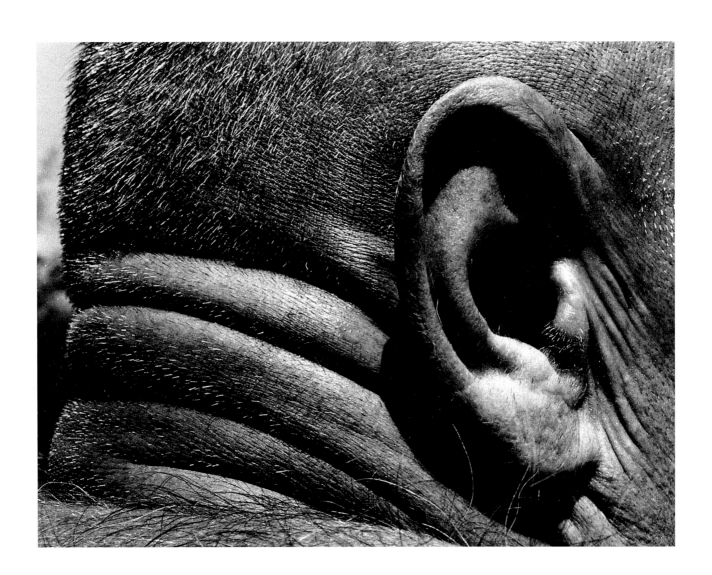

In 1965 the influential American illustrated magazine *Life* lived up to its name with a series of spectacular photographs of a kind never seen before. Taken by Lennart Nilsson, a photojournalist-turned-medical-photographer, the photographs showed a human foetus in utero at different stages of development. Nilsson's photographs were the fruit of four years of research involving endoscopic photography, by which a fibre-optic tube carried the image back to a camera outside the mother's body. Over the following years the photographer would continue to refine and add to this archive.

Although the photographs were presented in the magazine in the context of scientific enquiry, they could not help but evoke a sense of the miraculous nature of life and its beginnings. Not only was a key stage unveiled for the first time, but the drama of the presentation – the foetus in its complex craft, floating, as it were, in deep space – sparked thoughts about the individual human being in relation to the cosmos. Space was much on people's minds at the time, as the superpowers battled for its 'conquest', and worldwide interest in Nilsson's images reflected this growing excitement about humanity's impending voyage into the unknown. But Nilsson's imagery had more concrete political implications as well: the tiny beings launched on their trajectories towards the light of day were bound to colour the issue of abortion. The unborn had been given a face, and these images would fuel debates as to exactly when human life could be said to begin.

M i c r o c o s m

62.

Lennart Nilsson
Swedish, b. 1922
A Human Foetus at Three Months
1973
Chromogenic print

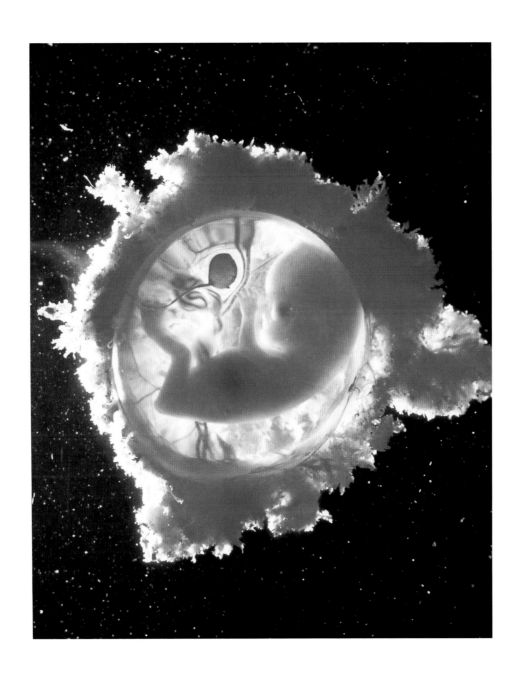

An old man, in evident decline, slides inexorably towards death, and the unrelenting eye of the camera follows every step. Pain permeates the process: we feel it in the clinical settings, devoid of all sentimentality; we sense it in the jerking, cinematic rhythm of the individual frames; we confirm it in the anguished facial expressions. If the viewer finds difficulty in witnessing, in such terrifying proximity, the demise of Jacob Israel Avedon, we can only imagine how his celebrated photographer son must have felt as he looked through the lens and charted the final stages of his father's journey. Perhaps only the painter Ferdinand Hodler has left us with a comparable series depicting a loved one's last passage, as his mistress Valentine Godé-Darel wasted away with cancer. Richard Avedon's forthright portraits mark a subtle shift in the direction of twentieth-century photography: less and less would photographers be content to idealize youth and flawless flesh; more and more would the focus shift to the sad realities of age and infirmity.

Gaze

63.

Richard Avedon
American, b. 1923
Jacob Israel Avedon, Sarasota, Florida
1969–1973
Gelatin silver prints

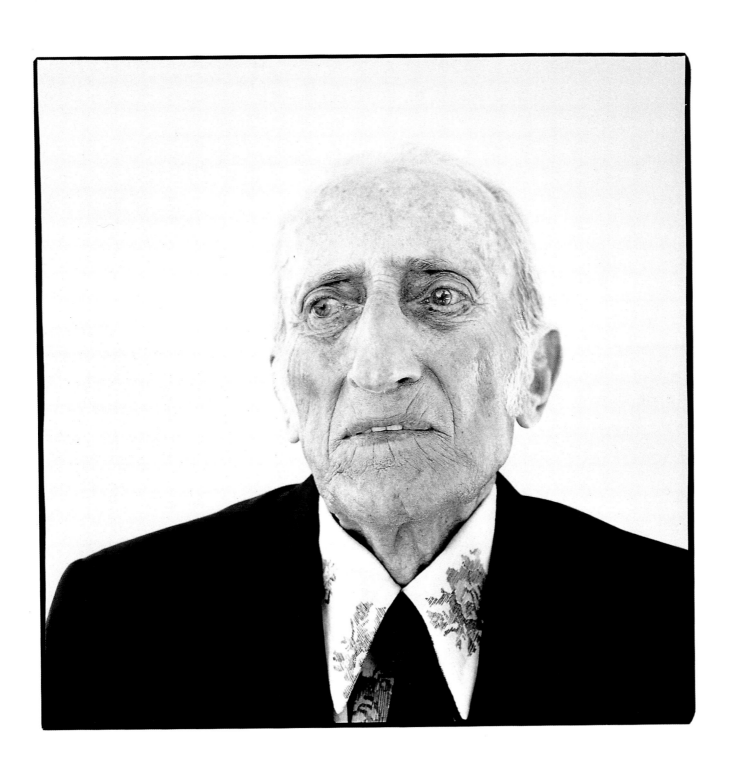

The 1960s and 1970s were decades of revolt and violence in Western societies. Artists did not escape the ferment, nor did they wish to. Of those who took on the challenge of critiquing society in a fundamental way, the men and women who used their own bodies to express their ideas left a decided mark on twentieth-century art history (and arguably on the larger context of political history as well). 'Body artists', as they are generally called, felt compelled to use extreme measures: whipping, slashing and mutilating the flesh, imprisoning themselves, depriving themselves of basic necessities and putting their lives at risk by challenging their audiences to react strongly to their provocative actions. Damage could be real or simulated. Part of the struggle was to force a radical rethinking of the idea of 'body', part was to oppose those forces in the artworld which had allowed art to be dominated, even obsessed, by the market. The artists' own flesh replaced canvas and stone.

Chris Burden was one of the earliest and most radical of these performance artists – had he not crawled across a floor of broken glass, lain tied up inside a canvas bag in the middle of a busy street, and had himself shot in the arm? Burden developed a strategy of documentation whereby a single photograph accompanied by a single paragraph would suffice for the art-historical record. In *Trans-fixed* he has allowed himself to be crucified, a nail through each palm, on the roof of a Volkswagen Beetle, with the motor running at sufficiently high speed to drown out his screams. Self-sacrifice on the altar of a consumerist society? Ironically, Burden's pain would be turned to profit by the art market: it is said that the nails he used were shortly afterwards put on sale by a New York gallery.

Expression

64. **Chris Burden**
 American, b. 1946
 Trans-fixed
 1974
 Gelatin silver print

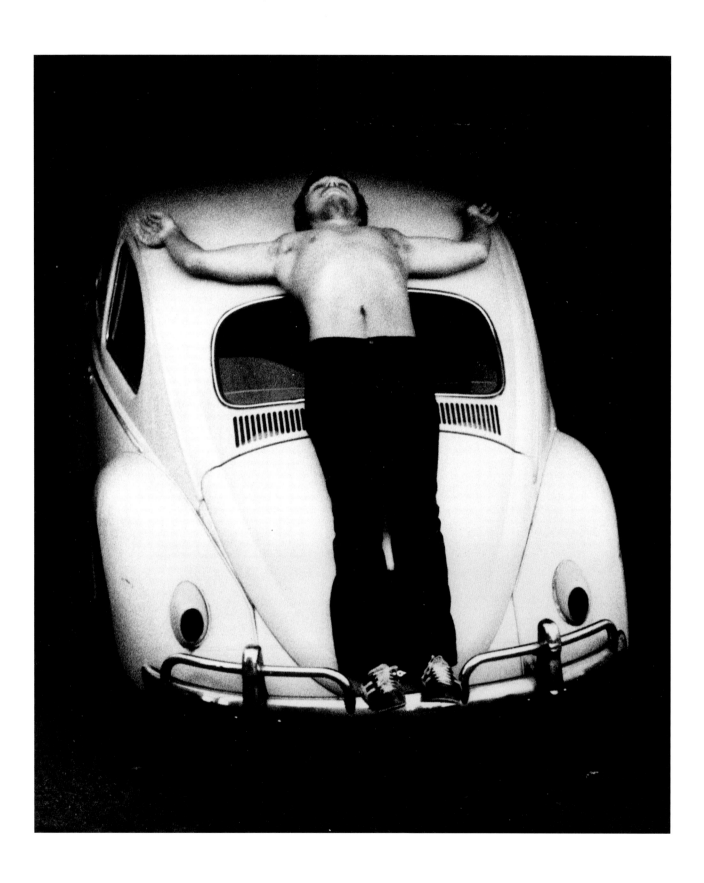

A hand semaphores through a sequence of signs: we learn from Dieter Appelt's caption that the hand is counting from one to ten in the language of the Masai people. The logic of the system seems simple enough to grasp, and we can only admire its elegance and economy. Coated in paint or ochre or mud, and with mummy-like wrappings, the hand seems to have broken through the soil to convey its information. One can imagine such a hand, thousands of years old, leaving its painted imprint on Australian rock faces. Nostalgia for the far-distant human past is not, however, Appelt's aim. A careful look at the background shows that the hand is in reality rooted in the very contemporary confines of a studio. It is Appelt's own hand we see in the photographs, just as it is his body in whole or in part that is the principal actor in all his work. Here, by means of the rich metaphor of sediment, Appelt suggests that the origins of human communication are unspeakably remote, measured according to geological time, and inseparable from the dust from which the body emerges and to which it will return.

Expression

65. **Dieter Appelt**
German, b. 1935
The Counting System of the Masai
1977
Gelatin silver prints

Leonard Freed is a prolific and peripatetic photojournalist who has often tackled such complex subjects as violence and racism. Like many of his distinguished colleagues in the cooperative agency Magnum, Freed believes that educating the public about social injustice is an important mission. In 1980 he published *Police Work*, which documented the activities of the New York police force, taking a dispassionate look at violent behaviour on both sides of the law, and implicitly questioning society's institutions of authority.

This image shows a young man who has been tightly handcuffed and put into the back of a police car. It is a complex picture offering multiple readings. We know that an adult male has been apprehended, but we know neither his name nor the reason why he is handcuffed. A serious crime or a relatively insignificant disturbance of the peace? The man's naked torso suggests something of the latter: a hot summer night, flared tempers, perhaps a fight... Whatever the *facts* of the moment (and we know even eyewitnesses can give conflicting accounts), we are struck by the eloquence of the form: were it not for the handcuffs, we might take the image for a beautifully modelled urban nude. This is the paradox of photographs, whose meanings often slip out of our grasp when we attempt too neat a categorization.

P a i n

66. **Leonard Freed**
American, b. 1929
In a Police Car, New York
1978
Gelatin silver print

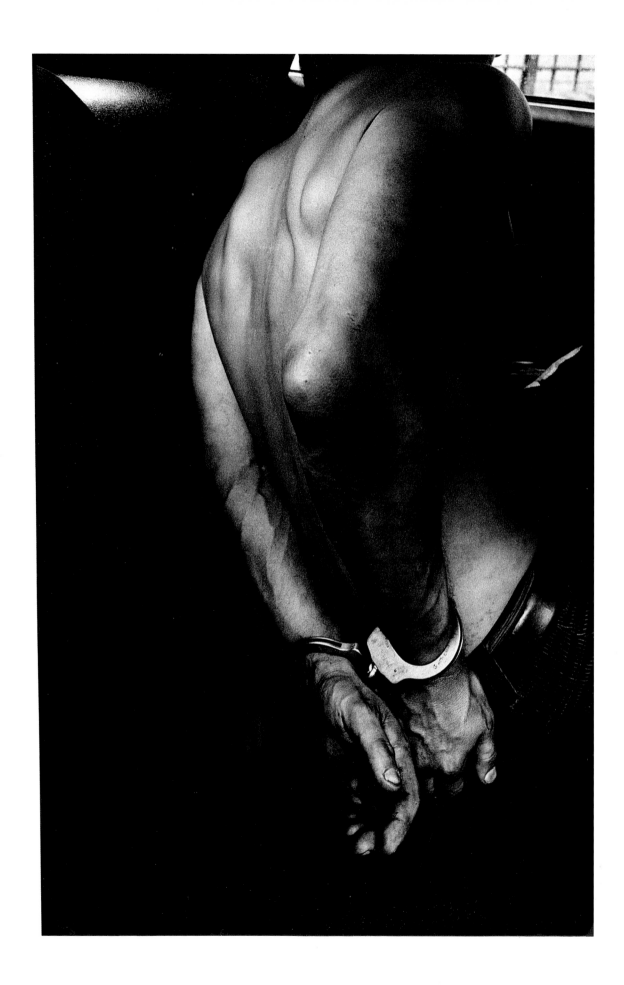

Even before tattoos and piercings became fashionable among young people in the 1990s, they had enjoyed a long history in decoration of the body. They often function as marks of membership for various groups – subcultures alienated from mainstream society by conviction, lifestyle or exclusion. The tattoo has always been particularly popular with sailors, but homosexuals too have used this highly expressive body language (sometimes accompanied by piercings) as a form of resistance to their culturally imposed marginality. Charles Gatewood's framing of the proudly flamboyant *Sailor Sid* conjures up a night-time world of private clubs where outrageousness and licentiousness are celebrated and encouraged. 'Sailor Sid' was an American tattoo and piercing enthusiast whose genital piercings eventually became so numerous that they set off metal detectors at airport security. Gatewood has long been fascinated by deviant behaviour and the grotesque – his interest in the tattoo found expression in a number of books, including *Pushing Ink: The Fine Art of Tattooing* and *Tattooed Women*.

Expression

67. **Charles Gatewood**
American, b. 1942
Sailor Sid
1978
Gelatin silver print

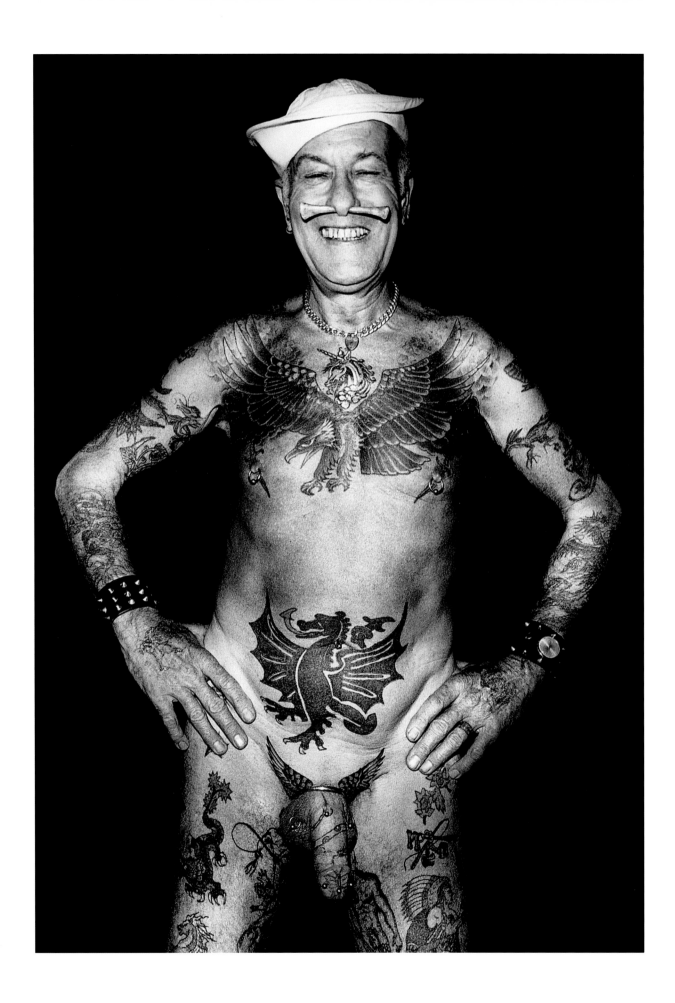

The transvestite is a traveller in his or her own body, the form and gender of which can be changed according to mood or need. But the transvestite does not necessarily try to imitate perfectly the opposite sex; the transformation is, rather, an act which manipulates the signs of femininity or masculinity in a clearly theatrical manner. The differences between men and women are far less pronounced than most of us admit (we all know that hair alone can confuse a gender reading at a distance). The transvestite plays with this subtle ambiguity. The face, which is the site *par excellence* of a person's individuality, is erased of its conventional (that is, given) sexual character and fashioned into a mask. Andy Warhol, by nature a showman and actor, offers in this self-portrait yet another variation of his chameleon-like self-image. A master of the provocative action, and fascinated by changes of identity and their manner of presentation, he poses in front of the lens in wig and full make-up. Like other practitioners of Pop Art, Warhol based much of his imagery on newspaper and magazine photographs of glamorous movie stars. Dressed here in high Hollywood style, he nevertheless uses a simple, unpretentious camera to create a sham portrait. The use of the Polaroid medium, moreover, was not incidental: with its instant gratification, it was perfectly in keeping with Warhol's view of the world.

Expression

68. **Andy Warhol**
American, 1928–1987
Self-Portrait in Drag
1979
Polaroid print

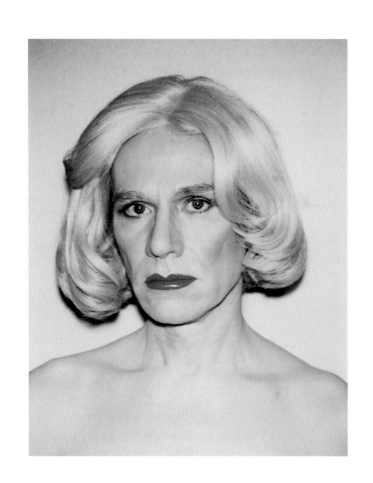

What could be more of a cliché in the visual language of seduction than a half-undressed young woman in a lascivious reclining pose? A *femme fatale*, rendered prisoner as much by her own gaze as by those of her countless invisible observers. She is but an image, existing only in the eyes of those voyeurs. Cindy Sherman launched a spectacular career as an artist with these *Untitled Film Stills* (the films themselves exist only in the artist's imagination). She realized how effectively, indeed indelibly, photography – in its widest sense of both still and moving pictures – had etched onto the public consciousness a series of archetypal women: the vamp, the small-town girl running away from home, the Hollywood starlet, the domestic drudge, and so on. Acting out the stereotypical roles one by one, mimicking the clothing, poses and gestures associated with each, and placing her *alter egos* in credible settings, Sherman accomplished two aims: a biting critique of the conventional codes of representation, demonstrating that notions of femininity, sexual attractiveness, beauty and the like are fundamentally cultural constructs; and a cautionary tale about the silver screen's tremendous seductive powers, feeding what Jean Baudrillard has called 'our immense collective narcissism'.

Politics

69. **Cindy Sherman**
American, b. 1954
Untitled Film Still No. 34
1979
Gelatin silver print

Since the mid-1960s, Ralph Gibson has been honing a personal, intensely lyrical style of photography which reduces to their essentials his quotidian yet visually complex experiences. Gibson subscribes to the school of photography that thinks that a fine photograph is *taken* in the world but *made* in the darkroom. A great believer in the art of fine printing, he brings to his imagery a love of subtle darkroom alchemy. *The Seagull* (a name Gibson has only recently chosen to give this image) is a fine example of this creed. On the one hand, it is a token of love (the woman is his wife), relating an intensely felt moment of pleasure (the couple were enjoying their very last sundrenched hour of vacation, having just finished a superb meal at 'The Seagull' restaurant). On the other, it is an occasion for which the physical setting has allowed a marvellous conjuncture of geometric elements which Gibson has transcribed fluently into photographic syntax: forms, lines, sharp contrasts and subtly orchestrated shades of grey. The whole forms a pleasing abstract canvas without sacrificing its depiction – indeed, its commemoration – of a very real event.

Form

70. **Ralph Gibson**
 American, b. 1939
 The Seagull
 1980
 Gelatin silver print

A key figure in the world of fashion photography since
the 1960s, Helmut Newton has established an international
reputation for a style featuring Amazonian women of such
haughty detachment and erotic ennui as to suggest that a
surfeit of luxury and indulgence could all but extinguish
the spark of life. For Newton's models, who are often posed
like actors in melodramas involving the rich and famous,
clothes of the finest quality are taken for granted – a natural
consequence of power, class and money. Pleasure does not
seem to enter the equation. *Sie kommen, Naked & Dressed*
evokes a specific fashion-world motif – the catwalk – though
Newton is careful to let us in on the artifice: those edges,
showing the cardboard background and its mechanism,
inform us that we are in fact in the studio. The four models
move with martial step towards the camera – naked or
dressed, it's all the same to them: they are neither proud
of their perfectly groomed bodies nor embarrassed by them.
Newton seems to have been suggesting that as we marched
towards the twenty-first century, perfection of the physical
body and its material coverings was assumed, though
perhaps at the price of greater spiritual malaise.

Icon

71. **Helmut Newton**
 Australian, b. Germany, 1920
 Sie kommen, Naked & Dressed, Paris
 1981
 Gelatin silver prints

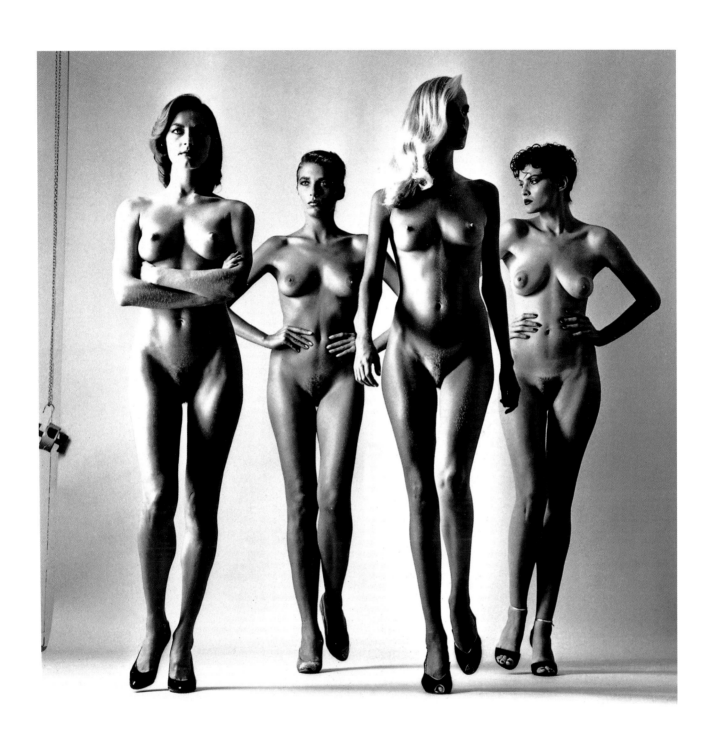

In the early 1980s the American photographer Robert Mapplethorpe burst upon the New York art scene with a persuasive style that combined a potent sexuality – often, but not exclusively, homoerotic – with a formal, geometric elegance which owed much to the great tradition of the nude as practised by Edward Weston and George Platt Lynes. His beautifully lit male and female bodies, their genitals prominently displayed, made few concessions to bourgeois convention, but the superb compositions and the exquisite modelling of the figures convinced most observers, despite vehement attacks, either that the label 'pornography' was ill-founded, or that the very definition of the word would have to be revised. Part of Mapplethorpe's genius was to express his often outrageous subject matter in the eloquent language of classicism, and since classicism has traditionally taken pains to neutralize eroticism, this strategy had substantial shock value.

Mapplethorpe made many pictures of the body-building champion Lisa Lyon, enough, indeed, to fill an entire book: *Lady, Lisa Lyon* (1983). We sense that the photographs were very much a collaborative enterprise, with Lyon acting out a range of stereotypes – the vamp, the starlet and so on – which featured her powerfully muscled body either whole or in part (fragments included her navel, a bicep, her pubis). Both Lyon and Mapplethorpe seem to have shared the view that her body was a finely sculpted work of art. In this 1982 image, the powerfully tensed, muscular arm and hands and the rounded breasts are the photographer's primary focus, but he has been careful to accentuate the contours of the arm by contrasting them with the dark fabric of her costume. The rhythmically curved parts of her body are then formatted geometrically: the perfect right angle formed by her bent arm is juxtaposed with the strong, triangular, throne-like element behind her. Meanwhile, enough of Lyon's face is shown to suggest her pride and determination, but not enough to distract the viewer's eye from the body. Much is made of the flower: a conventional symbol of decorous femininity, it serves only to highlight the very *un*conventional femininity that is championed here.

Icon

72. **Robert Mapplethorpe**
 American, 1946–1989
 Lisa Lyon
 1982
 Gelatin silver print

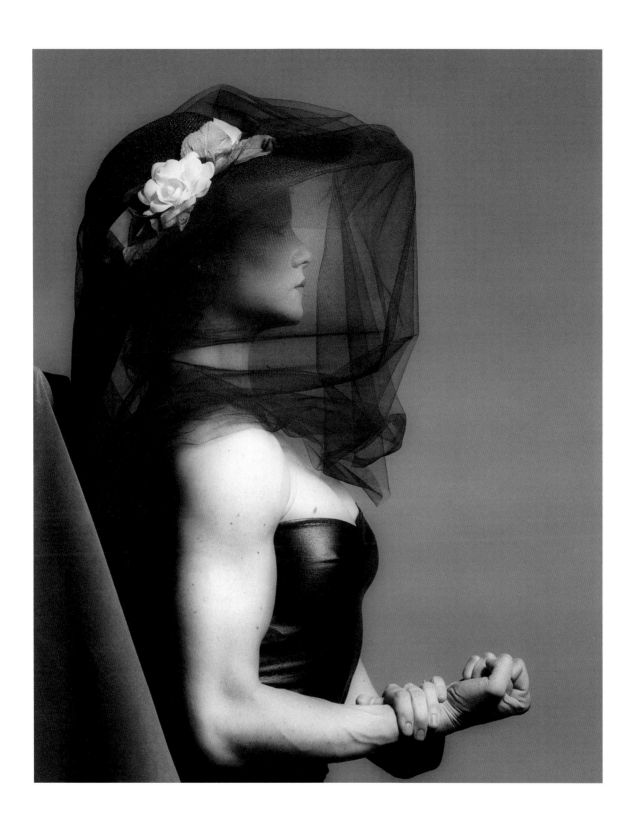

The portrait has been profoundly critiqued by the American artist Nancy Burson since the 1970s. Indeed, Burson proves that art can be made out of someone else's photographs. Her work, moreover, stands apart from the mainstream because of her pioneering use of the computer in fabricating portraits that contain both real and fictive elements. *Warhead I* is such a work, complex in both concept and technique. Burson began by collecting portraits of the leaders of those countries which owned nuclear weapons (and, by implication, the capacity to end human life on earth): Ronald Reagan, Leonid Brezhnev, Margaret Thatcher, François Mitterrand and Deng Xiaoping. Each 'found' portrait was scanned into the computer and equalized in terms of size. They were then placed one on top of the other with the eyes aligned as carefully as possible. Because the outlines of the heads differed to some degree, an average was taken, and the faces were then warped (morphed, in today's parlance) to fit this average shape. (The thinner faces were, in effect, stretched, and the wider ones narrowed.) The five faces were then once again superimposed on one another, but this time the visual information was weighted according to the number of deployable nuclear arms under each leader's control. (It is interesting to note that the combined arsenals of Thatcher, Mitterrand and Deng accounted for less than 1 percent, while Reagan's and Brezhnev's weighed in at slightly less than 55 percent and 45 percent respectively.) In this battle for supremacy of the image, Brezhnev and Reagan triumphed, just as they had come out on top in the stockpiling of weapons of mass destruction. Burson was producing her particular brand of 'cyborgs' years before the implications of computer-manipulated imagery had become clear to photographers, and her discerning use of the computer has been cited by a number of younger artists as a model and an inspiration.

Politics

73.

Nancy Burson
American, b. 1948
With David Kramlich and Richard Carling
Warhead I (Computer generated composite)
1982
Gelatin silver print

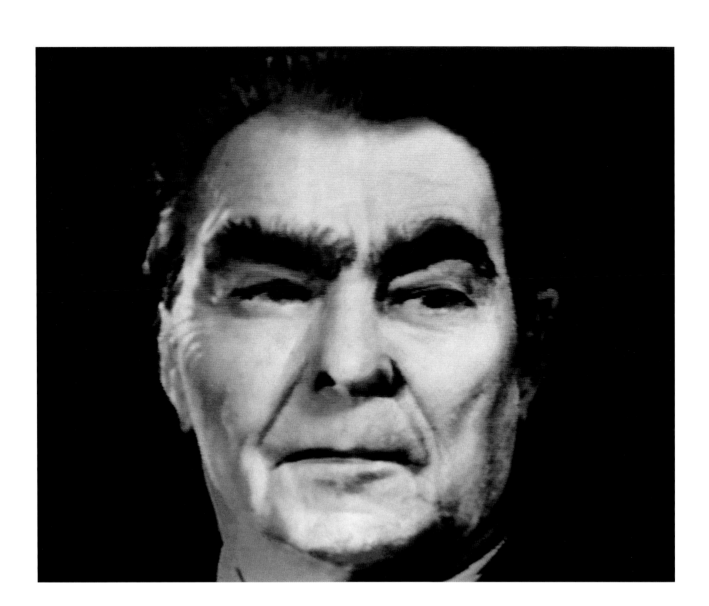

Lee Friedlander is generally associated with a novel
approach to photography that made itself known through
a landmark exhibition called 'New Documents', held at New
York's Museum of Modern Art in 1967. Despite the use of the
term 'document', the work of Friedlander, Garry Winogrand
and Diane Arbus represented a position that was poles
apart from the earnest, reform-minded practice that would
a few years later be labelled 'concerned photography'. The
newsworthy events that attracted photojournalists and
the dire social conditions that engaged documentary
photographers were of absolutely no interest to Friedlander
and his friends, who merely professed a desire to see the
world as it was, with a minimum of preconception; their
'subject' has always been photographic vision itself.
Friedlander has created an oeuvre of great breadth, in which
the motif of the human body appears in the context of
cityscapes, work situations, portraits and of course nudes.
Needless to say, Friedlander's 'body language' is observant,
dispassionate and original. Self-portraits, often involving
the body as well as the face, punctuate his production and
none is odder or wittier than the one shown here, where
the photographer's almost full-length shadow takes on a
body of its own, with grass for hair, and rocks and earth
as internal organs and tissue.

Expression

74. **Lee Friedlander**

American, b. 1934

Canyon de Chelly, Arizona

1983

Gelatin silver print

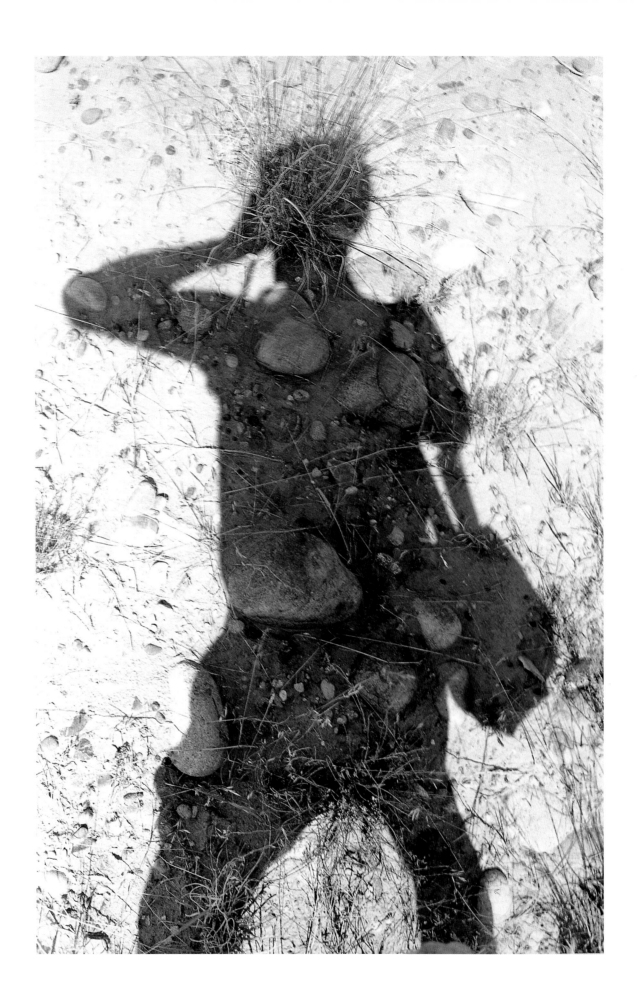

This photograph was made to illustrate the arteries and veins which supply blood to the cardiac muscles. The making of the image involved a time-consuming and complicated procedure. The blood vessels, which lie immediately below the surface of the heart, were first injected with dyed gelatine, so that even the smallest capillaries which form this exquisite arterial network can be seen. The heart was cleaned and then dehydrated by immersing it in a solution of alcohol. This step was repeated a number of times, each time placing the organ in a stronger alcoholic solution. The heart was then transferred to a bath containing a clearing agent which made its surface transparent to a depth of one to two millimetres, enabling the blood vessels to become visible. The layperson can be forgiven for thinking he or she is looking at the reflections of trees in a pond, or branches seen from the depths of a well. Scientific images of the body often remind us of other aspects of the physical world – landscapes in particular – and by bridging the gulf between art and science they can only confirm our appreciation of a human being's phenomenal physical complexity.

Enquiry

75. **Anonymous**
The Heart, Showing the Veins and Arteries
1983
Gelatin silver print

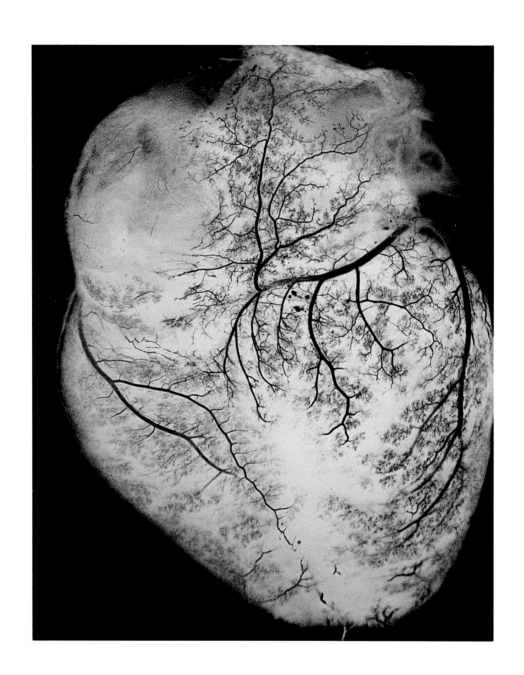

Ilan Wolff is a fan of the pinhole camera (also known as the camera obscura), a rudimentary photographic apparatus, the principle of which was already known in antiquity. If a small hole is pierced in one wall of a dark room, an inverted image of the daylight world outside is projected onto the wall opposite the aperture. The same result can be obtained using a lightproof box, and the image may be recorded on a sheet of film placed against the back wall. Because the device does not use a lens, however, the image is relatively blurred and distorted. In the hands of an artist, the pinhole camera's limitations are a source of creative transformation. In the nude shown here, the body flattens out, metamorphosing into a flat, scroll-like form which seems in danger of rolling back on itself.

Form

76. **Ilan Wolff**
Israeli, b. 1955
Nude
1984
Chromogenic print. From camera
obscura image

'The variety and exuberance of pathology, as well as the expressiveness exhibited by these patients, impressed me immediately. It all corresponded perfectly with my belief that the illustration of disease should include the suffering inherent to it.' So writes Miguel Ribeiro, describing his motives as a young doctor-cum-amateur-photographer on arrival at a South African hospital. A specialist in tropical diseases, the twenty-eight-year-old Portuguese had first to overcome the suspicions of the Afrikaner administrators at Kalafong Hospital, as well as those of certain colleagues. Apartheid was under siege in 1980, and a recently arrived foreigner roaming the corridors and wards with a camera was especially suspect, since hospital audiovisual materials had been used outside South Africa to criticise the regime.

Ribeiro's determination to pursue his photography, however, gradually wore down the opposition, particularly as he was willing to donate his imagery to the hospital slide library. For almost the entire decade, until 1989, when he left the hospital for work elsewhere and abandoned photography, he focused his camera on the full range of maladies around him. These were, in his words, 'unusual, florid, unmodified by therapy, and inadequately documented' (by which he meant that photographic evidence was lacking). Sometimes the conditions he recorded were the result of accident, violence or self-abuse. Conceptually, technically and aesthetically, Ribeiro's oeuvre is extraordinary, and comprises one of the most significant medical documents of the late twentieth century. If the pictures are, by necessity, clinical in their approach, they nonetheless manage to convey subtly but convincingly a sense of the physical and emotional anguish suffered by the patients. The tilt of the head of the woman in the study shown here, for example, betrays unspeakable pain.

P a i n

77.

Miguel Ribeiro
Portuguese, b. 1952
Beaten-up Woman
1986
Gelatin silver print

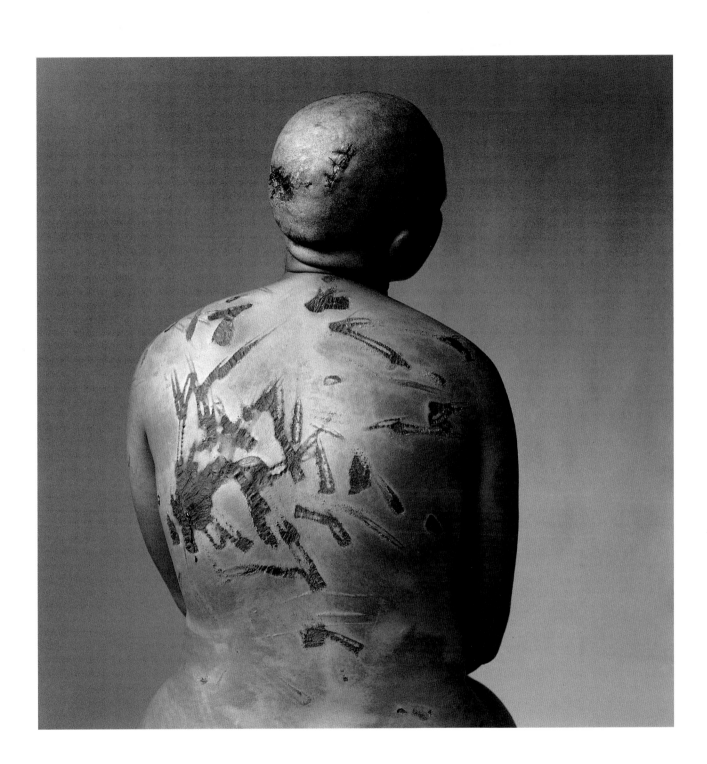

Feathers, petals, shells, animal hides, human skin…
Balthasar Burkhard is fascinated by the sensual surfaces
of living organisms which protect them from the external
world. The human envelope is, therefore, one of Burkhard's
preoccupations. In the diptych *Veins* (which, it must be said,
is a work of monumental scale, each part being approximately
180 by 66 centimetres [71 by 26 inches]), fragments of the
body, particularly arms and parts of arms, immediately call
to mind other things: the clinically descriptive plants of Karl
Blossfeldt, for example, Cycladic figurines, or the spindly legs
of a colt. Even when the mind registers the human element,
the imposing verticality suggests legs rather than arms. This
ambiguity forces us to look anew at a part of the body which
is virtually never seen fragmented in this way. We are
suddenly aware, for example, of its extraordinary thinness,
and of the striking difference between the upper and lower
arm, as the rivers of blood branch towards the hand with
ever more complexity. Perhaps it was this river metaphor that
inspired Burkhard years later to take to the air and record
American freeways, those great sinuous, pulsating veins of
the modern city.

Flesh

78. **Balthasar Burkhard**
Swiss, b. 1944
Veins
1988–1989
Gelatin silver prints

The subject of Helen Chadwick's work was always herself,
with her body as a primary component. A logical progression
in Chadwick's thinking since the early 1980s brought her
face to face with her body's most fundamental ingredient:
the cell. In a series of five *Viral Landscapes*, the artist
presented her cellular being as threatened by a particularly
dangerous type of invader: the virus, which ensures its own
proliferation by attaching itself to the genetic material. We
see what appears to be an electronic image of the virus in
the blood, followed by its escape into nature, where it takes
on macroscopic dimensions, washing over the rocky shoreline
like a great, destructive wave. Chadwick, conscious of her
internal body in a way unimaginable by an artist fifty years
earlier, could no longer look upon the world outside without
acknowledging the turmoil within.

Expression

79.

Helen Chadwick
British, 1953–1996
Viral Landscape No. 3
1988–1989
Computer-edited Cibachrome print

Since the 1970s, Arno Rafael Minkkinen has devoted himself to a particular genre, which is only partly described by the term 'self-portrait'. A self-portrait traditionally concerns itself with the face, the age-old unspoken assumption being that the face mirrors fundamental aspects of personality and character – what is today commonly referred to as 'identity'. Minkkinen, however, prefers to use as raw material his lanky, ascetic body, which he ingeniously fragments and inserts into natural environments which evoke his native Finland. Minkkinen studied photography at the Rhode Island School of Design and was much influenced by the poetic vision of his teachers, Aaron Siskind and Harry Callahan, in particular their belief that careful observation of the physical world would reveal truths about the self. Fulfilling the roles of director, actor and cameraman, he poses his body in ways that suggest other kinds of beings or inanimate objects. These strange forms might hover in the sky like a bank of clouds, emerge from a pond like the gnarled stump of a tree, drift silently down a stream like a log, or skim across a lake with the agility of a water spider. Shadows and reflections help Minkkinen weave his body seamlessly into nature and further confound the viewers. Contrary to appearances, however, there are no double exposures or other kinds of darkroom manipulations in Minkkinen's work: part-contortionist, part-dancer, part-shaman, he is content with the expressive potential of his own malleable body.

E x p r e s s i o n

80. **Arno Rafael Minkkinen**
 American, b. Finland, 1945
 Self-Portrait, Fosters Pond
 1989
 Gelatin silver print

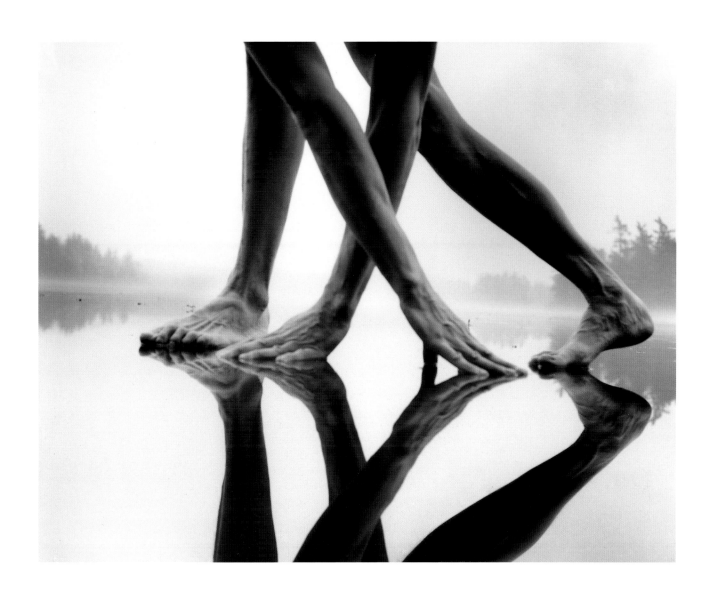

Gérard Lüthi has focused his camera on a subject close to
home and close to his heart: his father and his son. Without
any cloying sentimentality – the bane of family snapshots
and commercial greetings cards – he has produced a moving
series of images in which love and affection, and the passing
of the torch from generation to generation, are expressed
through the language of the body. By choosing to exclude
the faces, Lüthi breaks a fundamental principle of classic
portraiture, but nonetheless provides compelling and highly
individuated studies of two people dear to him. The
oppositions within the image give it its strength. First, the
scale of the two figures: the large bulk of the elder Lüthi,
his arms gently holding the tiny form of the child in a gesture
of protection and guidance; second, the skin, marking the
passage of time: the weathered hide and bulging veins of
the grandfather's body, reminding us of an ancient tree,
contrasted with the smooth, peach-like skin of his grandson
– a blank page on which the experiences of a lifetime have
still to be written.

Flesh

81. **Gérard Lüthi**
Swiss, b. 1957
From the series *Time Reconciled*
1989–1990
Gelatin silver print

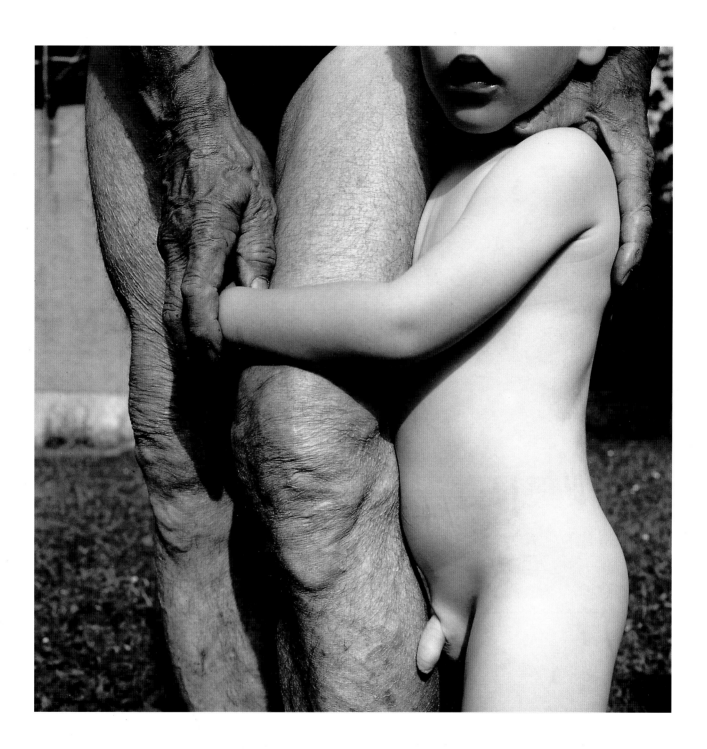

We are not used to thinking of medical photography, in particular photographs that show surgical operations, in terms of aesthetics. Given the horror, or at best the unease, with which most people view the idea of the human body opened up, is such consideration possible? Or even desirable?

Although to a layman this image suggests a highly complicated procedure, we are in fact witnessing a routine cataract operation. A cataract is an opacity in the lens of the eye which necessitates the replacement of the lens with a plastic part. The patient, having received a local anaesthetic, remains conscious throughout. A metal device holds the eye open to facilitate the work of the surgeon. To the uninformed observer this object looks uncomfortably like an implement of torture; indeed, we cannot help but note the extreme contrast between the tender, bleeding human flesh and the hard, gleaming instrument. Our unease is further reinforced by the lack of other facial features, which have been covered by protective sheeting.

Light focuses our gaze on the eye of the patient, whose dilated pupil seems almost inhuman. The black ground pulls the gaze inwards and accentuates the violence of the colours; in short, the eye is presented like a jewel in a case. People are seldom given the opportunity to see such photographs because it is assumed that they will create anxiety. As a result, the operations themselves retain aspects of the sacred and the taboo. Max Aguilera-Hellweg's undeniably *beautiful* treatment of the subject may have a salutary effect: by sharing his imagery with the public, he encourages further understanding of the body's stunning complexity and modern medicine's equally miraculous achievements.

192

Enquiry

82. **Max Aguilera-Hellweg**
American, b. 1956
Cataract Surgery. From the series
The Sacred Heart
1989–1997
Chromogenic print

From its earliest days, photography has concerned itself with the family unit. In the nineteenth century, family members put on their best clothes and visited photographic studios, where they sat stiffly alone or together while a professional photographer commemorated the important events in their lives. With the coming of inexpensive hand-held cameras, in particular the Kodak of 1888, families began to take these photographic rites into their own hands, though the habit of entrusting a 'true professional' with the most important moments, like weddings, remains a tradition to this day.

The American photographer Sally Mann, a mother of three, works within the long-established genre of family photography, but in the tradition of the art photograph, rather than that of the vernacular 'snapshot'. Unlike the vast majority of photographer-parents who are determined to put a sunny disposition on family life whatever the actual circumstances of the moment, Mann is interested in capturing the deeper and more turbulent currents which characterize the emotional lives of her children. Her pictures never exclude the adult world which circumscribes those lives. In *Hayhook* her central focus is unquestionably the thin, suspended body of the young girl, but the svelte, luminescent beauty of this form is all the more poignant in juxtaposition with the heavy, sedentary bodies of family members or friends, who, unlike the photographer, seem oblivious to the graceful performance and the moment of youthful abandon that is passing them by.

194

F o r m

83. **Sally Mann**
American, b. 1951
Hayhook
1989
Gelatin silver print

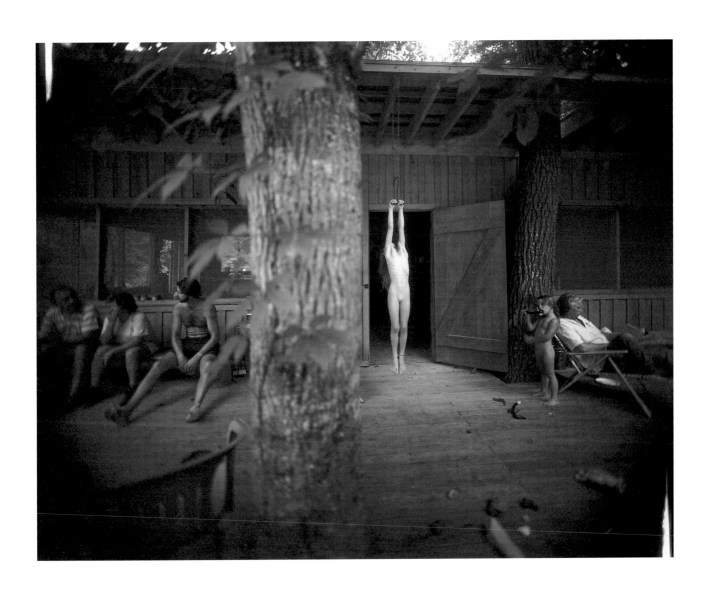

A sickly, clouded eye? A bowl? A pond? No, a 'portrait' of a simple fingernail, but divorced from the body and benefiting from the attention normally reserved for the face. Many twentieth-century photographers envision the body in fragments, but few have gone to the extremes, literally speaking, of the French photographer Patrick Tosani. Although hands, with their expressive connotations, are a common motif in photography, fingernails are rarely singled out – judged, apparently, inherently 'unphotogenic'.

Tosani sets out to correct this imbalance, training his camera on twenty-two highly individual specimens. Enlarging the nails dramatically, he sets them in tight, claustrophobic frames, then sets these frames in more generously proportioned neutral fields (each individual piece being 120 by 120 centimetres [47 by 47 inches]). Tosani's enlargement allows for almost microscopic scrutiny, and we perceive the fingernail as never before – an odd, ugly creature indeed, pushing up through the flesh at a snail's pace, its unevenly furrowed texture showing geological evidence of its difficult passage. This violent aspect of growth comes as a shock (especially as it seems frustrated by Tosani's tight framing), and reminds us of the body's continual struggle to maintain its defences against the outside world, all the while suffering maltreatment from the person to whom it belongs.

Flesh

84.

Patrick Tosani
French, b. 1954
Nail No. 6
1990
Cibachrome

A geisha, or a young woman presented as one, slouches on the floor in what appears to the uninformed Westerner to be a traditional Japanese setting. Her sexual attributes are exposed to the viewer, and her gaze transmits an unfathomable message. Is she conveying an invitation? A warning? Boredom? Distrust? Disgust? In one hand she holds a television remote control – and it seems the power to separate herself from the gaze of the viewer at the touch of a button – while a chic handbag sits in the corner behind her. She is wearing socks of the kind associated with schoolgirls, signalling a sexual fetish which enjoys a certain popularity in Japan. Nobuyoshi Araki has imagined a jarring *mise en scène* which combines elements borrowed from his country's ancient traditions with high-tech, high-fashion accoutrements which themselves betray no national heritage. There is something doll-like, even broken, in this woman's demeanour. This and other of Araki's stagings recall the fetishized dolls fabricated and photographed by Hans Bellmer in the 1930s. Like Bellmer's dolls, Araki's female subjects are often stripped, trussed and suspended, though an obvious theatricality of treatment suggests that Araki is making ironic comment rather than suffering a Bellmer-like obsession. What are we to make, then, of his visual games? An irreverent look at the mystique of the geisha, or titillating proposals involving the degradation of women's bodies? A protest against the new sexual morality of the 'politically correct'? Or, on the contrary, a violent backlash directed against the emancipation of Japanese women?

198

Desire

85. **Nobuyoshi Araki**
 Japanese, b. 1940
 Untitled
 1991
 Chromogenic print

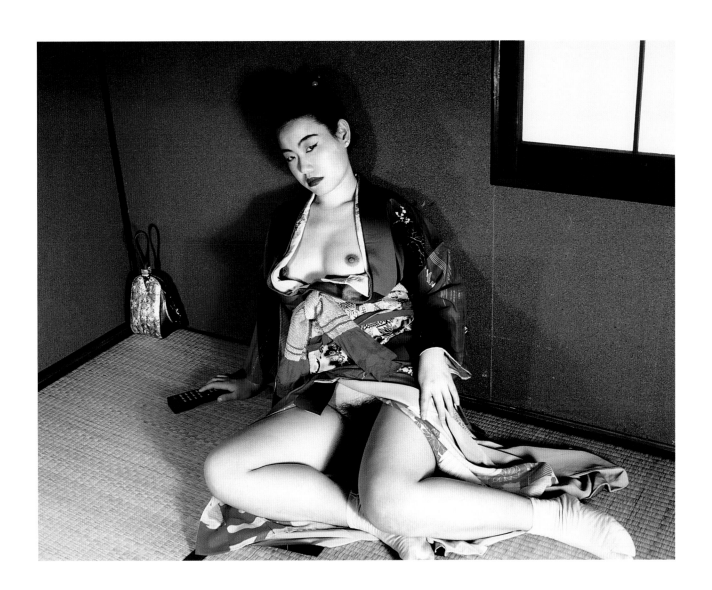

If representation of the dead is disturbing, the photography of those who have died violently is particularly horrifying, especially when the brutal facts – 'Jane Doe killed by police' – are the only context provided. *Why* did this happen?, *How* could it happen?, demands the viewer. Moral indignation at the horrors inflicted by one human being on another can go no further in the absence of additional information. The force of Andres Serrano's pictures stems precisely from the fact that he refuses to say more than: *'Here lies the evidence... Look.'*

Serrano's colour images, in large format (when exhibited in print form, this particular image is 127 by 152 centimetres [50 by 60 inches]), are almost baroque in their expressiveness. In most of the studies, the photographer opts for an extremely tight centring, which gives no respite to the eye. Instead, our gaze settles on detail: the putrefaction of the flesh, the traces of burn and injury, the stiffness of the corpse. The slow degradation of the body is presented dispassionately, with clinical detachment.

With the series *The Morgue*, Serrano tackles one of the most perturbing subjects of modern existence: death. Every city has its morgues, kept discreetly out of public view but ready at a moment's notice to take all comers. For urban dwellers, the death of strangers is an unpleasant reminder of one's own mortality and, if viewed by chance, a momentary disruption to the rapid flow of life; a quick and efficient removal of cadavers is therefore demanded by society. Serrano's morgue pictures are in this sense an unwelcome intrusion into our lives, and the horror is only augmented when we realize that these particular human beings have lost not only their lives, but also their identities.

P a i n

86.

Andres Serrano
American, b. 1950
The Morgue (Jane Doe Killed by Police)
1992
Cibachrome

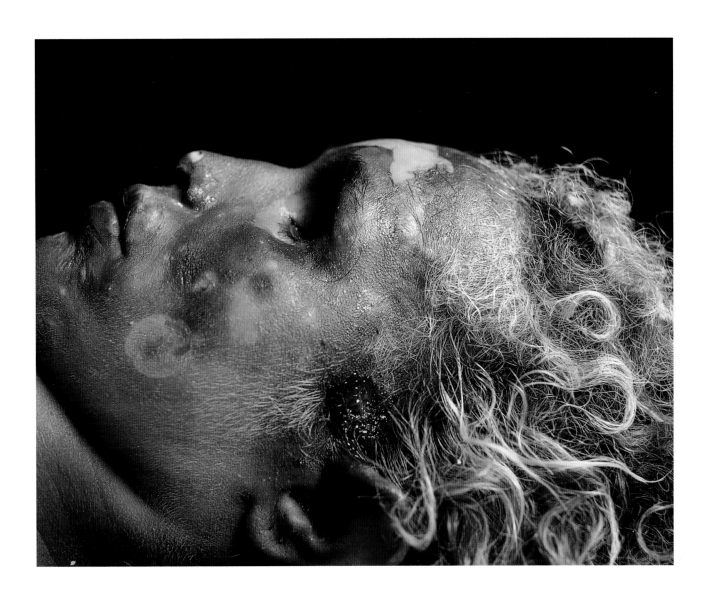

In a scene which could be a contemporary version of the Birth of Venus (Botticelli's in particular), a young girl is photographed on a beach in Poland. With her gaze fixed uncomfortably on the lens, her head slightly tilted and the weight of her body resting unsteadily on one leg, her position nevertheless recalls the classic pose of the female figure often found in Western iconography. While the photographer has issued no precise instructions to the model, other than to 'appear natural', the girl has adopted a pose which she considers appropriate for the occasion. However, a sense of vulnerability informs the image. Using colour and the bright light of her flash, and isolating the figure on a wide expanse of sea, Rineke Dijkstra reveals an adolescent who is hesitant and awkward in the public arena. It is in fact the presentation of the body in the public domain that seems to interest the photographer; otherwise she would surely have asked her subjects to pose nude in the privacy of the studio. Dressed only in a bathing suit, the girl's young, thin body is considerably exposed, and the growing pains that might otherwise have been hidden from view are touchingly evident. After working for several years on artists' portraits, Dijkstra achieved fame for this portrait and others in the series, taken on the beaches of Poland, Belgium and the United States. Impressed by the work of August Sander and Diane Arbus, Dijkstra sees photography as a means of exploring the human condition with dignity and respect.

Gaze

87.

Rineke Dijkstra
Dutch, b. 1959
Kolobrzeg, Poland. July 26
1992
Chromogenic print

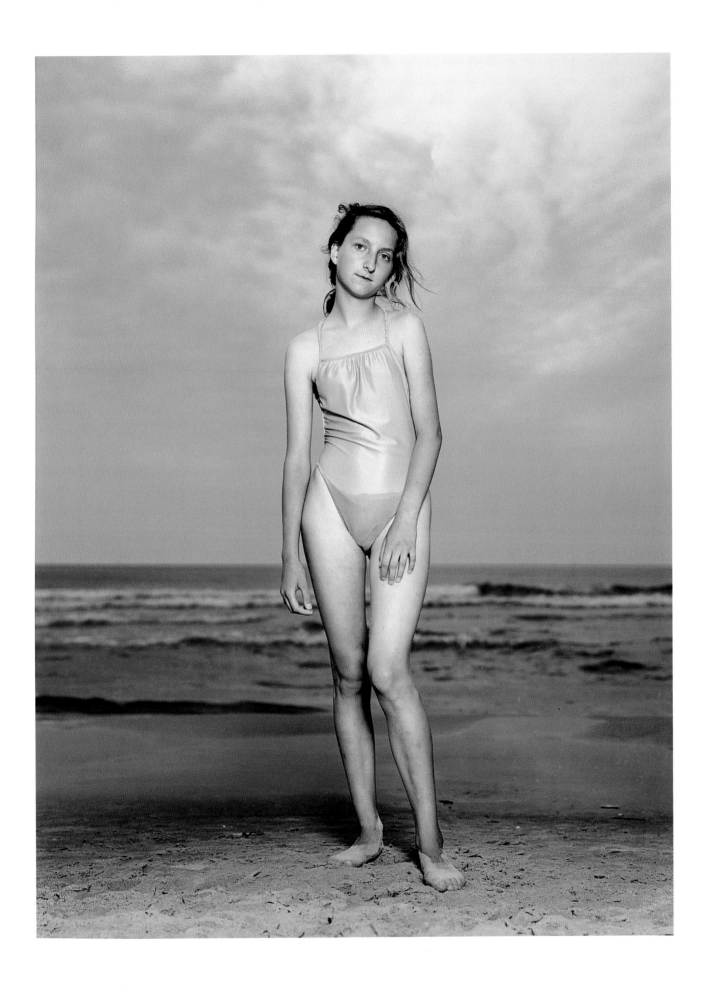

In 1984 John Coplans began training the camera on his own naked body. This in itself was not unique – other photographers had done it before. Few, however, had begun such a quest at the age of fifty-eight, or pursued it with anything like the same singlemindedness. And fewer still had been able to draw on such a wealth of art-historical precedents. Coplans had begun as a painter, but in mid-life gravitated to teaching and writing. In 1971 he cofounded the magazine *Artforum*, which soon became the epicentre of discourse on contemporary art of every genre, not to mention an extraordinary vantage point from which Coplans could follow developments. Thus, when Coplans decided to put writing aside to become a photographer, he not only had a stock of experiences behind him, but had also developed ideas and propositions about art which he was anxious to put to the test, and the body – specifically his own – was to be the vehicle.

Coplans's photographs are about ageing, but only on a superficial reading. There is no earthly reason why 'the nude' should be restricted to the young and the conventionally beautiful, especially when the genre seems to be on the verge of exhaustion. True, first viewing of Coplans's hirsute flesh comes as a shock, not because we never see elderly naked bodies, female or male, in real life, but because we very rarely see them in *photographs*. Once the shock has dissipated, however, we are ready to marvel at the forms Coplans's bulk assumes. In this three-part image, we sense a body in free fall, yet paradoxically feel a claustrophobia induced by the imprisoning grid. But there are also pleasures to be derived from contemplation of the image. Diverse associations spring to mind: a classical figure study, a frieze, a Primitivist sculpture, even a Brobdingnagian giant... Had Coplans's grasp of art and art history, including art photography, not been so broad, his work could never have had such rich resonances.

204

F l e s h

88.

John Coplans
British, b. 1920
Self-portrait: Upside Down, No. 7
1992
Gelatin silver print

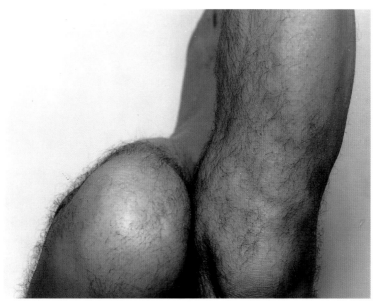

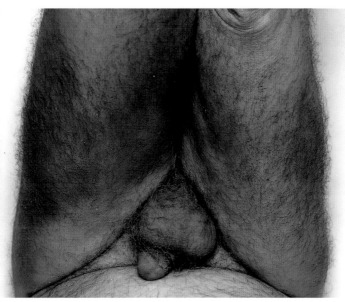

As the twentieth century drew to a close, the photographic self-portrait – at least in the standard close-up format, eye-to-camera – risked becoming a cliché. The British photographer David Hiscock's *Transmutations* provided an alternative. These were scans of the surface of Hiscock's body, and were intended to reveal something of the photographer's inner state. Hiscock trained his improvised photo-finish camera on his torso (more or less from navel to chin), while the film slowly wound past a slit aperture during a process that took as long as three minutes. He made these self-portraits on a regular basis, but only when he judged himself to be in a particularly intense mood, such as at times of concentrated creative work. During the exposures, he sometimes introduced an object for a moment or two – in this case an atlas – and these items left their peculiar traces on the film as well. *Transmutation XVII* recalls both beautifully grained wood and the kinds of patterns identified with oscilloscopes, electrocardiographs and DNA sequencing charts. But however abstract the body appears in *Transmutations*, Hiscock can still claim, in the final analysis, to have produced a set of objective, 'straightforward' documentary photographs.

Expression

89. **David Hiscock**
 British, b. 1956
 Transmutation XVII, Atlas
 1994
 Lightbox with Cibachrome transparency

Seemingly unbound by the force of gravity, two muscular dancers from Lausanne's Compagnie Nomades hurtle through the air in different directions, as if spun off by some invisible torque. Something of the electric, anxious pulse of modern life is conveyed by these powerful bodies. For more than thirty years Lois Greenfield has been working with dancers, both classical and modern, interpreting actual dance or the essence of a choreographer's style, or – her *preferred* way of working – creating her own 'photochoreography', which is to say, directing the dancers' movements explicitly for the camera. For this approach, Greenfield says, 'I tell the dancers to leave their choreography at the door.'

It must be said that dance photography is all too often second-rate art photography. The demands of dancers and choreographers for flattering pictures of their craft, showing impossibly perfect movements and gestures – often retouched, to add insult to the photographer's injury – has led to patently false and stultified imagery. Greenfield, however, puts her own medium first. Her aim, each time she triggers the shutter, is to make a superb photograph which can stand on its own as a work of art, and it is a measure of her skill that she manages to satisfy the dancers while fulfilling this requirement. Greenfield recognizes that her 'stage' is not the three-dimensional one on which the dancers actually perform, but a two-dimensional 'box' on a sheet of paper. Yet within this small square she miraculously coaxes her 'bodies' to fly, to float and to hover motionless in mid-air.

Expression

90.　　　　**Lois Greenfield**
　　　　　　American, b. 1949
　　　　　　Kathy Thompson and Gerald Durand
　　　　　　of Compagnie Nomades, Lausanne
　　　　　　1995
　　　　　　Gelatin silver print

Obsessed with the idea of keeping our bodies eternally young and healthy – a practice vigorously promoted by advertising and sustained by scientific research – we seem incapable of contemplating old age with serenity. Withered flesh is seen only as a sign of physical decrepitude and impending death. In this sense, the photography of the Japanese artist Manabu Yamanaka challenges convention. Here is a 'female nude', certainly, but one that is far removed from the standard incarnation of youthful sensuality to which we are accustomed. Photographed with clinical objectivity, a woman in her nineties poses naked against an empty white background. No 'props' soften the blow, nor does the subject make the slightest effort to hide her nakedness. Seeing an old woman thus – whether in the flesh or in a photograph – is, save for carers (Yamanaka practised as a nurse among elderly people for years, which explains the trust he earned), a rare and disturbing experience. We are caught between fascination and horror, not to mention sheer embarrassment. But the old woman seems comfortable enough with the act of being photographed, and the problem is ultimately ours to resolve. Maybe our discomfort lies in the fact that all such pictures are, in a manner of speaking, mirror images of our own bodies – not as they are now, perhaps, but as they will be at some date in the not too distant future. No wonder we prefer to look at the naked bodies of the very young and think of classic photographic nudes as 'timeless'.

F l e s h

91.　　　**Manabu Yamanaka**
Japanese, b. 1959
Gyahtei #2
1995
Gelatin silver print

Who has looked at a Van Gogh painting and not delighted in his swirling brushwork, as it animates the fields, clouds and brilliant, starry nights of his adopted Provence? This painter's style flashed into the mind of the British artist Mona Hatoum one day when she was washing her partner's back in the bath. Seeing the Van Gogh-like swirls that had taken shape in the thick, soapy hair, she quickly grabbed a small autofocus camera and recorded the image on film.

Several weeks later, thinking that the photograph was probably 'too much of a snapshot', and might be done better, she set up the situation again, this time using controlled lighting and a medium-format camera. The results, however, were disappointing; the photograph of the staged event was unconvincing, and could not begin to compare with the genuine feeling conveyed by the spontaneous 'snapshot'.

Mona Hatoum's art has been much concerned with visceral aspects of the body. In 1994 she produced the video installation *Corps étranger*, which showed the surface of her body and its interior, filmed with an endoscopic device. While the artist uses standard installation photographs to document her artworks, she likes to travel with a small camera, and considers the snapshot an ideal vehicle for seizing fleeting moments and chance occurrences.

Fiction

92. **Mona Hatoum**
British, b. Palestine, 1952
Van Gogh's Back
1995
Chromogenic print

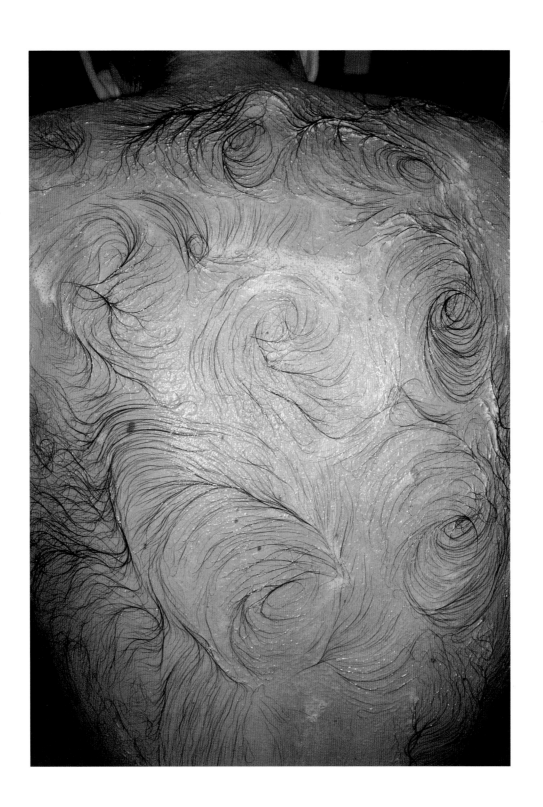

Many artists prefer to work in close collaboration with a partner: a husband or wife, a lover or friend, or someone who can bring to a partnership a particular expertise. One such couple, the German artists Friederike van Lawick and her partner Hans Müller, had the idea of looking more closely at this kind of relationship, literally putting a face on it. Among their subjects were Muriel Olesen and Gérald Minkoff, Swiss artists who use photography extensively in their art, working independently on certain projects and collaborating on others. As with other works in the series *La Folie à deux*, Van Lawick and Müller start with passport-style photographs of each partner, which, with the aid of a computer, they blend or morph together in a sequence of sixteen images, so that, leading from top left to bottom right, Olesen's face becomes that of Minkoff's, and vice versa. Between any two images, however, the change is imperceptible to the human eye. In the images in the middle of the sequence, the two faces are truly indistinguishable. Van Lawick and Müller's 'folies' are marvellous metaphors for the creative process of working as a couple: each of the parties has a distinctly individual contribution to make to the collaborative endeavour, but, at the same time, there is a 'middle ground' where their personalities fuse. In a larger context, Van Lawick and Müller's art is part of a growing tendency by contemporary photographers to make creative use of the computer in imagery relating to the human body.

Fiction

93.

Friederike van Lawick / Hans Müller
German, b. 1958 / German, b. 1954
Portrait of artists: Muriel Olesen and Gérald Minkoff.
From the series *La Folie à deux*
1996
Digitally processed photographs

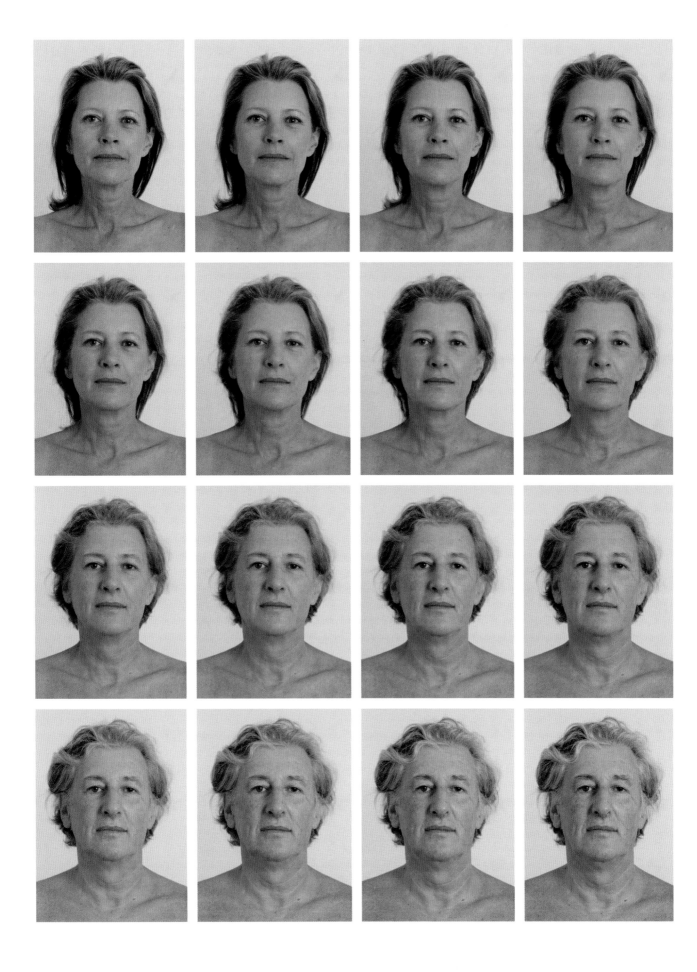

'In the consumer package', observes Jean Baudrillard, 'there is one object finer, more precious and more dazzling than any other – and even more laden with connotations than the automobile, in spite of the fact that that encapsulates them all. That object is the body.' For a number of years, the Swiss artist Daniele Buetti has been working with advertising and editorial photographic imagery taken from beauty and fashion magazines. Though at first glance the brandnames worn proudly by these virile young men and beautiful young women seem to have been etched permanently into their skin, in fact they have been scratched onto the reverse side of the magazine pages. Big business, Buetti seems to suggest, is successfully colonizing the human body, valorizing it as prime real estate. What better way to do this than to brand bodies like cattle? In *No Logo: Taking Aim at the Brand Bullies*, Naomi Klein quotes a young man who decides to get a Nike swoosh tattooed on his navel. 'I wake up every morning', he says, 'jump in the shower, and that pumps me up for the day. It's to remind me every day what I have to do, which is "Just Do It".' Earlier generations tucked their clothing labels discreetly out of sight; this one feels the need to parade the signs of conspicuous consumption and tribal identity. Buetti's simple grid arrangement stresses the actual uniformity of a culture that boasts of its individuality.

216

Politics

94.

Daniele Buetti
Swiss, b. 1956
Good Fellows
1996–1998
Composite of manipulated photographs

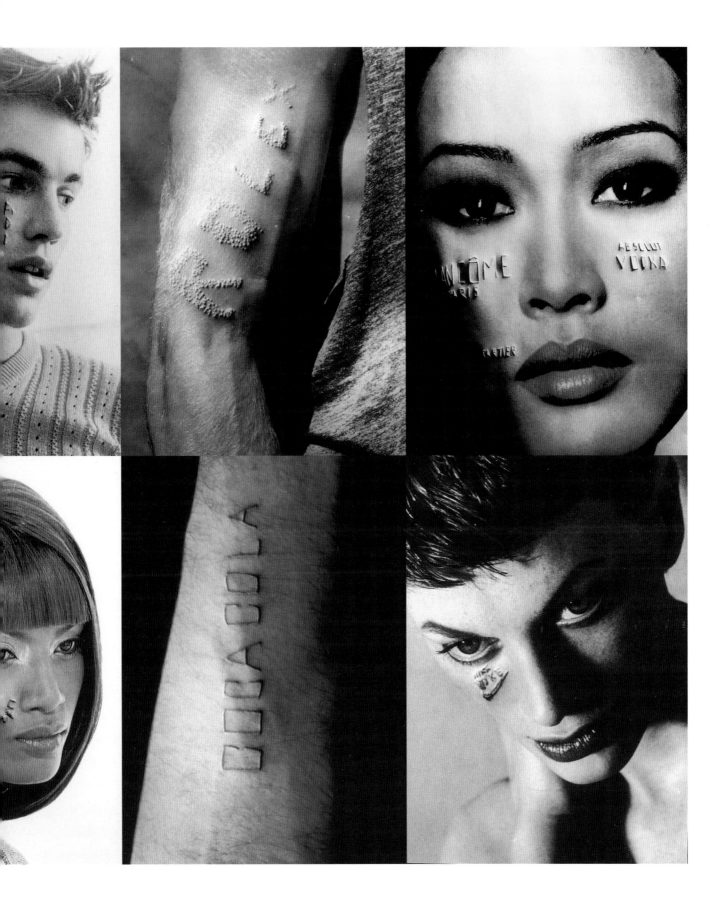

Although she lives and works in one of the world's great metropolises and spends her days on its crowded sidewalks, New Yorker Ann Mandelbaum makes art that concerns itself with a narrow band of the physical spectrum: the surfaces of the body, seen in extreme close-up. Her subjects are family members and intimate friends, whose eyes, ears, mouths, tongues, hairs, moles, nipples and other bodily details fascinate her. 'I am particularly intrigued by the body's orifices,' says Mandelbaum, 'by the difference between those which beckon and those which repel... Think of the tongue, a most bizarre animal which lives inside most of the time but darts outside on forays!' Mandelbaum attributes the germ of her obsession to parents who were professional beauticians, but her interest centres on differences and particularities rather than on idealized features. Her aim is to create something that will demand that viewers acknowledge their physical presence, their needs, and their desires. However, Mandelbaum employs a psychological distancing device in her printing; she uses partial solarization, by which positive tones are reversed to negative, to transform the raw material of the body into something precious and beautiful. 'Her subjects are large enough to be seen by the unaided eye,' notes curator Trudy Wilner Stack, 'but the focus is so particular through the filter of her camera's macro lens and her refined enlargements, that each visible detail becomes itself a universe of information...a macrocosm of human mortal material.'

Flesh

95. **Ann Mandelbaum**
American, b. 1945
Untitled
1997
Gelatin silver print

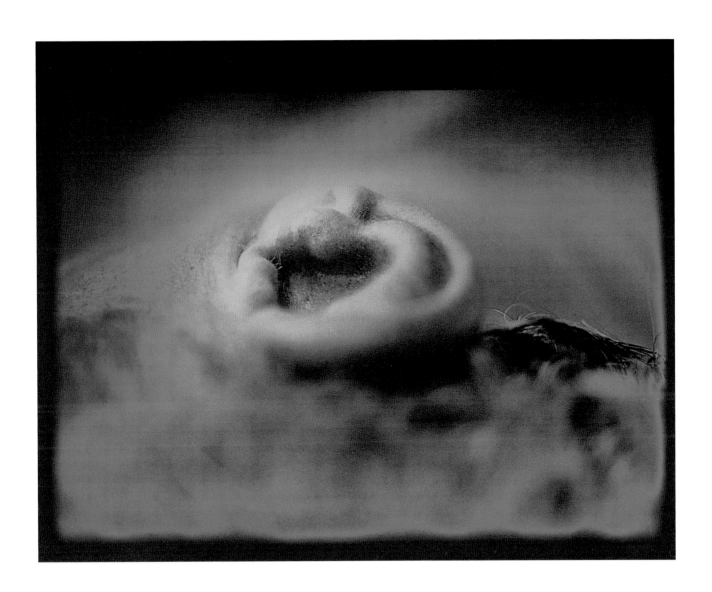

In 1801 the illustrator Samuel Thomas von Soemmerring wrote: 'Just as, on the one hand, we assume that all works of art representing the human body and claiming ideal beauty for themselves needs be correct from an anatomic point of view, so, on the other hand, should we as readily expect that everything that the dissector describes anatomically as a normal structure must needs be exceptionally beautiful.' This extraordinary picture – which in its beauty confirms von Soemmerring's observation – was made from a specimen prepared by dissector Bari Logan for the benefit of nurses. It shows a general dissection of the epiglottis from behind, with muscle layers and basic structure revealed.

Ralph T. Hutchings has been specializing in photography of the human body since 1970, believing the corporeal terrain to be a virtually inexhaustible source of images. Far from being a discrete and inherently limited subject, the body is of such complexity that it allows anatomical photography to renew itself constantly. Newly expanding fields, like cosmetic surgery, heart surgery and foetal *in vivo* surgery, call for new sets of images. When Hutchings began working at the Department of Anatomy at the Royal College of Surgeons in London, he found many pictures in existing anatomy atlases to be poorly made or, worse, erroneous, and set out to furnish replacements. Hutchings takes great pains with his pictures, working closely with dissectors, and may light an object with his flash as many as 250 times in exposing a single sheet of film. This is sometimes necessary to achieve the requisite three-dimensional effect. In spite of the pride he takes in his craft, however, Hutchings believes that photography, no matter how sophisticated, can never match the experience of dissecting a real cadaver, and should always be considered as an aid rather than as a substitute for the knife. He has also voiced concerns that modern lenses and cameras are inferior to those used in the 1950s, a disquieting development as far as the future of his *métier* is concerned.

E n q u i r y

96. **Ralph T. Hutchings**
 British, b. 1945
 Larynx, Pharynx and Oesophagus, from Behind
 1997
 Colour transparency

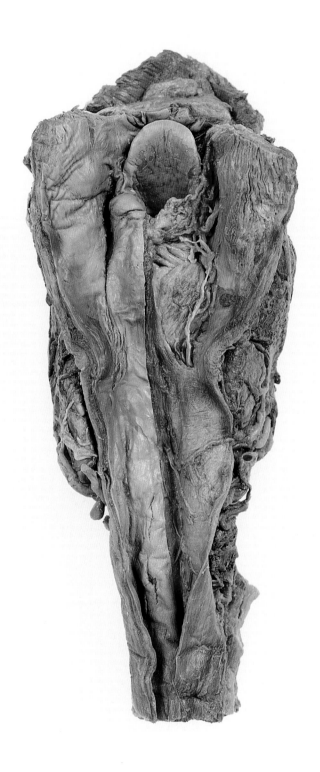

Two naked young women pose, utterly relaxed, in what appear to be idyllic surroundings – warm weather, calm water, roughly textured wood and rich vegetation shimmering as if in a dream. The body in the foreground neatly frames the standing figure in the background which, struck by the full force of the sun, is transformed into a kind of abstract sculpture. The site is somewhere in Northern California, so highways and fast-food outlets cannot be much more than a stone's throw away, but nothing of the modern world impinges directly on this Eden.

Since the early 1980s Jock Sturges has been seeking out the refuge of naturist communities (which differ from nudist colonies in that naturists wear or do not wear clothing as the need strikes them), spending time getting to know his subjects before setting up his large-format camera and lights. Influenced by Alfred Stieglitz's cumulative portrait of Georgia O'Keeffe, and Edward Weston's many studies of his lover, Charis, Sturges believes that depth in a photograph only comes about with true knowledge of the sitter. Once photographer and subject are comfortable with each other, pictures can be made with a high degree of spontaneity. This is important, since the sun provides its splendid opportunities for only very brief moments: 'At the end of the day, when shadows stretch and pivot,' notes Sturges, 'one is surely outstripped if tangled by thought and measure.'

Form

97. **Jock Sturges**
American, b. 1947
Allegra and Karuna; Northern California
1998
Gelatin silver print

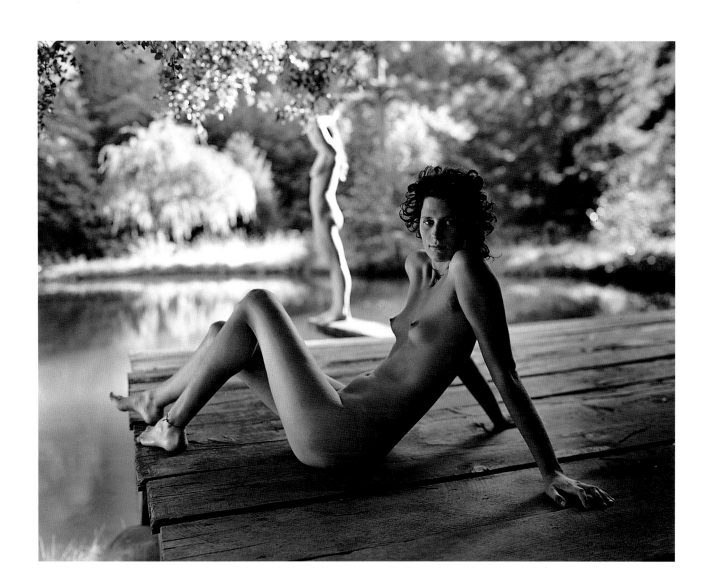

This female nude would be a figure of classical beauty were it not for that third nipple. This kind of disturbing physical anomaly (artificial in this case) is a typical feature of the work of Joel-Peter Witkin, whose Bosch-like tableaux involving both the living and the dead have provoked equal measures of outrage and admiration. Allegory is another key aspect of Witkin's art: he uses a panoply of different figures to personify ideas, vices and virtues. Thus, his bizarrely endowed 'beauty' (whom he models on the Eve figure in a painting by Lucas Cranach the Elder) allows Witkin to reflect on what he calls 'the imperceptibility of consciousness' in imagery of the body. This Eve is a goddess-like creature (all the more ethereal for having agreed to shave her pubic hair and be covered in white powder), blessed with beauty, grace and the special quality of 'otherness'. But what can she be thinking and feeling? That the earth is a hard and forbidding terrain? Perhaps she is contemplating her suicide, or martyrdom: a ladder waits to assist her heavenward. Or is she dreaming of flying or sailing away to an earthly paradise, as the attributes of kite and boat suggest? It is not entirely in a spirit of irony that Witkin mimics the appearance of nineteenth-century allegorical photographs, with their morbid atmospheres and their surfaces scratched and mottled by time; he simply recognizes the tradition as the best means of addressing the great mysteries of life.

Fiction

98. **Joel-Peter Witkin**
American, b. 1939
Beauty Has Three Nipples, Berlin
1998
Toned gelatin silver print

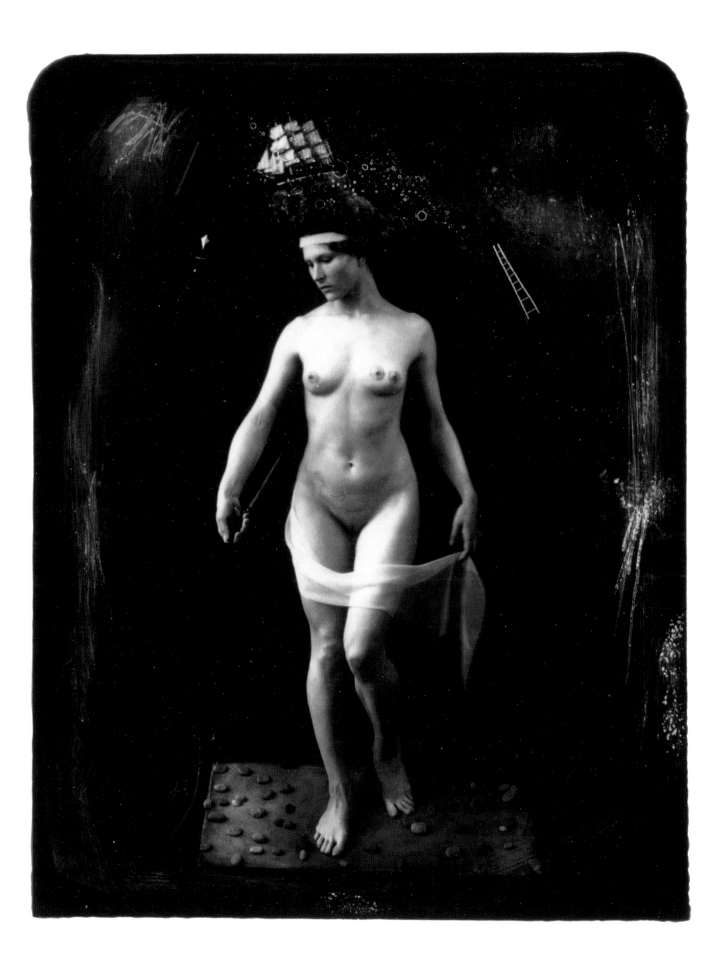

This artist duo have emerged since the early 1990s with a unique body of work which questions both the pictorial conventions and the cultural constructs pertaining to beauty, bodily perfection, gender and sexuality. Their imagery also denounces the pervasiveness of the computer in our lives and our blind faith in high-tech solutions for every social and personal problem. Moreover, their approach raises questions about the nature of photography itself. In the past, Aziz + Cucher have used computer manipulation to transform bodies into grotesque yet attractive mutants that strike us as genetic engineering experimentation gone awry. Their work featured superbly conditioned naked men and women with neither genitals nor nipples. This was followed by a series of faces, shown in close-up, which were devoid of eyes, mouths and nostrils, but extremely detailed in terms of other features, such as beauty marks, wrinkles, blemishes and facial hair. It was as if the skin of the body had grown over the entire face, leaving the impression, as photohistorian Patrick Roegiers has put it, 'of bodies walled in on themselves with unspeakable suffering'. In their latest series, *Interior*, the body is *literally* walled in. The flesh walls, ceilings and floors of these otherwise empty rooms are a nightmarish vision of a future in which a surfeit of rational planning, commercial ambition and highly developed techniques of genetic engineering have transformed the built environment into flesh – or *vice versa*. Aziz + Cucher warn us, as Claudia Springer also did in *Electronic Eros*, that 'those who adulate technology's penetration of the human body and mind can lose sight of how the attempt to become a technological object leads to extinction.'

226

F l e s h

99. **Aziz + Cucher (Anthony Aziz and Sammy Cucher)**
American, b. 1961 / Venezuelan, b. 1958
Interior #5
1999
Chromogenic print

In 1997 and 1998, Gary Schneider undertook a complex self-portrait using imaging techniques normally found only in the context of diagnostic and research medicine. Schneider had been offered a chance to create a new body of work relating to the Human Genome Project, and with the help of an array of instruments – including a nanoscope atomic force microscope, a scanning electron microscope, an X-ray machine, and a fundus camera – the artist was able to envision his body in novel ways down to the level of a single cell and its genetic material.

Schneider's composite portrait also included images that made use of a traditional photographic technique – the photogram – though he modified it in a particular way. A photogram is a cameraless image produced by placing an object or objects on a sheet of photographic film or paper and then exposing the ensemble to light; the object will block the light, leaving its imprint on the paper. Schneider's hands were imaged in this manner, so that the heat and moisture of his body also registered on the film. 'It was with the addition of my hand prints that the portrait moved from a harvesting of my biological information to an emotional response to the Human Genome Project,' Schneider has explained. He sees his portrait as an act of faith in the biological future despite his misgivings about stepping into the unknown.

The 'thermohydrogram' presented here, though not part of the original 'genetic self-portrait', proves that Schneider remains intrigued by the concept and will certainly explore it further. He is evidently more sensitive now to its macro-cosmic implications. Like many scientific imagemakers of the body's most minute structures, he too has been awed by their resemblance to the infinitely vast structures of the universe.

M a c r o c o s m

100.

Gary Schneider
American, b. South Africa, 1954
Lips
2000
Toned gelatin silver print, thermohydrogram

Notes and Sources of Photographs

Foreword

1. For an intelligent speculative view of the future of genetic engineering and artificial intelligence, *see* George Dyson, *Darwin among the Machines: The Evolution of Global Intelligence*, Reading, Mass., 1997, and Ray Kurzwell, *The Age of Spiritual Machines: When Computers Exceed Intelligence*, New York, 1999.

2. For a wide overview of body-centred imagery since the invention of photography, *see* William A. Ewing, *The Body: Photoworks of the Human Form*, London and New York, 1994. For a theoretical and academic viewpoint, *see* John Pultz, *Photography and the Body*, London, 1995.

Form, Fragment and Flesh

1. For an excellent synthesis of nineteenth-century attitudes, *see* Stephen Kern, *Anatomy and Destiny: A Cultural History of the Human Body*, Indianapolis, Indiana, 1975.

2. For an overview of war photography, *see* Frances Fralin, *The Indelible Image: Photographs of War 1846 to the Present*, New York, 1985.

3. The earliest reliable and inexpensive methods of flash photography date from 1899, but it was not until 1929 that the flashbulb was made commercially available. *See* Pierre Bron and Philip L. Contax, *The Photographic Flash: A Concise History*, Allschwill, Switzerland, 1998.

4. Even the advent of the hand-held camera did not result in the immediate production of credible sports photography. On 13 January 1888, the year the Kodak was invented, the *Photographic News*, London, remarked that: 'It is strange that no one has thought of taking an instant camera to the recent prize fight. Such is the interest in the contest, the photos would have sold like wild-fire.'

5. As Carol Wax points out, 'The increasingly prosperous and powerful middle class evolved into the largest market for reproductive prints. Furthermore, the rise in literacy and journalism helped create a more informed public, with enough uniformity in opinions and fashions that printsellers could risk selling larger editions.' *The Mezzotint: History and Technique*, London, 1990, p. 105.

6. Aside from the disdain, there were technical limitations. Writing on early clinical photography in Scotland in *History of Photography*, Vol. 23, No. 3, Autumn 1999, Mike Barfoot and A. D. Morrison-Low tell us that an important 1862 article which should have been illustrated with photographs was by necessity 'restricted to rather crude printed reproductions', p. 206.

7. The breakthrough came with the invention of the half-tone screen in the 1880s.

8. An overview may be found in Martin Kemp's essay, 'A Perfect and Faithful Record', in *Beauty of Another Order: Photography and Science*, Ann Thomas, ed., Ottawa and New Haven, Conn., 1997, pp. 120–149. Albert Londe, an innovative photographer who specialized in medicine at the Salpêtrière in Paris from 1882, could write in 1893 that medical photographers were 'only at the infancy of this new science'. (Kemp, p.141).

9. Modern cell theory, as elaborated by M. J. Schleiden and Theodor Schwann, dates from 1839, the exact year of the daguerreotype's debut. 'Un microscope daguerréotype' was used the same year by Léon Foucault and Alfred Donné in order to record samples of both human and animal tissues and fluids.

10. *See* J. J. Courtine and C. Haroche, *Histoire du Visage: exprimer et taire ses émotions XVI^e-début XIX^e siècle*, Paris/Marseilles, 1988.

11. *See* Guillaume-Benjamin-Armand Duchenne de Boulogne, *Mécanisme de la physionomie humaine*, Paris, 1862, and Charles Darwin, *The Expression of the Emotions in Man and Animals*, London, 1872.

12. Galton is best known for having founded the field of eugenics. Typical of his composite works was 'Prevalent types of features among men convicted of larceny (without violence)'. Galton's illustrated *Inquiries into Human Faculty and Its Development* was published in 1883.

13. We find in a *Photographic News* article of 7 April 1865 an assessment by one Ferdinand Beyrich of contemporary police photography. He writes that 'photography has forced itself into the law in its twenty-five years… One photograph would say more than a thousand words… and… performs its work in a few minutes'.

14. The discovery in 1861 of the gorilla, first described as a 'treeman', led to instant comparisons with the supposedly lowest order – the blackest skins. In Britain, Irishmen were placed no higher. A *Punch* cartoon of 23 November 1861, shows an Irishman looking at a photograph of a gorilla, with the caption 'the new photographic looking glass'.

15. There was much hypocrisy voiced in the journals and newspapers of the time. The *Photographic News* of 14 November 1879, while arguing for the natural nobility of Zulu nakedness, wrote: 'Should a gentleman ever allow an image of his wife to be exhibited anywhere near portraitures of half-naked actresses and entirely naked Zulu women, he can have but little respect for himself, for her, or for his position.'

16. *See* Robert Sobieszek, *The Art of Persuasion: A History of Advertising Photography*, New York, 1988, pp. 16–35. The author explains that advertising photography in the modern sense dates only from the 1920s.

17. Bayard's invention was, like Talbot's, a paper process, but unlike Talbot's, which was based on positive prints made from paper negatives, his involved a direct positive image, each being by definition unique. The scientist François Arago, who championed Daguerre as the inventor of photography, did his best to push Bayard into the shade.

18. An excellent collection of early erotic imagery is found in *Die Erotische Daguerréotype: Collection of Uwe Scheid*, with an introduction by Grant Romer, Weingarten/Freiburg, 1990.

19. For an excellent treatment of the nineteenth-century nude, up to the Pictorialist era, *see* *L'Art du nu au XIX^e siècle: le photographe et son modèle*, Paris, 1997.

20. *See* William A. Ewing, *The Photographic Art of Hoyningen-Huene*, London, 1986.

21. For a well illustrated anthology of the subject, *see* Maria Morris Hambourg and Christopher Phillips, *The New Vision: Photography between the World Wars*, New York, 1989.

22. *International Herald Tribune*, 20 February 1949.

23. For a clear description of these imaging techniques and a concise history of microscopes dating from the Renaissance, *see* Jeremy Burgess, Michael Marten and Rosemary Taylor, *Microcosmos*, Cambridge, 1987.

24. For an overview, *see* Nancy Hall-Duncan, *The Art of Fashion Photography*, New York, 1978.

25. *Requiem: by the photographers who died in Vietnam and Indochina*, edited by Horst Faas and Tim Page, London, 1997.

26. For a survey of the movement, *see* Paul Schimmel *et al.*, *Out of Actions: Between Performance and the Object 1949–1979*, The Greffen Contemporary at The Museum of Contemporary Art, Los Angeles, 2 February – 10 May 1998, New York, 1998.

27. For an appreciation of the subject, *see* William A. Ewing, *The Fugitive Gesture: Masterpieces of Dance Photography*, New York and London, 1988.

28. *Visible Human Project*, National Library of of Medicine/National Institutes of Health, Rockville Pike, Maryland, 1986, http://www.nlm.nih.gov/pubs/factsheets/visible_human.html

Sources

Pages

2 Courtesy The artist, Lausanne; © 1997 Olivier Christinat. 6 Courtesy Musée Nicéphore Niépce, Chalon-sur-Saône; © 1961 Pierre Boucher. 9 Courtesy The artist, London; © 1991–92 Andrew Sabin. 10 Courtesy The artist, St-Aubin; © 2000 Yves André. 12 Courtesy Staley-Wise, Inc., New York; © 1962 Bert Stern. 14 Courtesy Keystone, Zurich. 17 Courtesy Société Française de Photographie, Paris; © All rights reserved. 18 Courtesy National Gallery of Canada, Ottawa; © All rights reserved. 19 Courtesy Nicolas Crispini Collection, Geneva. 20 Courtesy Estate of Barbara Morgan, Hastings-on-Hudson, New York; © Estate of Barbara Morgan. 21, 22 Courtesy Uwe Scheid Collection, Uberherrn/Saar. 25 Courtesy The artist, London; © 1996 Melanie Manchot. 26, 27 Courtesy Zabriskie Gallery, New York; © 1975, 1999 Nicholas Nixon. 28 Courtesy The artist, London; © 1996 Nicholas Sinclair (Outfit by Anthony Gregory). 28 Courtesy PPOW Gallery, New York; © 1997 Gary Schneider.

Plates

1 Courtesy Nicolas Crispini Collection, Geneva; © All rights reserved. 2 Courtesy National Gallery of Canada, Ottawa. 3 Courtesy Musée de l'Elysée, Lausanne; © Reprinted with permission of Joanna T. Steichen. 4 Courtesy The Wellcome Library, London. 5 Courtesy Fotomuseum, Münchner Stadtmuseum, Munich. 6 Courtesy Keystone, Zurich. 7 Courtesy Burns Collection Ltd, New York; © Stanley B. Burns, M. D. and the Burns Archive. 8 Courtesy Uwe Scheid Collection, Uberherrn/Saar. 9 Courtesy Musée de l'Elysée, Lausanne. 10 Courtesy Nicolas Crispini Collection, Geneva. 11 Courtesy National Gallery of Canada, Ottawa, with permission of Fraenkel Gallery, San Francisco; © Lee Friedlander. 12 Courtesy Musée de l'Elysée, Lausanne. 13 Courtesy National Gallery of Canada, Ottawa; © All rights reserved. 14 Courtesy Burns Collection Ltd, New York; © Stanley B. Burns, M. D. and the Burns Archive. 15 Courtesy Musée national d'histoire et d'art, Luxembourg; © Reprinted with permission of Joanna T. Steichen. 16 Courtesy Kathryn Abbe, New York; © Estate of James Abbe. 17 Courtesy Uwe Scheid Collection, Uberherrn/Saar. 18 Courtesy Museum Ludwig, Cologne; © 2000 ADAGP/Man Ray Trust, Paris, and Rheinisches Bildarchiv, Cologne. 19 Courtesy Musée de l'Elysée, Lausanne. 20 Courtesy Gérard Lévy, Paris. 21 Courtesy Galerie Rudolf Kicken, Cologne; © Galerie Rudolf Kicken, Cologne, and Phyllis Umbehr, Frankfurt-am-Main. 22 Courtesy Galerie Berggruen, Paris. 23 Courtesy

Acknowledgments

National Gallery of Canada, Ottawa, with permission of Die Photographische Sammlung/SK Stiftung Kultur-August Sander Archiv, Cologne; © DACS, London 2000; ADAGP, Paris 2000; VG Bild-Kunst, Bonn 2000. **24** Courtesy National Gallery of Canada, Ottawa; © Ervina Boková-Drtikolová, Podebrady. **25** Courtesy Paul Strand Archive of Aperture Foundation, Inc., Millerton; © 1976 Aperture Foundation Inc., Paul Strand Archive. **26** Courtesy Musée de l'Elysée, Lausanne. **27** Courtesy Imogen Cunningham Trust, Berkeley; © 1978 Imogen Cunningham Trust. **28** Courtesy The Metropolitan Museum of Art, New York; © The Metropolitan Museum of Art, Ford Motor Company Collection, Gift of Ford Motor Company and John C. Waddell, 1987 (1987.1100.144). **29** Courtesy Museum Ludwig, Cologne; © 2000 ADAGP and Rheinisches Bildarchiv Cologne. **30** Courtesy Max Kozloff, New York; © Gilberte Brassaï, Paris. **31** Courtesy Imogen Cunningham Trust, Berkeley; © 1970, 1989 Imogen Cunningham Trust. **32** Courtesy Private Collection, Cambridge; © Yorick Blumenfeld. **33** Courtesy Fotomuseum, Münchner Stadtmuseum, Munich. **34** Courtesy Collection Ann and Jürgen Wilde, Zülpich; © Werner Rohde, Collection Ann and Jürgen Wilde. **35** Courtesy *Vogue* Paris; © Hoyningen-Huene. **36** Courtesy The Metropolitan Museum of Art, New York; © The Metropolitan Museum of Art, Ford Motor Company Collection, Gift of Ford Motor Company and John C. Waddell, 1987 (1987.1100.15). **37** Courtesy Private Collection, New York. **38** Courtesy The Metropolitan Museum of Art, New York; © The Metropolitan Museum of Art, Ford Motor Company Collection, Gift of Ford Motor Company and John C. Waddell, 1987 (1987.1100.9). **39** Courtesy Musée de l'Elysée, Lausanne; © 1936 Rodchenko Archive, Moscow. **40** Courtesy Leni Riefenstahl Production, Pöcking; © 1936 Leni Riefenstahl. **41** Courtesy Museum Ludwig, Cologne; © 1981 Arizona Board of Regents, Center for Creative Photography, Tucson, Arizona, and Rheinisches Bildarchiv, Cologne. **42** Courtesy Bayerische Staatsbibliothek, Munich. **43** Courtesy Musée de l'Elysée, Lausanne; © 1939 Condé-Nast, Inc. (renewed 1967). **44** Courtesy Musée de l'Elysée, Lausanne; © The John and Annamaria Phillips Foundation. **45** Courtesy Fotomuseum, Münchner Stadtmuseum, Munich. **46** Courtesy Fondation Select, Boncourt; © 1948 George Rodger/Magnum Photos. **47** Courtesy Fondation Select, Boncourt, with permission of Staley-Wise, Inc., New York; © 1948 Estate of Louise Dahl-Wolfe. **48** Courtesy Musée de l'Elysée, Lausanne; © 1952 Gerhard Kiesling. **49** Courtesy Fondation Select, Boncourt, with permission of Bill Brandt Archive Ltd, London; © 1953 Bill Brandt. **50** Courtesy National Gallery of Canada, Ottawa, with permission of Howard Greenberg Gallery, New York; © 1955 Stuart Karu. **51** Courtesy The artist, New York; © 1963 Carolee Schneemann. **52** Courtesy Galerie Krinzinger, Vienna; © 1965–66 Angelika Hausenblas. **53** Courtesy The artist, Pietrasanta; © 1968 Romano Cagnoni. **54** Courtesy Museum Ludwig, Cologne, with permission of Goro International Press, Tokyo; © 1968 Kishin Shinoyama and Rheinisches Bildarchiv, Cologne. **55** Courtesy Pace/MacGill, New York; © 1968 Duane Michals. **56** Courtesy The artist, Vienna; © 1969 Peter Hassmann, Vienna, Archiv Valie Export. **57** Courtesy The artist, Batcombe, Somerset; © 1969 Don McCullin. **58** Courtesy Collection Alain Weill, Paris; © 1970 Ronald

Haeberle, Life Magazine, Time Inc. **59** Courtesy Maison Européenne de la Photographie, Paris; © 2000 ADAGP/Françoise Molinier. **60** Courtesy Fondation Select, Boncourt, with permission of Keystone, Zurich; © 1972 Nick Ut/The Associated Press. **61** Courtesy Musée de l'Elysée, Lausanne. **62** Courtesy Albert Bonniers Förlag AB, Stockholm; © 1973 Lennart Nilsson. **63** Courtesy Maison Européenne de la Photographie, Paris; © 1969–1973 Richard Avedon. **64** Courtesy The artist, Topanga; © 1974 Chris Burden. **65** Courtesy Maison Européenne de la Photographie, Paris, with permission of Galerie Limmer, Cologne; © 1977 Dieter Appelt. **66** Courtesy Fondation Select, Boncourt; © 1978 Leonard Freed/Magnum Photos. **67** Courtesy Musée Nicéphore Niépce, Chalon-sur-Saône; © 1978 Charles Gatewood. **68** Courtesy The Andy Warhol Foundation for the Visual Arts, Inc., New York; © 1979 ProLitteris, Zurich. **69** Courtesy The artist and Metro Pictures, New York; © 1979 Cindy Sherman. **70** Courtesy The artist, New York; © 1980 Ralph Gibson. **71** Courtesy Maison Européenne de la Photographie, Paris; © 1981 Helmut Newton. **72** Courtesy Estate of Robert Mapplethorpe, New York; © 1982 Estate of Robert Mapplethorpe. Used with permission. **73** Courtesy The artist, New York; © 1982 Nancy Burson. **74** Courtesy Fraenkel Gallery, San Francisco; © 1983 Lee Friedlander. **75** Courtesy Keystone, Zurich. **76** Courtesy The artist, Seyssel; © 1984 Ilan Wolff. **77** Courtesy The artist, Lisbon; © 1986 Miguel Ribeiro. **78** Courtesy Galerie Liliane & Michel Durand-Dessert, Paris; © 1988–89 Balthasar Burkhard. **79** Courtesy Galerie Friedman-Guinness, Frankfurt, and the Estate of Helen Chadwick. **80** Courtesy Barry Friedman Ltd, New York; Nathalie C. Emprin, Paris; Photo & Co., Turin; © 1989 Arno Rafael Minkkinen. **81** Courtesy The artist, Moutier; © 1989–90 Gérard Lüthi. **82** Courtesy Steven Kasher Gallery, New York; © 1991–97 Max Aguilera-Hellweg. **83** Courtesy Edwynn Houk Gallery, New York; © 1989 Sally Mann. **84** Courtesy Galerie Liliane & Michel Durand-Dessert, Paris; © 1990 Patrick Tosani/2000 ADAGP. **85** Courtesy Fotomuseum, Winterthur, with permission of Photo-Planète Co., Ltd, Tokyo, and Galerie Bob van Orsouw, Zurich; © 1991 Nobuyoshi Araki. **86** Courtesy Paula Cooper Gallery, New York; © 1992 Andres Serrano. **87** Courtesy The artist, Amsterdam; © 1992 Rineke Dijkstra. **88** Courtesy The artist, New York; © 1992 John Coplans. **89** Courtesy The artist, London; © 1994 David Hiscock. **90** Courtesy The artist, New York; © 1995 Lois Greenfield. **91** Courtesy Stefan Stux Gallery, New York; © 1995 Manabu Yamanaka. **92** Courtesy The artist, London; © 1995 Mona Hatoum. **93** Courtesy The artists, Kirchheim u. Teck; © 1996 Friederike van Lawick and Hans Müller. **94** Courtesy The artist, Zurich; © 1996–98 Daniele Buetti. **95** Courtesy Galerie Françoise Paviot, Paris; © 1997 Ann Mandelbaum. **96** Courtesy The artist, London; © 1997 Ralph T. Hutchings. **97** Courtesy Galerie Dorothée de Pauw, Brussels; © 1998 Jock Sturges. **98** Courtesy Galerie Baudoin Lebon, Paris; © 1998 Joel-Peter Witkin. **99** Courtesy The artists, New York; © 1999 Aziz + Cucher. **100** Courtesy PPOW Gallery, New York; © 2000 Gary Schneider.

The Musée de l'Elysée wishes to thank the many museums, galleries, public collections, private collections and individual photographers who helped make this publication possible.

The book was inspired by the exhibition 'The Century of the Body: Photoworks 1900–2000', which was commissioned by Culturgest, Lisbon, and produced by the Musée de l'Elysée, Lausanne. It therefore seems appropriate to mention here those individuals who were responsible for mounting this ambitious project.

Exhibition Curators: William A. Ewing; Daniel Girardin; Christophe Blaser; Nathalie Herschdorfer
Project Coordinators:
Nathalie Herschdorfer; Raphaël Biollay
Researchers: Nassim Daghighian; Marco Costantini; Rachel Vez Fridrich
Registrar: Corinne Coendoz
Technical Organisers: André Rouvinez; Jean Clivaz; Michèle Guibert
Administrator: Béatrice Béguin
Assistants: Marie-Claude Bouyal; Michèle Koller; Bernadette Theurillat; Gabriela Schuepbach; Manfred Bathke; Christine Giraud; Yves Wagner; Pascale Pahud; Nathalie Choquard; Georges Focseneanu
Interns: Isabelle Burgy; Christina Natlacen
Translators: Félicie Girardin; Brian J. Mallet
Book Designer: Valérie Giroud
Reproductions: La Chambre Claire, Neuchâtel

In addition, we wish to express our gratitude for the support of The Leenaards Foundation, Lausanne; Culturgest, Lisbon; The British Council, London; The Henry Moore Foundation, Hertfordshire; Pro Helvetia (Art Council of Switzerland), Zurich; The Cultural Affairs Service of the Canton of Vaud, Lausanne; and The Elysée Foundation, Lausanne.

Index

Page numbers in *italics* refer to captions, commentaries and/or photographs.